INDIA: ECONOMIC, POLITICAL AND SOCIAL ISSUES

EXPLORING THE OPPORTUNITY AND CHALLENGES OF WOMEN IN INDIA

INDIA: ECONOMIC, POLITICAL AND SOCIAL ISSUES

Additional books and e-books in this series can be found
on Nova's website under the Series tab.

INDIA: ECONOMIC, POLITICAL AND SOCIAL ISSUES

EXPLORING THE OPPORTUNITY AND CHALLENGES OF WOMEN IN INDIA

SURENDRA BHASKAR
EDITOR

Copyright © 2019 by Nova Science Publishers, Inc.

All rights reserved. No part of this book may be reproduced, stored in a retrieval system or transmitted in any form or by any means: electronic, electrostatic, magnetic, tape, mechanical photocopying, recording or otherwise without the written permission of the Publisher.

We have partnered with Copyright Clearance Center to make it easy for you to obtain permissions to reuse content from this publication. Simply navigate to this **publication's** page on Nova's website and locate the "Get Permission" button below the title description. This button is linked directly to the title's permission page on copyright.com. Alternatively, you can visit copyright.com and search by title, ISBN, or ISSN.

For further questions about using the service on copyright.com, please contact:
Copyright Clearance Center
Phone: +1-(978) 750-8400 Fax: +1-(978) 750-4470 E-mail: info@copyright.com.

NOTICE TO THE READER

The Publisher has taken reasonable care in the preparation of this book, but makes no expressed or implied warranty of any kind and assumes no responsibility for any errors or omissions. No liability is assumed for incidental or consequential damages in connection with or arising out of information contained in this book. The Publisher shall not be liable for any special, consequential, or exemplary damages resulting, in whole or in part, from the readers' use of, or reliance upon, this material. Any parts of this book based on government reports are so indicated and copyright is claimed for those parts to the extent applicable to compilations of such works.

Independent verification should be sought for any data, advice or recommendations contained in this book. In addition, no responsibility is assumed by the Publisher for any injury and/or damage to persons or property arising from any methods, products, instructions, ideas or otherwise contained in this publication.

This publication is designed to provide accurate and authoritative information with regard to the subject matter covered herein. It is sold with the clear understanding that the Publisher is not engaged in rendering legal or any other professional services. If legal or any other expert assistance is required, the services of a competent person should be sought. FROM A DECLARATION OF PARTICIPANTS JOINTLY ADOPTED BY A COMMITTEE OF THE AMERICAN BAR ASSOCIATION AND A COMMITTEE OF PUBLISHERS.

Additional color graphics may be available in the e-book version of this book.

Library of Congress Cataloging-in-Publication Data

ISBN: 978-1-53616-424-4

Published by Nova Science Publishers, Inc. † New York

This book is dedicated to my loving daughters
Nistha *& **Arvi**, their arrival in my life made me more responsible and respectful towards women*

Contents

Preface		ix
Acknowledgments		xv
Chapter 1	Current Scenario of Women-Led Social Enterprises in Odisha *Suman Dhaka and Bijeta Mishra*	1
Chapter 2	The Impact of Globalization on Indian Women: Feminist Discourse *Avneet Kaur*	21
Chapter 3	Health Challenges and Opportunities for Indian Women: An Anthropological Approach of Allahabad Population *Arnasha Singh*	35
Chapter 4	Impact of the 73rd Constitutional Amendment Act (1992) on the Empowerment of Women in India *Shivani Chugh and Surendra Bhaskar*	57
Chapter 5	Financial Connectivity of Women in Rural India: The Role of the Mann Deshi Bank *Vinita Shrivastava*	71

Chapter 6	The Role of Education in Gender Sensitivity *Ravi Jhajharia and B. L. Bhamoo*	95
Chapter 7	Women Entrepreneurs in India: Opportunities and Challenges *Hemlata Mahawar*	107
Chapter 8	Electronic Governance and Women in India: Challenges and Prospects *Yogendra Singh*	121
Chapter 9	B. R. Ambedkar's Vision of Women's Right in India with Reference to the Hindu Code Bill *Avneet Kaur and Dilpreet Singh*	135
Chapter 10	Multiple Roles of Working Women: An Impact of Psychological Distress on Working Women in India *Suman Dhaka and Nilanta Mukherjee*	153
Index		173
Related Nova Publications		179

PREFACE

Contributing on **Exploring the Opportunities and Challenges of Women in India** the analytical, theoretical and empirical papers shed light on different aspects of women in India. The rainbow of contributors is quite informative and presents a new perspective to understand Indian women. The editor and authors of different chapters are quite hopeful that this book will definitely satisfy its readers and will help them for further advanced study.

In opening paper **"Current Scenario of Women- Led Social Enterprises in Odisha"** Suman Dhaka and her scholar Bijeta Mishra informs that, the inclusion of women has become imperative for the maximal economic development in 21st Century. In recent years it has been noticed an upward trend of women participation in the entrepreneurial world. Women have played a pivotal role in various Social Enterprises. Odisha, designated as an under developed state of India depicts a dismal picture in the economic scenario in relation to the contribution of women entrepreneurs. During this study author has experienced an increased participation of women entrepreneurs, yet there are many obstacles in the form of societal, educational, financial and psychological aspects. Adequate steps must be taken in the form of financial aids, modulating the gender roles and stereotypes, training and workshops and counseling

sessions which can help in boosting up the participation and performance levels of the women entrepreneurs.

Avneet Kaur says in **"Women in the Era of Globalization: Indian Feminist Discourse"** that increasing interdependence and integration of world economy exchange the information technology from one group of people to other group all over the world. The process of globalization has made things easy for the mankind to sustain but at the same time it has pose many challenges to the marginalized people residing in developing countries. The Structural Adjustment Programme (SAP) and New Economic Policy (NEP) which the developing countries adopted in the early1990's have posed new challenges to the political governance of the respective countries. There has been many problems related to global poverty, protest by the people against LPG policies, destruction of dams and livelihood of the people and most important gender issues are new critical concerns. Due to the information technology women all over the world are connecting with each other leading to a strong feminist movement for demand of their rights across global boundaries. The paper studies various dimensions of the impact of globalization on the women and their demand of social, economic and political rights.

Arnasha Singh in his Chapter **"Health Challenges and Opportunities for Indian Women: An Anthropological Approach of Allahabad Population"** concludes that India has achieved better life expectancy as compared to before by better health care system. The main aim of her study is to know health scenario of women among urban and rural population and to find out health care and challenges in women population. Since1990, India has left over half its population out of extreme poverty while making significant studies in improving health facilities for its people. Author describes the causes of women's health problems, especially those related to their diet and health impact and explain what can be done to prevent or treat those problems. Women health condition now is far better than past. In particular, more efforts are now being made to train health and family planning workers, provide supplies and equipment, and help women reach medical facilities. Finally, it is found in her study that there are so many health challenges present with less

opportunities. Urban women health is far better than rural women due to awareness and facilities.

Surendra Bhaskar and Shivani Chugh studied the **"Impact of the 73rd Constitutional Amendment Act (1992) on the Empowerment of Women in India"**. The paper deals with the emergence of 73rd Amendment act and the provisions related to the disadvantaged section specially the women. This act gave them one-third reservation in the Panchayati Raj Institutions and the Urban Local Bodies. Study reflects that the reservation has led only to formal and not real empowerment of women in the Panchayats. It was noticed that in most of cases husbands of elected lady members function on their behalf in local bodies. The finding of the study highlighted that only reservation in Lok Sabha and the State Legislative Assemblies would not be lead to the real empowerment of women. They should be educationally, socially, economically and psychologically empowered. The conservative, neo-feudal and patriarchal culture too will have to be changed.

Vinita Shrivastava in her chapter **"Financial Connectivity of women in Rural India: Role of Mann Deshi Bank"** highlights that in India being male dominant society women have secondary status and lower level in the family and society. They do not have the authority to give consent or view about their life, marriage education. She points out that rural women are not getting basic financial services at the time of requirement due to lesser bank account in India. If women will have access on their own account and source of earning, they will have more bargaining power and can be the participant in the family decision process. If a female member of a family will be economically powerful they brought up their children in a holistic manner. Financial connectivity with any formal financial institution is an important step towards women empowerment. She studies the function of a co-operative bank named Mann Deshi Mahila Sahakari Bank limited which is working in Satara district in Maharashtra for financial inclusion of rural women. The author is trying to highlight the financial status of rural women and the model of Mann Deshi Bank in solution for improving the condition of women.

Ravi Jhajhria and B.L. Bhamoo have examined the **"Role of Education in Gender Sensitivity"**. The result reveals that the status of women all over the world is a cause of serious concern. Women irrespective of societies experience varying forms of discrimination and oppression. In India, condition of women is still in not a good shape primarily due to patriarchal form of society. In all the patriarchal societies, gender bias starts from womb and girls are subject to discrimination in almost every area ranging from nutrition to childcare and education to work. Gender is determined socially; it is the societal meaning assigned to male and female. Gender Sensitivity is defined as the ability to recognize gender issues and to understand women's different perceptions and interests arising out of the difference in biological attributes, social position and gender based roles. This paper points out that mindset of younger generations needs to be changed with positivity in minds towards it as they are the ambassadors of change in every society, with their ideas, thoughts and practices suited to the changing times. In this, school can play a very important role which has the responsibility of shaping the young minds.

Hemlata Mahawar in **"Women Entrepreneur in India: Opportunities and Challenges"** focuses on the concept of woman entrepreneurship in India, traits in opportunities and challenge they are faced by set up and make some suggestions for future prospects for development of woman entrepreneurs. Women entrepreneurship in our country faces several challenges and needs a radical amendment in attitudes and mindsets of society. According to her, the number of women entrepreneurs in India is relatively, low but global changes have created economic opportunities for women who want to own operate and grow businesses. Besides this, family earning and consumption patterns have been transforming in India over the last two decades.

While talking about the digital world, Yogendra Singh, in chapter **"Electronic Governance and Women in India: Challenges and Prospects"** discusses about E-Governance in neo-liberal regimes with the emergence of Liberalization and Privatization. It has been an important platform through which ideology of good- governance can be promoted.

Women have been beneficiaries of the system in the governance process. Information technology has been a powerful source to transform their life. It is also experienced that expectations of end users of such systems keep rising as they gradually become accustomed to technology usage and become more and more aware about the power of ICT. The paper highlighted the fact that E-governance is one of the important medium to empower women socially, economically as well as politically. However the paper discusses the impediments faced by women in making use of these technologies. The study concluded with the fact that although it has some negative implications but prospects of the technology cannot be ignored.

While evaluating **"B.R. Ambedkar Vision of Women's Rights in India with Reference to Hindu Code Bill"** Avneet Kaur and her scholar Dilpreet Singh reports that Ambedkar has been regarded as the 'Champion of Women's Rights'. This paper intends to study the role of Ambedkar in providing recognition to the rights of women through the interpretation of various social rights movement. He instilled a sense of confidence among the Indian women. In the introductory part they talk about the issues of the whole norm of human rights and their linkages to the women's movement than elaborates the status of women in the historical times ranging from pre independence to post independence era. Author also discusses the constitutional provision related to the concern of women rights. This paper also deals with major provision, debates, adoption, and weakness of the bill and its implication of bill on the contemporary women.

In concluding chapter Nilanta Mukherjee and Suman Dhaka discuss on **"Multiple Roles of Working Women: An Impact of Psychological Distress on Working Women in India".** Due to patriarchal system in ancient India women of our country not enjoyed the freedom of working in earlier times but now situation is improving rapidly. Today women are creating a niche for themselves in each and every employment sector thereby diminishing the gender disparity in a faster rate. But to uproot the stereotypical concept from the minds people that women can only serve as homemakers is a herculean task. Therefore there is an increasing need to eliminate gender disparity in the society, adopt strategies like problem

based coping, and stress alleviating interventions in order to help the women of 21st century balance well between work and family and make optimal use of their abilities.

Dr. Surendra Bhaskar

ACKNOWLEDGMENTS

For most, I find myself proud to thank the Almighty for giving me an opportunity to contribute my small part in the noble cause of Education. A project of this magnitude could not have been accomplished without any support. So it gives me immense pleasure and proud to acknowledge with gratitude for help, inspiration and guidance I have received in bring the book in the present form. First of all I bow my head with utmost gratitude to my Ph.D guide, late Prof. K.P. Singh who had infused strength in me to take the challenges.

I am very thankful to all my contributors for their timely support because of which the present work has been accomplished. In addition to this I am also thankful to Prof. H.S. Mali and Asst. Prof. Suman Dhaka for their much needed support.

I am truly indebted to Indian Air Force for shaping my future and gives wings to my thought process to think high. All my staff members of RSCPCR and Education Department also deserve a note of thanks for giving their valuable time and suggestions throughout the process of writing this book.

This book would not have been possible without the unwavering support of my **"Govind-Kripa"** family members. Thank you very much to my grandparents for showing me the true path of life through prism of their own simple life. Your words are constant inspiration to me. To my parents,

thank you for instilling in me the desire to do valuable deeds in life, and for your unshakeable faith in me throughout this journey. A special thanks to all my Uncle and aunts, for your tireless support and encouragement.

Wholeheartedly thanks to my brothers Brijendra, Ashok, Arvind, Kamlesh, Vikash, Dr. Atal, Ashu and sisters Vinod, Meena and Heena as you have been my source of endless strength and real back up for life. You guys taught me to view the world with so much hope. I am indebted to my true source of inspiration, better half **Sarita** for her unconditional love, kindness and support. A special thanks and lot of love to my two beautiful angels, **Nistha** & **Arvi,** who sacrificed much time and attention so that I could achieve this goal; they are my inspiration to do more in life.

In this series I also offer thanks to all my friends & classmates, especially Banwari and Jodhpur Hunters, for their words of encouragement, which motivated me to give my best to this task. Last but not least, I am thankful to Nova Publication for showing faith in me by collating, synthesizing and editing this book.

Dr. Surendra Bhaskar

In: Exploring the Opportunity …
Editor: Surendra Bhaskar

ISBN: 978-1-53616-424-4
© 2019 Nova Science Publishers, Inc.

Chapter 1

CURRENT SCENARIO OF WOMEN-LED SOCIAL ENTERPRISES IN ODISHA

*Suman Dhaka**, *PhD and Bijeta Mishra*

Department of Humanities and Social Sciences
National Institute of Technology, Rourkela, Odisha, India

ABSTRACT

With the changing societal dynamics in the 21st century, the inclusion of women has become imperative for maximal economic development. Although women have been a part of the economic scenario for several decades, recent years have seen an upward trend of women participation in the entrepreneurial world. Many women entrepreneurs are the face of successful enterprises with a broader aim to modify the societal dynamics and ensure the well-being of individuals. Women have played a pivotal role in social enterprises, which are entrepreneurial ventures aimed at *'fair-business'*, serving equally to their social objectives. India aligns with the global scenario, with significant contributions of many women-led social enterprises. According to the Census data 2011, Odisha which

*Corresponding Author's E-mail: dhaka.ssuman@gmail.com.

is designated as an underdeveloped state, however, depicts a dismal picture in the economic scenario concerning the contribution of women entrepreneurs. Although there are many women social entrepreneurs who are working tirelessly towards fulfilling their social mission through entrepreneurial activities; they face a lot of challenges in the form of financial, social, educational and psychological issues which inhibit them to showcase their full potential. The need of the hour therefore is, to rise up to the occasion and take adequate steps in the form of financial aids, modulating the gender roles and stereotypes, training and workshops, and counseling sessions which can help in boosting up the participation and performance levels of the women entrepreneurs thereby making a significant growth in the economic status of the individuals and state as a whole.

Keywords: social enterprises, women entrepreneurs, challenges, encouragement, Odisha

INTRODUCTION

"Any woman who understands the problems of running a home will be nearer to understanding the problems of running a country."

Margaret Thatcher

The word "entrepreneur" has been derived from the French word *"enterprendre"*, which means *'to undertake'*. Entrepreneurship can be defined as the art of developing, organizing, and managing a venture that yields financial output and ensures optimal development and a secured lifestyle of an individual and contributing largely to shape the business ecosystem of society. According to the Global Entrepreneurship Monitor since 1999, the entrepreneurial activities in various countries have experienced an upward trend. Globally, around seventy-five percent of the world's population gets benefited by one of the varied aspects of entrepreneurial ventures in terms of their livelihood and entrepreneurship as a whole contributes up to ninety percent of the total GDP (Xavier, et al. 2013). Apart from economic development, various enterprises play a vital role in the development of society by fostering various activities aimed at

enhancing the well-being of individuals. These enterprises are termed as "social enterprises". Social enterprises are businesses that work towards alleviating the prevalent social issues along with profit-making. There has been a sea of change in the attitude of entrepreneurs in recent years with 65% of CEO's rating 'inclusive growth' one among their top three concerns (Deloitte, 2018). The Indian economy in recent years has seen an upscale in entrepreneurial ventures with various policies. With a population of 120 crores, the people of India face diverse socio-economic issues that are being addressed by almost two million social entrepreneurs. Reliance Group, Tata Group, and Kalinga Group have been pioneers in the field of social enterprises who have been actively working in the fields of healthcare, education, and alleviation of poverty apart from bringing economic laurels to our nation.

With the onset of the 21st century, globally, the need for women equity has been prevalent. There has been a roaring demand towards giving women their rights and encouraging their participation at par with men. The Global Entrepreneurship Report 2017 showcases that woman entrepreneurial activities has been on a rise of 10% and has been able to bridge the gender gap by 5%. This is evident through the fact that women across the globe hold positions and lead various companies, thereby strengthening their stance about their capabilities in leading entrepreneurial empires. They also shoulder the responsibility of social change with equal expertise with phenomenal work in the fields of education, empowerment of women and well-being of individuals thereby doing their bit in making the world a better place to live in. Shiza Shahid, co-founder of Malala Fund, an organization working towards girl's education; Mallika Dutt working to eradicate violence against women through her organization, Breakthrough; Brit Gilmore employing homeless for designing jewelry through her organization 'The Giving Keys' are examples of women entrepreneurs who are changing the world economy and social scenario through their business contribution. Societies where there is parity in the involvement of women in the form of socio-economic process, experience faster and equitable growth.

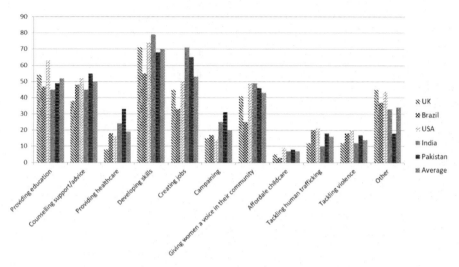

Source: British Council of Social Enterprise Women's Empowerment in India Report.

Figure 1. Impact of social enterprise in empowering women and girls.

India also boasts of women entrepreneurs contributing significantly to the growth of the Indian economy and modifying the social milieu in both urban and rural set-up. Sairee Chahal, founder of Sheroes has contributed notably to women empowerment through her online business platform by providing flexible work timings for women and thereby helping over ten lakh women become independent.

Social ventures initiated an interactive platform for companies, NGO's, and philanthropists to work towards the 'social good'. These are some bright examples of women entrepreneurs of India who have made their mark in changing the dynamics of the Indian economy while catering to the social needs. Govt. of India defines a woman entrepreneur as *"an enterprise owned and controlled by a woman having a minimum financial interest of 51% of capital and offering at least 51% of employment to women"* (Sharma, 2013). According to the sixth economic census, as reported by Business Standard, women constitute 13.7% of the total number of entrepreneurs in India which amounts to 8.05 million out of 58.5 million entrepreneurs. Approximately 2.76 million women entrepreneurs are engaged in the agrarian sector, while 5.29 million women

entrepreneurs create their niche in the non-agricultural sectors (Tiwari, 2017). According to a research conducted by McKinsey Institute, bridging the gender disparity in the mercantile set-up can boost up the global GDP by $28 trillion by 2025, and around $3 trillion to India's GDP alone. In the current scenario, India posits itself in the bottom 20 to the 131 countries in terms of involvement of the female labor force and only 5% of women being in the top positions as compared to the global average of 20%. Apart from this, the contribution of women through social entrepreneurship is only 24% which is significantly low than other developed countries across the globe (British Council Report, 2018). This draws a gloomy picture of India in the world economy.

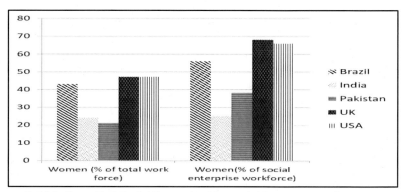

Source: British Council of Social Enterprise Women's Empowerment in India Report.

Figure 2. Contribution of women in the workforce.

HISTORICAL PERSPECTIVE OF WOMEN IN BUSINESS

The contribution of women to the economy has been undermined throughout history. It dates back to the Puranas where women were held in deep regard and had their say in important decisions of the state. Gradually with a shift in the societal dynamics, women started contributing to the income of the family but in a docile manner, where men still exhibited dominance and were the leading contributors to a family's income. Women's entrepreneurial contribution was limited to three P's namely

Pickle, Papad and Powder. This was considered as an extension of their domestic responsibilities. With the changing societal scenario and increase in the social status of women, increased involvement of women was witnessed in the mainstream economic dimension, and the focus of women entrepreneurship shifted to three E's, namely, Energy, Efficiency and Effectiveness (Behara & Niranjan, 2012). From the 1990's India witnessed a transition from a passive phase to being actively involved, where women took the initiative to start enterprises and nurture them to grow into their full potential. India records engagement of 185900 women in the self-employed sectors which accounts for just 4.5% of individuals engaged in the business set-ups according to the 1991 census data. A steep increase in the contribution of women entrepreneurs was observed in 1995-96, where women claimed 11.2% of the total of 2.64 million entrepreneurs in India (Deshpande & Sethi, 2009). A brighter picture was evident from the data of 2001 census where women entrepreneurs constituted 22.73% of the total entrepreneurial population (Wajih & Imtiaz, 2011). According to the 2011 census, around 14% of the business enterprises are owned by women and amounts to 8.05 million in comparison to 58.5 million enterprises in India. Though the contribution of women through the entrepreneurial sector has increased, it is yet to make a significant mark in the status of the Indian economy.

WOMEN SOCIAL ENTREPRENEURSHIP IN ODISHA

Odisha has been consistently under the umbrella of underdeveloped states of India where individuals struggle to meet their ends. However, with the efforts and plan implementation of the government, there has been an increase in the number of individuals being engaged in setting up their businesses. The culture-rich state, which has a sex ratio of 972 (Hans & Patel, 2012), has witnessed the involvement of women in entrepreneurial set-ups. Though in the past years the involvement of women in unorganized sectors was high and there was a sparse women population playing the role of entrepreneurs in the organized sectors. Recent years

have experienced an increasing trend of women setting their foot in entrepreneurial ventures and creating a niche for themselves. According to the Gender Disparity Report (GDR) 2010, there around 200,000 women entrepreneurs in Odisha and every year over 4000 potential women entrepreneurs are trained to make their mark and contribute substantially. Women entrepreneurship can be best understood by gaining insight regarding the types of enterprises managed by urban and rural women. The entrepreneurial ventures initiated by the rural women mostly come in the purview of the unorganized sectors, while those taken up by the urban women can be considered to be a part of the organized sector. Among these women entrepreneurs of Odisha, many have made their mark as being the social entrepreneurs who have effectively worked towards addressing the varied social issues prevalent in the state. Though women have been consistently contributing to the growth and development through their business mavericks and contributing towards the development of the social scenario, their efforts are less acknowledged and the various aspects of women entrepreneurship, including the challenges and achievements, are less explored.

SOCIAL ENTREPRENEURSHIP AND WOMEN OF RURAL ODISHA

Entrepreneurship is a multifaceted phenomenon. This view remains very true in case of women entrepreneurs of rural Odisha, who are engaged in various kinds of ventures like handicrafts including brass and metal works, toys and jewelry made up of mud, containers made up of palm leaves, silver and filigree work, terracotta and pottery, stone and wood carvings, appliqué works, pattachitra, cane work, preparing brooms to name a few (Shreedhar & Dwivedi, 2014). They are also involved in businesses like dairy and poultry, fishery, handloom, agricultural avenues like paddy cultivation, coconut business, etc. Many women showcase their entrepreneurial abilities by collecting and selling off the forest produce like

honey, leaves for disposable plates, jhuna, lac, berries. In the recent years, intending to empower and enable the women of rural Odisha and make them financially independent, the Govt. of Odisha introduced 'Mission Shakti', a program aimed at enabling women to earn for themselves and their families and thereby contribute towards the economic growth of the nation. Self Help Groups (SHG's) have emerged as powerful tools to help women of Odisha acquire financial independence, alleviate poverty thereby empowering them and ensuring their well-being. Self Help Group is an attempt to disburse micro-credit to the rural women entrepreneurs in an organized manner. SHG can be defined as an informal group of not more than twenty members. They are an example of a small yet powerful way of building up social enterprises by women, working relentlessly towards their empowerment in various domains like financial, social, etc. SHG's have been working in intricate networks with co-operative banks, NABARD, DRDA, regional rural banks and NGO's, etc. to boost up the entrepreneurial activities initiated and carried out by women. In the present scenario of 21st century, rural women have been engaged in the making of badi, papad, pickles, spices, mushroom farming, greetings, handlooms, soap making, broom making apart from being actively engaged in the agrarian activities and varied types of handicraft items, ready-made garments in order to establish their own enterprise. They are therefore making a strong stand for themselves and generating employment opportunities for many girls and women who otherwise would not have come out of their houses; therefore contributing to women employment. According to the reports by Orissa Diary (2017), 15% of the MSME's in Odisha are owned by women entrepreneurs. Though the statistics depict a gloomy picture, the trends are changing with each passing year and the rural women of Odisha are slowly but surely making their mark in the economic scenario of India.

There are some unspoken heroes of the economy who have contributed substantially by working in the rural set-up of Odisha and tirelessly putting in efforts towards making the state a better place to live in and set examples for others to witness, admire, and follow. Kamala Pujari who was conferred the Padma Shri award is one such bright example of a social

entrepreneur doing her bit towards conservation of the environment by meticulously practicing organic farming. She has efficiently shouldered the responsibility of preserving numerous varieties of indigenous paddy seeds ensuring the component of sustainability. Geetanjali Tripathi, an empowered tribal woman entrepreneur of Sundargarh district is a member of a Self Help Group, backed by Hand in Hand NGO. She showcases her independence and skills by participating in Mahila Melas, where she sells off the products prepared by her group thereby making her stance evident in the economic growth of the nation. She also takes up the responsibility to encourage more women of her area to associate themselves with SHG's, thereby donning the hat of a social entrepreneur. Sarojini Das has been conferred with the 'Best Entrepreneur Award 2006' by the Govt. of Odisha for showcasing her intricate and novel designs of bamboo jewelry. She is now on an expansion spree, thus employing and empowering more women in the enterprise. Subhrarani Mohanty, a resident of Jagatsinghpur with her indomitable effort has been able to form a social enterprise making low cost-low carbon emission cooking stoves. She is instrumental in bringing about a radical change in the cooking system, thereby reducing the fuel consumption and improving the overall health of rural women who since time immemorial have been affected by various diseases due to the adoption of an improper cooking system. She is a perfect example of an entrepreneur-cum-environmentalist who with her efforts has been financially independent, empowered, and contributes to the protection of the environment in her small way.

WOMEN AS SOCIAL ENTREPRENEURS IN URBAN PARTS OF ODISHA

Women in urban areas of Odisha also play a vital role in building an economically stronger state and changing the societal scenario. The new Odisha of the 21st century has witnessed increased and active participation of women in business-related activities and there has been a rise in women-

led social enterprises. Women have set their feet in various fields like education, beauty, communication, fashion to name a few, where they are positioning themselves at par with their male counterparts. These strong women have created a respectable position for themselves and have reached the pinnacle of success with their entrepreneurial skills and have been able to defy the patriarchal norms of society. With these social entrepreneurial ventures, they have been able to contribute significantly towards addressing social issues like education, generating employment facilities, empowering women, working towards providing equal rights and adequate opportunities to the differently-abled individuals to name a few.

Women in the urban parts of Odisha are increasingly becoming financially independent. Though there is a long way to achieve the target, the radical process of change is evident through the plans of the Government aimed at encouraging the participation of women in the enterprise sector. There is an increasing need for inclusion of more women in the social enterprises which will enable them to empower themselves and women around and address various social issues while contributing to the development of the economic scenario.

Odisha boasts of various successful women social entrepreneurs who have been consistently succeeding with their skills, motivation and a desire to be known and respected as an individual entity with their acquired financial and social independence. Ms. Shaifalika Panda owns a social enterprise and is the CEO of the Bansidhar and Ila Panda Foundation. She has been working towards education of the deprived mass, providing adequate health facilities, water and sanitation to the underprivileged, and generating employment for the people below the poverty line with a special emphasis on women and youth. Dr. Shruti Mohapatra is an epitome of strength, vigor, and positivity. From a woman who was denied a position in the civil services to set-up an institution to train the civil service aspirants, the journey of this humanitarian-cum-social entrepreneur has been truly incredible. Along with this institute, Dr. Mohapatra is the founder and CEO of SWABHIMAAN a platform aimed to empower Persons with Disabilities. She also initiated children's festival named *'Anjali',* the one of its kind, which served as a platform for the students

both with and without disabilities to showcase their talents. Another beaming female social entrepreneur who is relentlessly putting in efforts to change the education scenario in Odisha by focusing on the holistic development of the future architects of the nation is Poly Patnaik. Ms. Patnaik aims to provide a nurturing and inspirational environment to the students to learn and grow, through her entrepreneurial venture, Mothers Public School located in the capital city of Odisha. Therefore, she contributes substantially to the growth of the economy as well as contributes significantly to the societal changes. Women of Odisha have also made their mark in the fashion world and have contributed to the development of society through their enterprise. Budding designer Reemly Mohanty is one such example who owns a boutique and is towards preserving the importance of handlooms and popularising them by incorporating them into the designs of the current trends. By doing this, she actively and passively encourages the weaver's community thereby, fostering their source of income. Apart from this, she has also successfully created employment opportunities to the skilled workers in forms of tailors, embroiderers, etc.

Though the success stories of the women social entrepreneurs show us a positive side, life is not a bed of roses for these flag bearers of women empowerment. With the change in the societal dynamics and enforcement of various policies demanding equity for women in the entrepreneurial set-up, the situation of women essaying the roles of entrepreneurs has enhanced. Yet as they encounter and struggle continually towards achieving equity and perform optimally, the realization dawns that even in the 21st century, there are various challenges faced by the women entrepreneurs which prevent them to showcase their optimum potential.

CHALLENGES FACED BY WOMEN SOCIAL ENTREPRENEURS OF ODISHA

Women entrepreneurs face a host of financial, societal, educational, and psychological issues which act as hindrances in their growth and development:

- **Shortage of Finance:** Women entrepreneurs face the scarcity of finance and working capital which poses a threat to the development of enterprises owned by them (Nanda, 2017). Two broad reasons can be attributed to this stance. The first being the fact that India being a patriarchal society, the percentage of assets owned by women is lower in terms of monetary worth, which can be collaterally used for obtaining adequate finance to run their businesses. Even banks and finance companies refrain from lending higher amounts to women doubting their credibility and capabilities to be able to repay the same. It has been reported than more than fifty percent of women make use of their accumulated funds or funds borrowed from their parents, spouses or near and dear ones rather than depending on the banks and finance companies to set-up their businesses (Das, 2000). Therefore, with poor financial assistance, women face the issues of accessibility of finance which prevents them from establishing themselves in the entrepreneurial world.
- **Marketing Problems:** Women entrepreneurs particularly in the rural areas are not allowed mobility outside their homes and do not have access to technology. As a result of which they face troubles in marketing their products. Many a time, they depend on middle-men for accomplishing the job. This poses a problem for popularizing the products, thereby negatively affecting their business. The situation even worsens as they constantly face stiff competition from their male counterparts involved in a similar business and have better access to marketing strategies. Though

steps have been taken by the Govt. agencies to popularize the produce, it is inadequate and there are still many women entrepreneurs devoid of adequate marketing.

- **Shortage of Raw Materials:** The failure of many co-operatives operated by women can be accredited to the paucity of raw materials. Women are unable to procure sufficient amounts of raw materials to deliver adequate quantity and optimum quality. For e.g., the basket business dependent on forest raw materials saw a decline in 1971 due to the unavailability of raw materials. Therefore, among the various problems encountered by the women entrepreneurs, scarcity of resources tops the list (Nayyar, et al. 2007).

- **High Cost of Production:** The high cost of production impedes a threat to the growth and development of women-led entrepreneurial ventures. With the increased cost of raw materials and lack of technological advancements, women entrepreneurs are unable to accrue maximum profits for their efforts put in. On the other hand, it is imperative for women entrepreneurs to expand their enterprises as it would guarantee the survival and stability of their businesses in the long run thereby helping them in becoming financially independent.

- **Patriarchal Society:** Even though the Constitution of India grants equal rights to women, patriarchy is very much prevalent in the social attitude of Odisha. In the male-dominated society of Odisha, women are usually repressed and are not allowed to gain a name for them in the entrepreneurial world even if they possess the capabilities to do so. To initiate a business, they usually have to depend on the approval of the head of the family who is essentially a male. This acts as a hindrance to their growth as the men assume women venturing into businesses to be a big risk and this acts as a hindrance to women's entry and prosperity in the world of entrepreneurship.

- **Family Ties:** In their personal lives, often women succumb to the social stigma that it is their responsibility to take care of their

families and children even if they are engaged in entrepreneurial ventures. This takes a toll on their efficiency resulting in a lack of optimal productivity. Indira Nooyi, famous entrepreneur and the CEO of PepsiCo, one of the world's largest beverage corporation quoted in an interview *"You might be president of PepsiCo. You might be on the board of directors. But when you enter this house, you're the wife, you're the daughter, you're the daughter-in-law, and you're the mother. You're all of that. Nobody else can take that place. So leave that damned crown in the garage."* In juggling and trying to strike a balance between their personal and professional roles, women lag in terms of achievement and success in their entrepreneurial ventures as compared to their men counterparts.

- **Lack of Family Support:** As women have been essayed with the role of nurturers and are expected to take care of their children and family member, their decision to start or join any entrepreneurial ventures is highly discouraged in many households of Odisha. As a result of this, the state experiences reduced participation of women and the ratio of women-led enterprises in alarmingly less as compared to that of men.
- **Medical and Health-Related Issues:** In the pursuit of taking care of their family and catering to the demands of the enterprises, women, particularly in the rural set-up, often tend to neglect taking care of their health. There is a large scale prevalence of health issues related specifically to menstrual health. Lack of awareness regarding safe and hygienic practices can also be attributed as one of the major causes of such illnesses. Apart from this lack of nutritious diet and ignorance regarding healthy lifestyle practices often adds to the prevailing health problems. Women also have the ability and responsibility of procreation. There often exists an inverse relationship between reproduction and effectively managing the entrepreneurial activities especially in the initial years, due to the broken health of the mother and child-rearing process.

- **Lack of Education:** According to Govt. Of Odisha report, the women literacy of Odisha stands at 64.01%. This draws our attention towards the dismal picture of the status of women entrepreneurs and explains to a great extent their reason for the struggle. Illiteracy constricts them from exploring those varied opportunities around and prevents them from being aware of the mechanisms which would aid them in the growth of their businesses.
- **Lack of Entrepreneurial Training:** Though some amount of training is provided for enterprise set-up with regard to the skills for the production purpose, many of the women entrepreneurs are deprived of the training aimed at polishing the managerial abilities, including production and distribution, finances and employees which are equally important for the success of any business set-up. Many of them are unaware of the technical advancements which hinder their productivity, detrimentally affect the quantity and quality of production, and are cost-ineffective. A large number of women entrepreneurs do not have access and adequate training in social media which prevents them from advertising their business on a large scale. This, in turn, acts as an obstacle to the optimal efficiency of the enterprise.
- **Legal Formalities:** Any business enterprise requires certain legal formalities to be fulfilled. This becomes a herculean task for women in the societal structure of Odisha where they are assumed to be individuals with less potential. Therefore, it becomes increasingly turbulent for women to comply with various legal formalities like obtaining licenses, etc. as compared to the men.
- **Lack of Entrepreneurial Aptitude:** Women during their bringing up process are usually embedded with the idea that they are the nurturers who are supposed to take care of the family. They have been suppressed and protected in the family and have never been asked for their 'say' in any significant matters in the men dominated families. The role of decision making is never bestowed on them as a result of which they tend to have the low risk-taking

ability, find it difficult to take stand in the decision-making process and lack the aptitude to run an enterprise led by them.
- **Low Self-Esteem:** In the male-dominated society of Odisha, there exists clear dichotomy in the upbringing process of girls and boys. Boys are encouraged to voice their opinions, take risks and be outgoing, whereas the girls are appreciated if they abide by the rules set up for them and are severely criticized for any mistakes that they do. This has a significant impact on the development of self and results in low self-esteem among girls, which is reflected in their behaviours as grown-up women. The attribute of low self-esteem has a detrimental impact on women entrepreneurs and prevents them from reaching the pinnacle of success in terms of their business accomplishments.

ENCOURAGING WOMEN SOCIAL ENTREPRENEURS OF ODISHA

Considering the need for bridging the gender disparity prevalent in the society and boosting up the economic scenario of the backward state of Odisha, taking up steps towards the encouragement of women-led social enterprises is the need of the hour.

On the financial grounds, women should be provided more support in the form of Govt. schemes. The formalities of procuring loans from the banks should be lessened and the methods of procuring loans can be made lucid by bringing about reforms in the bank policies and finance corporation, which will enable the women to contribute substantially to economic progress. In rural settings, the role of SHG's can be strengthened by providing financial aids. Establishment of forums and platforms where the women entrepreneurs can take a stand to demand their rights to financial aids can help to eliminate the obstacle of the financial crisis to a large extent.

There is an increasing necessity to bring about a radical change in societal dynamics and redefine the role of women in society. The need of the hour is to dismantle the gender role stereotypes and build up an understanding of the fact that women are equally capable of owning and managing business enterprises. There is also a need to voice our opinions in favor of gender equity where the roles and duties of both home and work front are distributed among both men and women. Therefore, family support can foster the development and enrichment of women in the entrepreneurial world thereby helping them to contribute maximally.

Considering the status of education and training to the women entrepreneurs of Odisha, it is essential to bring about changes in the system. It is imperative to provide a basic level of education to women. There is an increased need to organize workshops, seminars, conferences, and training programs for budding and established women entrepreneurs. This will be instrumental in empowering them with skills; acquaint them with the modern and evolved technological assets and enrich them with the legal aspects and the policies and facilities provided by the Govt. which will enable them to initiate new entrepreneurial ventures and expand the existing ones.

Women of Odisha have always taken a backseat when it comes to leading enterprises. One of the major causes attributed to this actuality is that they lack entrepreneurial aptitude, possess low self-esteem and exhibit personality traits that inhibit them from making the best out of the available opportunities. To combat this issue, group counseling programs can be organized where they can be motivated to utilize their potential optimally. Interaction sessions with successful women entrepreneurs can also yield positive outcomes. Acknowledgment from the Govt.'s organizations and SHG's can act as reinforcements to boost up their morale and self-esteem thereby having a positive impact on their productivity. Organizing family counseling sessions and sensitization programs for members of the women entrepreneurs' families, can help in changing the mindsets of people and increase the participation of motivated women in the business setups.

CONCLUSION

Women-led social enterprises working to establish parity between social causes and business is an important dimension of the changing societal and economical set-up. India has seen an upscale in the involvement of women social entrepreneurs. This has women empowerment, improved education status of women and an increased number of financially independent women. Women social entrepreneurs have also addressed issues like menstrual hygiene, sanitation and maternal care which have brought about significant changes in the lifestyle of people thereby making India ahead in the well-being index. The women-led social enterprises in Odisha are slowly yet steadily beginning to make their mark in the social and economic scenario. Though in the present scenario, Odisha has experienced increased participation of women entrepreneurs, yet there are many obstacles in the form of societal, educational, financial and psychological aspects. Through the various government mechanisms and schemes, we have been able to combat financial issues to a great extent. Yet, there is a need for the above-discussed amendments for ensuring the optimal progress of women entrepreneurs of the state and help them create a mark for themselves in the Indian and global economy.

REFERENCES

Babson College. (2017). *Women's Entrepreneurial Activity Up 10 Percent, Closing the Gender Gap By 5 Percent Since 2014.* Retrieved from http:// www.babson.edu/ about/ news-events/ babson-announcements/ global-entrepreneurship-monitor-womens-report/.

Behara, S., & Niranjan, K. (2012). Rural Women Entrepreneurship in India. *International Journal of Computational Engineering & Management, 15*(6).

Business Standard (2018). Retrieved from https://www.business-standard.com/ article/ news-cm/ women-constitute-around-14-of-total-entrepreneurship-in-country-118071600642_1.html.

Das, D. J. (2000). Problems faced by women entrepreneurs. *Women Entrepreneurship, New Delhi, Vikas Publishing House*.

Deshpande, S., & Sethi, S. (2009). Women Entrepreneurship in India. *Shodh, Samikshaaur Mulyankan (International Research Journal)*, 2(9-10), 13-17.

Directorate of Economics and Statistics, Govt. of Odisha. (2019). *Gender Disparity Odisha.*

Government of India (1996). *1991 Census Hand Book.*

McKinsey & Company (2015). *How advancing women's equality can add $12 trillion to global growth*. Retrieved from https://www.mckinsey.com/ featured-insights/ employment-and-growth/ how-advancing-womens-equality-can-add-12-trillion-to-global-growth.

Ministry of Statistics and Programme Implementation, Govt. of India. (2016). *All India Report of Sixth Economic Census.*

Nayyar, P., Sharma, A., Kishtwaria, J., Rana, A., & Vyas, N. (2007). Causes and constraints faced by women entrepreneurs in the entrepreneurial process. *Journal of Social Sciences*, 14(2), 101-102.

Pepsi CEO Indra Nooyi: 'I Don't Think Women Can Have It All' (2019). *Entrepreneur India*. Retrieved from https://www.entrepreneur.com/article/235334.

Sharma, Y. (2013). Women Entrepreneur in India, *IOSR Journal of Business and Management*, 15(3), 09-14. doi: 10.9790/487x-1530914.

The Economic Times (2018). *We're focused on bridging the trust deficit between industry and Govt.* Retrieved from https://economictimes.indiatimes.com/topic/jagi-mangat-panda/news.

Tiwari, N. (2017). Women Entrepreneurship in India: A Literature Review. *Amity Journal of Entrepreneurship*, 2(1), 47-60.

Wajih, S. A., & Imtiaz, M. (2011). Impact of Socio-Cultural Values and Its Diffusion on the Entrepreneurial Performance of Indian Middle-Class Women Entrepreneur: An Analytical Study. *International Journal of Computing and Corporate Research. 2(3).*

Xavier, S., Kelley, D., Kew, J., Herrington, M., &Vorderwulbecke, A. (2013). *Global Entrepreneurship Monitor (GEM) 2012*. Retrieved from https://www.researchgate.net/publication/263806655_Xavier_ SR_ Kelley_ D_ Herrington_ M_ Vorderwulbecke_ A_ 2013_ Global_ Entrepreneurship_Monitor_GEM_2012_Global_Report.

In: Exploring the Opportunity ...
Editor: Surendra Bhaskar

ISBN: 978-1-53616-424-4
© 2019 Nova Science Publishers, Inc.

Chapter 2

THE IMPACT OF GLOBALIZATION ON INDIAN WOMEN: FEMINIST DISCOURSE

Avneet Kaur[*], PhD
Amity Institute of Public Policy, Amity University, Noida, Uttar Pradesh, India

ABSTRACT

From the past few decades, neo-liberal policies have an enormous impact on the lives of women in developing countries. Generally speaking, globalization is a process that mobilizes different ideas, culture, capital and integrated them into a single economic system. Many feminist thinkers believed that the spread of neo-liberal ideologies result in the opening of new markets by emphasizing on economic growth and efficiency. The technological revolution has led to new forms of innovations and creativity that impact the World economic structures. It is entrenched patriarchal norms that exist in Indian society due to which women fails to attain a respectful and dignified life. The innovations in information and Communication technology have revolutionized the lives

[*] Corresponding Author's E-mail:akaur5@amity.edu.

of women all over the world. Due to this transformation there is a growing demand for strong feminist movement for women's rights. The paper studies various dimensions of the impact of globalization on the women and concludes with the possible suggestions and outcomes.

Keywords: women, globalization, rights, empowerment, human rights

INTRODUCTION

The globalization may be defined as a complex global system that involves economic interactions with other countries. It is a platform that provides a boost to the opening up of markets and expanding the business and services throughout the world. The emergence of globalization has transformed the lives of India's women in terms of better employment opportunities, economic independence, and empowerment. However, the negativities of approach have to be taken into considerations. In particular care for women during maternity is still lacking in many parts of the world. Approximately 529000 women die annually during pregnancy and child birth (Gender statistics 2010). Countries with the lowest maternal mortality rate (deaths per 100000 live births) include Estonia (2), Singapore (3) and Greece (3) while the highest mortality rates can be found in Chad (1100), Somalia (1000) and Sierra Leone (890) (CIA world fact book). To help remedy worldwide gender disparities, the UN's millennium development goals have given importance to gender equality and the empowerment of women. The leaders of the world believe that women should be provided with ample opportunities so that the prosperity of the nation is possible (Lafontaine, 1997). United Nations Development Fund for Women observed that in the last few decades the ideologies of privatization have widened the inequalities among the nations of the world. Since the period of the 1990s, many policymakers have debated on the importance of women empowerment for their social, political and economic interdependence. Even at the social sphere impact has been visible on women's employment and development across the globe. The educated women are getting the opportunity to work in corporate sectors but

unskilled women worked in small scale industry and they become a victim due to the marginalization of small scale industry.

The number of unpaid women workers has increased because of the privatization of the economy and withering away of the welfare policies by the state in the developing countries. The private contractors and owners of the private firms don't follow the labor laws and thus workers are forced to work for longer hours and under the inhuman conditions. It is necessary to mention that the vast majority of the workers who are employed in the unorganized sector of the economy are constituted by women. The hire and fire policy adopted by industry in the liberalized and privatized economies has also forced labor to dance to the tunes of the management as the unemployment level in the developing countries is very high as compared to the developed countries (Harrigan, 1991,pp.63-94). The new forces of global politics have impacted the prospects of female's employment.

The five-year plans have focused on the perspective of the socio-economic and political development of women. The basic objective of the First Five Year plan (1951-56) was to provide the services to the women to promote their welfare as well as their role in the family as well as the community. The situation of women was very different in different kinds of communities and the welfare agencies have to work out their programs and activities according to the specific requirements of the organization (Government of India, 1986, p.12). It is important to study the impact of globalization on the socio-economic and political rights of women at the national as well as the universal level.

GLOBALIZATION: A CONCEPTUAL FRAMEWORK

There have been wide debates by social workers, activists, academician and scholars all over the world on the different dimensions of globalization. There were different kinds of opinions on this critical issue some believe that globalization harms the marginalized sector, especially in developing countries while other scholars were optimistic about the implication of globalization at the global level. They further believe that

technology has made the life of individuals easy and comfortable. The report of the World Bank has highlighted the concern of existing poverty in the developing nations. Further, the bank was of the view that due to the emergence of globalization the poverty in these nations has decreased. According to some official figures, people living in poverty in the developing world have increased from 1.23 billion in 1987 to 1.31 billion in 1993. In South Asia and North Africa more people in 1993 than in 1987. In South Asia, 43% of its total population is poverty-stricken" (Naidu, 1998). The scholars of globalization have raised a concern about the future perspective of the ideology. It has been argued that globalization has an impact on the issues of environment, democracy, Human rights, and social justice" (Stidglitz, 2001). Hence it can be said that there has been a divergent opinion about the implication of globalization at the domestic as well as international level.

The definition of the globalization varies in terms of the assumption by various scholars. According to Robert McCorquodale who believed that the concept is contested all over the globe and there is no single definition that can be accepted as a norm. Further, he believes that it is a multidimensional arena that covers various aspects of human lives (Kumar, 2004). In addition to Bhardwaj was of the view that the term is complex and complicated to be understood as it is not restricted to one economy of the world. It incorporates different political and social dimensions that have universal applicability across the border (Bhardwaj, 2003, pp.30-31). Hence it is a process that involves the emergence of the free market as well as open trade ideology. It is not only limited to technological innovations but it also integrates the principles of cultural hegemony and good governance (Mishra, 2004, p.3). Mishra further highlighted that although in 16th and 19th century globalization as a concept was visible but it was only after the period of the 1990s that it became significant in opening different economies of the world (Mishra,2004, pp.5-6). It can be derived that globalization is not a new concept it has existed in the traditional times only the preview and scope have transformed by the turn of the new century.

The consequences of Globalization have been negative in the functioning of the world's economic system. Further, it has divided the world into several factions (Mishra, 2004). In addition, it has impacted the expansion of economies and leads to global integration by unifying the world into the umbrella of one market system (Radhankrishnan, 2004, pp.1403-1405). Scholars like John Harris view globalization as the promoter of the capitalism and opening up of the market system. While Tomlinson was of the opinion that it is a process which is associated with different societies, culture, organization individual and community. The benefit of such innovation is the shrinking of time and space, the development of social relationships with other humans of the world. Hence according to him, it is only through this innovation that is connecting individuals to the world systems making them open to different economies (Tomilason, 1996). Further Sjolander opines that the concept needs to be understood in a wider perspective taking into account various factors that affect the world systems (Bharadwaj, 2003, pp.30-31). Baylis Smith defined globalization a historical process that has brought transformation among different nations of the world (Smith, 2005). David Held and Anthony McGrew view globalization as a medium of the increasing connectivity worldwide. He suggests due to the growth of the political system and the emergence of various societies a network has been built to connect to the other economies of the world. Hence it is a shift from domestic interaction to the global integration by the process of globalized economic approach (Held, 2000).

Hence from the above conceptual dimensions, it is analyzed that globalization is a concept that denotes interconnectedness with the global space by thickening time-space boundary. It talks about the global culture, global village, the transformation of cultural norms and interrelation of the world economy in the ear of neoliberal economic reforms. Although globalization has many positive traits it also has negative implications on the developing countries. It is important to understand the historical dimension of the demand for women's rights in India.

IMPACT OF GLOBALIZATION

Positive Effects

There has been a balanced opinion on the impact of global policies on women. With the emergence of globalization exchange of goods and services has taken place as a result women are highly paid due to the corporate culture that exists in big companies. Globalization has led to the enhancement of salaries of women leading to their professional as well as personal growth chances. Due to their economic independence, they can contribute to their family income and participate in social as well as cultural activities. Feminists have raised the question of their domestic services that they provide to household activities without getting paid. Hence their work is undervalued. Globalization has opened up new avenues for women to gain their self-respect and status in society. Further, it has also open doors for participation in international trade. In addition, it has opened new levels of communication and encouraged the concept of equality of sexes. The increase in the profitability of cash crops in the international markets increases the independence of women. In urban areas, women are becoming self-independent. The lower middle class is experiencing a shift in the way family relations worked. Traditionally women stayed at home and take care of domestic needs and children. In modern times, women have come out of their places to earn a living (Kaur, 2018, p.41-44).

Globalization has arisen the need for capitalist ideology leading to the expansion of consumer goods and products in the global space. One of the organization namely "The Self-Employed Women's Association (SEWA)" is a platform that provides economic opportunities for women, globalization has aided their opportunities in various ways. They have made policies through which women residing in rural areas can be benefited. With the upcoming internet technologies, women can access different markets of the world and are contributing to national domestic growth prospects. Another advantage of this development is the enhancement of their self-confidence and women having a strong voice

against any kind of discrimination and injustice. Due to the rising awareness among women about their rights, they have become more vocal in promoting their concerns. Women are participating in various fields actively with the promotion of the advertisement industry.

Majority of Non-Government Organization are providing vocational skills to women so that they are empowered to handle technical functions. One of the most significant organization, India Corps has developed many programs to assist women economically. Even in the state of Bihar; a program is operational wherein women are trained to create different crafts to generate income. With such initiatives, they are becoming independent as well as fulfilling their domestic duties. In rural areas, globalization has been promoted through the medium of media like radio. Through the use of media, awareness about the importance of women's participation has increased. Since Indian culture hinders women's access to jobs in stores, factories, and the public sector, the informal sector is particularly important for women. There are estimates that over 90 percent of working women are involved in the informal sector (Kaur, 2018, p.41-44). The informal sector constitutes a job like a domestic servant, small trader, artisan, or field laborer on a family farm. The majorities of these jobs are unskilled and low paying and do not provide benefits to the worker. More importantly, however, cultural practices vary from region to region. In recent years, the conditions of working women in India have improved considerably. More and more women find themselves in positions of respect and prestige; more and more workplaces are now populated with women who work on equal terms as men. Working is no longer an adjustment, a mere necessity; but a means to self-worth and growth. Globalization has not only to provide an opportunity for women in the job sector but also lead to increased political participation. In recent years government in order to promote their participation in politics initiated the policy of reservations for women in Panchayati Raj Institutions. There are many elected women representatives at the village council level. At the central and state levels women are progressively making a difference.

Negative Effects

There has been negative impact of globalization on women as they have to perform a dual role as a house maker as well as professional. For fulfilling household responsibilities, they are not paid and services are undervalued. Even at the professional level women are paid fewer wages as compared to male folks. Another significant factor is the problem of sexual harassment at the workplace that resists women to work in the corporate organization. Further, in rural areas, the persistence of illiteracy and poverty aggravates the situation of the women. No doubt globalization has paved many ways for women to improve and empowered but certain negatives affect their growth prospects. The prevalent Gender differences in terms of access to productive inputs and agency have muted positive impacts for some and added to inequalities between men and women. In the education sector, males are sent to schools or for attaining higher education as compared to women (Deb and Sen, 2016). This kind of difference has limited the employment choices for women in society.

In the sector of agriculture, there have been myriad transformations leading to increased productivity but because of the low level of education, women face lots of trouble in access to international markets. Further, due to domestic responsibilities, they fail to accrue any benefits from profitable sectors. Hence their number is less in the formal sector and is significantly more at the informal level. Women's right to property is limited therefore they are not able to achieve profits from the trade policies. In the context of technology, at home women are deprived of accessing TV, remotes, radio while at workmen assume that computer is something; women cannot learn to operate. Hence this apprehensive attitude has made situations more complex than before.

In professional sectors, wages are low, tenure insecurity exists and training level is not appropriate. Some gender obstacles hinder the effect of women's paid work. In agriculture, gender impact on trade differs according to the type of agriculture and region. For example; in Asia and Latin America, women almost do not have any rights in the agriculture system. The farmer's chance to enter the export sector leads to conflicts

concerning gender because the returns are always biased against women. Export opportunities are not available in an equal manner to women all over the world. In many countries, women have fewer export opportunities due to their restriction in getting loans and the non-availability of market channels. In the era of globalization, women have very few employment opportunities compared to those of agriculture and industry. Women's participation in the private sector is also limited to many aspects concerning higher managerial positions. According to Vandana Shiva, an Indian economist and scholar believe that international organizations such as the World Bank and the International Monetary Fund have created slave wages. These wages are not the outcome of unequal societies but about the undervaluation of people's work. While globalization has brought jobs to rural, developing areas such as India where there was previously no employment, but these jobs are based on gender discrimination (Deb and Sen, 2016). It has been noticed that work that has been assigned to women are not paid highly and are stressful as well as physically unhealthy.

Another important thinker Merlin A. Taber and Sushma Batra wrote a book called "Social Strains of Globalization in India" in that they believed that many women have migrated to urban spaces for better employment opportunities but this corporate culture fails to integrate them into their professional setup. This corporate culture and Western values are dissolving family and community social controls as witnessed by higher rates of family violence, rape, divorce, and family breakdown." For instance, women are exploited in Noida Export Processing Zone where they are hired to do strenuous jobs. Women due to their submissive behavior take up such jobs to earn sufficient for running their families. There are no maternity benefits and the minimum wage is never enforced. Women who become pregnant or marry are immediately fired. Even Overtime is compulsory but women are paid lower rates than men. To avoid being fired, women turn to unsafe abortions performed by unqualified "doctors." In the zone, "respiratory problems, pelvic inflammatory disease, and severe cases of dehydration and anemia are common" (Bagchi, 2000). Hence it is clearer from the above that globalization also has negative effects on the lives of women.

Suggestions

Following are few suggestions can be put forward for women to sustain in the era of globalization:

a) Women should be provided with ample opportunities so that they can be affirmative towards their personal growth and development.
b) Stringent laws should be framed to monitor the levels of harassment at the workplace.
c) The government should formulate such policies that promote the welfare of women in the neo-liberal environment.
d) The role of media, as well as the press, is significant to spread awareness among the women for their rights.
e) In the agriculture sector, proper training camps should be organized to educate women about the importance of foreign investment and their cooperation in international trade.

Conclusion

After India attained its independence women achieved fewer benefits of free individuals. The country got freedom from the York of colonial domination but the position of women did not improve significantly. Due to the patriarchal norms, it was considered a sin if women work outside their homes. Only a few women were employed in the informal as well as formal sectors. The majority of the women were involved in agriculture activities. Due to the emergence of globalization, the role of women was transformed from being a conservative mindset to an open approach by accepting the importance of individuals' freedom and rights. Today, women are more practical and rational wherein they think about their career advancement and growth. However, Women play a double role as house-maker as well as professional. In-home, she fulfills all domestic responsibilities but in the outer-sphere, she is earning and making her space in the corporate world. However, women face lots of problems in the

workspaces such as physical and mental harassment, low wages, no maternity leaves, non-acknowledgment of their labor. All these hinder the progress of women. Even at the political spaces, she is recognized by the availability of the policies of reservations but the decisions are still controlled by the male counterparts.

REFERENCES

Bagchi A. (2000). Globalization, Liberalization and Vulnerability Indian and third World, *Economic and Political Weekly*, Vol.34, No.48, pp. 3219-30.

Bharadwaj, P. (2003). 'Globalization: Politics of U. S. Hegemony and Democratic Processes in Developing Countries,' *Man and Development*, Vol. 15, No. 4, pp.30-31.

Bhattacharji, S. (1991). 'Economic Rights of Women in Ancient India,' *Economic and Political Weekly*, vol. XXVII, no.9, March 1991, p.507.

Biju, M.R. (2012). *Globalization, Democracy, and Gender Justice*, New Delhi, New Century Publication.

Chibber B (2000). Globalization and its Impact on Women A Critical Analysis, *Mainstream*, May 9, Vol. XLVII, No.21.

Deb, M. and Sen S. (2016). Globalization and its impact on women in India: A review, *International Journal of Applied Research,* Vol.2, No. 7, pp.336-340.

Das, A.N. (2010). *Global Campaign for Women's Human Rights*, New Delhi, MD Publication.

Government of India, "National Perspective Plan for women 1988–2000AD," Report of the Core Group, Department of Women and Child Development, *Ministry of Human Resource and Development*, New Delhi, 1986, p. 12.

Gurappa N. (2006). "Globalization and its Impact on Indian Society", *The Indian Journal of Political Science*, vol. XXXXXXVII, no.1, JAN. - MAR., 2006, pp. 65-76.

Harrigan, J. and Paul M. (1991). "Evaluating the Impact of World Bank Structural Adjustment Lending: 1980-87,"*The Journal of Development Studies*, vol. II, no. 3, April, pp. 63-94.

Held D. and McGrew, A. (2000). The *Global Transformation Reader*, Oxford Polity Press: Blackwell Publishers.

Jain, J.C. (1947). *Life in Ancient India*, New Delhi, Vikas Publishing House.

Kant, A. (2008). *Women and the Law*, New Delhi, APH Publication.

Kapur M., Asha (1999). 'Globalization and Women,' Raj Mohini (ed), *Globalization Culture and Women's Development*, Jaipur, Rawat Publications.

Kaur, P. (2018). "Impact of Globalization on Women," *Global Journal of Commerce and Management Perspective*, Vol.7, No.2, pp. 41-44.

Kumar, A. (2004). "Globalization Sovereignty and Human Rights: A Perspective," *Globalization: Myth and Reality*, Concept Publication: New Delhi.

Kusago, T. and Tzannatos, Z. (1998). "Export Processing Zones: A Review in Need of Update," *World Bank Discussion Paper No. 9802*, World Bank, Washington, D.C, January 1998, pp. 673-722.

Mishra, Anil (2004). "Globalization: Concept and Nature", Anil Dutta Mishra and Govind Prasad (ed.), *'Globalization: Myth and Reality,'* New Delhi, Concept Publication.

Naidu, G. (2006). "Globalization and its Impact on Indian Society," *The Indian Journal of Political Science*, vol. XXXXXXVII, no.1, JAN. - MAR., 2006, pp. 65-76.

Pandit, M. (2011). *Human Rights and Social Justice*, Delhi, Swastik Publications.

Radhakrishnan, P. (2004). 'Religion under Globalization,' *EPW*, March 27 2004, pp. 1403-1409.

Sharma, R.S. (1983). *Material Culture & Social Formulations in Ancient India*, Madras, Macmillan India, pp.89-134.

Sharma, S. K. (2004). "Demystifying the Globalization Myth," The *Indian Journal of Political Science*, vol. XXXXXXV, no. 4,Oct.-Dec., 2004, pp. 659-661.

Singh, A. K. (2004). 'Globalization Sovereignty and Human Rights: A Perspective,' in 'Globalization: *Myth and Reality,*' New Delhi, Concept Publication.

Stiglitz, J. (2001). *Globalization and Its Discontents,* London, The Penguin Press.

Tomlinson, J. (1996). 'Cultural Globalization: Placing and displacing the West,' *European Journal of Development Research*, 8,2 Dec,1996.

Ulrich, Beck (2001). *What is Globalization,* U.K., Polity Press.

Vishnoi, S. (1993).*Economic Status of Women in Ancient India,* Meerut, Kusumanjali Prakashan.

William, Rayon F (2001). "Globalization, Religion and New Promising Role of NGOs,' in Stan D' Souza (ed.), '*Population and Poverty Issues at the Dawn of the 21st Century,*' Indian Social Institute, New Delhi, pp. 371-382.

In: Exploring the Opportunity ...
Editor: Surendra Bhaskar

ISBN: 978-1-53616-424-4
© 2019 Nova Science Publishers, Inc.

Chapter 3

HEALTH CHALLENGES AND OPPORTUNITIES FOR INDIAN WOMEN: AN ANTHROPOLOGICAL APPROACH OF ALLAHABAD POPULATION

Arnasha Singh[*], PhD
Department of Anthropology, Lucknow University, Lucknow, India

ABSTRACT

India has achieved better life expectancy as compared to before, due to better health care system over time. Since 1990, India has excluded over half its population out of extreme poverty along with having significant studies in improving health facilities for its people. In 1990, 125 babies died per 1000 live births. In 2015, the number dropped to 37. Also, in nearly three decades, India's life expectancy increased from 57 years to almost 70 years in 2015. However, India's progress on reducing maternal mortality rate has been slow with 174 deaths per 100,000 live

[*]Corresponding Author's E-mail: arnashasingh@gmail.com.

births in 2015. The paper has been prepared with survey on 100 respondents from urban and rural population each, and aims to study the health scenario of women among the urban and rural population. This chapter aims to explain about women's health issues and the reasons behind these problems. Hypothesis of this paper is that challenges are more and opportunities are less in India to improve health. The research methods and techniques used in this chapter are diet plan, anthropometric measurements, interview schedule etc. for collecting data. Finally, it is found that there are so many health challenges present with less opportunities. Urban women's health is far better than rural women due to awareness and facilities.

Keywords: women, health, urban, rural, diet plan, nutritional status

INTRODUCTION

Health is the foundation of any society and societies need a strong backbone which leads to a strong nation. Strong nation is built by healthy women who give birth to healthy children.

Health, as so much of all aspects of twenty-first century life, is inextricable bound up in global relationships. Global health therefore refers to perceiving health as the outcome of global processes, with solutions to improving the health of the global population as being the responsibility of an alliance of global organization national governments and NGOs (Yuill, Crinson & Duncan 2010, p. 81).

The state of our body as a result of the foods consumed is called Nutritional Status. Nutritional status can be good, fair or poor. The characteristics of good nutritional status are: alert, good natured personality, a good body with normal weight for height, well developed and formed muscles, healthy skin, reddish pink color of eyelids, and membranes of mouth, good layer of subcutaneous fat, clear eyes, smooth and glossy hair. In general, good health is evident by stamina for work, regular meal times, sound regular sleep, normal elimination and resistance to disease. Poor Nutritional status is evidenced by a listless, apathetic or irritable personality, undersized and poorly developed body, abnormal

body weight, small and flabby muscles, pale skin, too little or too much subcutaneous fat, dull or reddened eyes, lusterless and rough hair, poor appetite, lack of vigor and endurance for work and susceptibility to infections. Poor nutritional status may be the results of poor food selection, irregularity in schedule of meals, work, sleep and elimination (ibid).

The WHO has defined health as the state of complete physical, mental, and social well-being and not merely the absence of disease or infirmity. An undesirable kind of nutrition leading to ill-health is malnutrition. It results from lack, excess or imbalance of nutrients in the diet. It includes undernutrition and overnutrition. Undernutrition is the state of insufficient supply of essential nutrients. Undernutrition can be primarily due to insufficient supply of one or more essential nutrients and it can be secondary which means it results from an error in metabolism, interaction between nutrients and drugs used in treatment. Overnutrition refers to an excessive intake of food that creates a stress is the bodily function (Mudambi & Rajagopal, 1987).

In India, a majority of the people live in rural areas where chances of poverty are higher than in urban areas. Since independence, the proportion of the population living in poverty has reduced substantially, but still remains high as compared to global numbers. Getting formal education and access to health services are considerably low by this population. Various programs in the past decades have led to a substantial improvement in health indicators. India was first country in the world to take up a national family planning program in 1951 and many other countries took up such programs later (Bijli, 2012, p. 4).

The occurrence of the diseases caused by malnutrition and nutritional deficiencies may be correlated with the quality and quantity of food intake which the population gets in general. A disease of nutritional deficiency may not necessarily be due to lack one nutrient element. It may occur due to the deficiency of more than one nutrient in the diet taken by a section of population for a considerable period of time. Similarly, the deficiency of one nutrient, usually, may not necessarily be producing only one particular disease. The deficiency of one or more nutrients may produce different diseases according to the degree of deficiency of the nutrient, human

resistance, variable climatic conditions, and various endemic relationships to malnutrition or deficiency conditions, differences of food items at a certain place from one period to another. No one nutrient functions alone and its usefulness to the body may be curtailed by the absence of other nutrients and as only a few nutrients are stored in the body, some necessary nutrients may be discarded by the body without being used because other essential nutrients are lacking in the diet. It is because satisfactory metabolism of proteins requires the co-operative activity of certain vitamins and their lack results in abnormal intermediary reaction of amino acids and formation of unusual and often deleterious end products, while a number of vitamins appear to have specific role in protein metabolism (Zaidi, 1982, p. 204).

Eating and physical activity are two critical behaviors with the potential to influence energy balance in the body. It is now widely accepted that changes in life style and patterns of consumption have followed wider social, economic and cultural change within modern societies and have resulted in systematic reductions in human energy expenditure. These include change in employment patterns that have led to a reduction in manual labor and an increase in sedentary non-manual jobs, longer working hours, widespread car ownership and the rise of labor-saving devices for use at home and work. Nevertheless, the impact of these changes in the physical activity of children is less clear, that is despite evidence of reductions in walking and cycling to school and other factors may also be relevant, such as the increased fears of parents about unsupervised out-door play for children. (Yuill, Crinson and Duncan, 2010, p. 94).

According to S. Akhtar Hussain Bokhari (2005), Principal oral Diseases affecting the population are "Dental caries and periodontal Diseases" with etiological factors of sugar in the diet and bacterial dental plaque. Among the other oral problems, oral cancer is a major concerning disease that affects although a minority, but the prevalence is increasing in some countries because of the classical risk factors of smoking and alcohol. The additional identified risk factors are of tobacco that is commonly used in subcontinent, and pan-supari, which has become more

harmful in children in Pakistan with respect to oral cancer. Lifestyle is defined in terms of diet pattern, social class, income level, education, habits, culture and environment etc. 'Life style influences," including diet, effective oral hygiene, and smoking are pivotal to the occurrence of oral diseases. L. Jane, Harper and M. Spencer (1987) very accurately and aptly observe that food intake plays a constant and essential part in maintaining the chemical processes of life. In the second and less evident case, food consumption is equally important in relation to other life processes in ways still often misunderstood because food consumption is usually intertwined with the rituals and customs of everyday living. For instance – the practice of offering food to gods and deities and receiving "Prasad" in return has been analytically examined by Laurence Babb. Babb (1970) observes that the acceptance of "Prasad" indicates the lower position of the devotees as compared to the deity (Doshi, 1995, pp. 1-5).

The main cause of Blindness in children is a deficiency of vitamin A. By including some leafy vegetables in the diet, preferably every day this can be prevented. In one Asian country, bone fractures are very common in all age groups, primarily because of very low calcium intake. Calcium is found in leafy vegetables and even tree leaves provide calcium. In India, the leaves of the drumstick tree are put into certain cooked dishes, and this not only provides some of the necessary vitamin A but also some calcium and iron, in which large percentage of the populations in many developing countries are deficient to the point that they have iron deficiency anemia (Doshi,1995, pp. 1-5).

Food Preferences by Sex

There appears to be little sex difference in children's preferences for foods below about the tenth year. In older children, sex difference in preference for food becomes important. In one study girls registered more dislikes for foods than did boys from the fifth grade through high school, except for the eighth grade, which brought the largest number of dislikes

from both boys and girls. Women have more dislikes than men (Ethel, Austin and Martin, 1970).

More boys than girls accept milk and dairy foods. More number of men in college selects milk in college dining halls as compared to number of women. In older adult groups the ratio is similar; more men like and choose milk than women do. There is also a sex difference in attitude towards vegetables, although they are unpopular with both sexes. More boys will accept green and yellow vegetable than girls, strong juicy vegetables are more acceptable to boys than girls and more boys than girls are "willing to eat" cooked cabbage and "greens." College women on the other hand, rate vegetables higher than men do and favor salad in particular. Home makers list vegetables as the most disliked (by their families) of the food groups, but women personally favor the use of vegetables more than men do. It is likely that the positive effect of serving vegetables at the family table is offset, in terms of the children's acceptance of it, by the parent's own dislike for vegetables (ibid).

The negative attitude towards vegetables revealed in the studies reported here points to the need for children to learn early to know and like a wide variety of common vegetables. The attitudes of teachers and parents, particularly fathers, toward all foods, are major influences in creating children's preference. Tasting lessons at schools can help children to know favorably and to like many foods, including vegetables. But such programs must in some way, reach parents as well as children if preferences are to be translated into food habits (ibid).

Despite general trends in food preferences, there are vast differences in individual likes and dislikes within group. The significance of such variation as applied to nutritional adequacy of diets will take on meaning as study of nutrition proceeds (ibid).

OBJECTIVES

- It aims to study the health scenario of women among urban and rural population.

- To find out contrast between health and educational status of urban and rural women.
- Chapter elaborates and focuses on health care and challenges in women.

HYPOTHESIS

- Hypothesis of this chapter is that challenges are more and opportunities are less for Indian women to improve their health.

METHODOLOGY

It is a form of descriptive research. Here several methods are used for data collection like sampling, observation, interview-schedule etc. It is a comparative research and the study is conducted with 2 areas which are rural (Yadavpur, Kodra, Manoharpur Village) and urban (Preetam Nagar colony) of the Allahabad population, which is based on random sampling. The field work is based on research work and 100 households were chosen from each population. It is quantitative analysis and shows the field work research. Assessment of nutritional status-

- Dietary history and intake data
- Anthropometric data
- Pertinent health history

ABOUT THE AREA

This research chapter is based on 3 rural areas namely Yadavpur, Kodra, Manoharpur. The households in these areas are economically and socially different. People of different caste live there, but 'Yadav' caste is

the dominating caste in these villages. 100 households were selected and within these households, female population was 190. Land is not much fertile there, so they have to purchase the food items from market rather than home grown food. Preetam Nagar colony (Urban area) represents middle working class people which have different caste.

ANALYSIS ON WOMEN HEALTH CHALLENGES

The below table shows us the distribution of the educational status of females in different age groups and it shows correlation between health and education, how education alleviates health issues.

Maximum number of illiterate women (14) in rural areas belongs to the age group (36-40). Of all females under survey, number of females having post graduate or technical education is found nil. Illiterate females constitute 48.947 percent, whereas Aaganwadi educated females are 1.052 percent. Primary educated women constitute 14.210 percent, and high school educated females are 22.105 percent. On the other hand, intermediate level educated form 8.947 percent, and finally, under-graduate level educated females constitute 4.736 percent.

Maximum number of illiterate women (8) in urban areas belongs to the age group (16-20). Of all females under survey, illiterate females constitute 12.631 percent, whereas Aaganwadi educated are 1.403 percent. Primary education women constitute 11.228 percent, and high school educated is 20.350 percent. If we see intermediate level education, it forms 23.508 percent, and the under-graduate level constitute 14.035 percent, whereas post graduate educated females are 12.280 percent, and finally, technical education females are 4.561 percent.

Literacy Rate (rural women) $= \dfrac{No. of\ Literates\ in\ a\ population}{Total\ Population} \times 100$

$= \dfrac{97}{190} \times 100 = 51.052\%$

Literacy Rate (urban women) $= \dfrac{249}{285} \times 100 = 87.368\%$

Table 1. Showing educational level of rural women

S. No.	Age group	Illiterate	Aaganwadi	Primary edu.	10 class	12 class	Undergraduate	P G	Tech
1.	0-5		2	3	2				
2.	6-10	10		9	5				
3.	11-15	12		4	21			NIL	NIL
4.	16-20	9		2	6	8	2		
5.	21-25	8			1	6	3		
6.	26-30	10		3			2		
7.	31-35	9		2	1	1			
8.	36-40	14		1	1	1	1		
9.	41-45	6		2	3	1	1		
10.	46-50	6		1	1				
11.	51-55	5			1				
12.	56-60	1							
13.	61-65	2							
14.	66-70	1							
15.	70 – above								
	Total	93	2	27	42	17	9		

Table 2. Showing educational level of urban women

S.N	Age group	Illiterate	Aaganwadi	Primary edu.	H.S.	Inter	U.G.	Post Graduate	Tech.
1.	0-5		4	8					
2.	6-10			11	5				
3.	11-15	5		4	11				
4.	16-20	8		5	10	13	5		1
5.	21-25	7		2	10	8	9	10	3
6.	26-30	3		2	12	1	7	13	3
7.	31-35	2			10	1	3	2	3
8.	36-40	4				6	16	2	3
9.	41-45	1				5	12	1	3
10.	46-50	2				2	6	5	
11.	51-55	2				4	6	2	
12.	56-60	1					1		
13.	61-65						2		
14.	66-70	1							
15.	70 – above								
	Total	36	4	32	58	67	40	35	13

Finally, it depicts that urban women literacy rate is much greater than rural women.

The problem of malnutrition is evident in the society, whether rich or poor, if balanced diet pattern is not followed. The subjects with deficiency of protein content in their diet are prone to more health issues. This deficiency results in growth disorders. Undernutrition can occur at any stage of life which leads to various deficiency diseases. The children and adolescents with unbalanced diet show irregular growth and development, malnutrition during pregnancy result in birth of underweight infants or may cause stillbirths. The children with imbalanced diet are prone to severe health disorders and low immunity due to which they are subjected to various communicable diseases such as diarrhea, pneumonia etc. In this chapter, the dietary pattern of rural and urban women is provided and analyzed. In this chapter, the pattern of consumption of food items with their calorie is accounted. In dietary pattern of urban population, consumption of less cereals and inclusion of other food item such as pulses, fruits, vegetables, milk, egg, meat etc. is found evident as these things are easily available in urban areas. The society with higher economic status have shown influence of globalization in their dietary pattern, as they tend to have low cereal intake and more protein rich food products, fruits and vegetables.

Rural Population Diet Pattern

Women living in rural areas prefer pure vegetarian food which makes them feel light in the mornings. First of all, they take tea which provides them 40-45 kcal. (1 cup) energy. 18-30 yrs. to 30-60 yrs. age group women take a large amount of tea, along with which they take snacks and toast. Two toast provides them 160 kcal energy. Rural women take a simple breakfast which has high energy content, but not much of nutrition due to which their breakfast is not proper. According to their work, rural women may fall under the category of heavy work, but they do not get sufficient amount of energy which they need.

In lunch, they take pulses, vegetables, rice, chapattis, and salad in variable quantities. Consumption of pulses is high in urban areas whereas in rural areas it is less. One bowl of pulses provides 105 kcal in 100 gm. Rice provide 130 kcal energy. In vegetables, they mostly take green or seasonal vegetables. It is observed that the lunch pattern of urban area women is better than the rural area women. This means that their nutritional and energy level is better than the rural area women. Food rich in proteins, carbohydrates and fats are usually consumed by them daily. Adult females take a low amount of pulses and a high amount of rice which causes bad effect on their nutrition because of which they have disease like anemia and other stomach problems.

Before dinner, normally they take single cup of tea in the evening. In the dinner they only like to have vegetables with chapatti. 100 gm of vegetables provide 54 kcal energy. 6-8 chapattis are consumed in the dinner; where one chapatti provides 85 kcal energy. In rural areas, the families are joint families and usually large, due to which complete diet is not possible. The livelihood of the people depends upon the business of milk selling. In these rural areas, milk is in abundance but children rarely get milk to drink due to which their mental and physical growth is not proper.

Urban Population Diet Pattern

In urban population, middle class women were selected under study to compare their dietary pattern and its impact on their health and physique, so their data are described hereby:

Middle class women take variety of food in their breakfast which provides them good amount of energy and nutrition. 1 person takes 2 *stuffed parathas* which provides them 720 kcal of energy. One cup of tea provides them 45 kcal energy which they generally take after their breakfast. They get 85 kcal of energy on the consumption of snacks (namkeen). A single person can take 2 *sandwiches* which provide 380 kcal

energy. Children take 1 cup of milk which provides them 103 kcal of energy.

Middle class women have good food in their lunch which provides them large amount of energy. They take complete lunch like pulses, rice, chapattis, vegetables, salad etc. Pulses give them 335 kcal energy and 22.3 gm protein. Carbohydrates, proteins, vitamins and fats in the body are the basic needs, the deficiency of which makes a person suffer from malnutrition. Rice provides them 349 kcal energy and 77.4 gm carbohydrates. *Chapatti* provides them 85 kcal energy and these people take 2-4 *chapatti* at a time. They usually consume green vegetables or potatoes, paneer, chhole, beans etc.

In the evening they take a lot of snacks items like samosa, namkeen, poha with tea. These items are spicy as well as oily. One person takes one samosa which gives them 210 kcal energy. One cup of tea gives them 45 kcal energy which they use to take after their snacks. They gain 85 kcal energy on the consumption of namkeen. Sometime a person takes *poha* which provides 211 kcal energy.

In the dinner, middle class women usually take good amount of food. They take a lot of oily and spicy food. In the dinner, along with their meal they like to take *curd* which gives them 60 or 80 kcal of energy. Normally, they take chapatti and vegetables which give them 85 kcal (1 chapatti) and vegetables give 70 kcal. A normal diet of a person includes 4 chapattis and 150 gm vegetables. This provides them good nutrition, but often they face obesity, blood pressure, heavy weight problem etc. These people suffer from over nutrition.

Before the morning breakfast they usually like to have bed tea. After which, their breakfast with vegetables (60gm.) and *Paratha* (2) gives them 30 kcal and 520 kcal energy respectively. Sometimes they take light breakfast which includes snacks when they do not go for work, they take toast and butter which provides them 50 kcal and 72 kcal energy respectively. This diet when they do not go to work is the main reason for being unhealthy.

Table 3. Showing food item's nutritive value by Indian Council of Medical Research (ICMR)

S. No.	Food Items	Energy (kcal)
1.	1 Cup Tea	45
2.	1 Cup Milk	103
3.	1 Piece Samosa	210
4.	100gm. Vegetable	54
5.	1 Chapatti (RURAL-35gm.)	70
6.	1 Chapatti (URBAN MIDDLE CLASS)-25gm.)	80
7.	2 Spoon Namkeen	85
8.	Dal	105
9.	Rice	349
10.	TOAST (2 slice)	265
11.	BUTTER (5 gm.)	35
12.	Curd	67
13.	Salad	9
14.	Sandwich	195
15.	Stuffed Paratha	360
16.	Plain Paratha	121
17.	Poha	211

This is the list of different food items which is the intake for our selected population; it shows its quantity and energy content of food.

Calorie Consumption

The energy requirement of every person is different. It depends on their physical activity like -

Energy expenditure in relation to intensity of muscular work (Durin and Passmore, 1955) by Swaminathan (2003)-

1. Light Work - 150-294 kcal/hour (desk jobs) Light industry, carpentry, military drill, domestic work, gymnastic exercise, plastering agricultural work and driving a truck.
2. Moderate Work - 300-444 kcal/hour, (domestic work) Agricultural work (Non-Mechanized), Cycling etc.

3. Heavy work - 450-594 kcal/hour cool mining, Football; gymnastic exercise, agriculture
4. Very Heavy Work - Over 600 kcal/hour swimming, running etc.

Table 4. Showing the age group and energy requirement followed under study in accordance with the standard of ICMR (Indian Council of Medical Research) advisory committee report-1981

Age group		Energy Requirement
Infant	0-6 M	92 kcal.
	6-12 M	80 kcal.
Children	1-3 Y	1060 kcal.
	4-6 Y	1350 kcal.
	7-9 Y	1690 kcal.
Adolescent	10-12 Y (M)	2190 kcal.
	10-12 Y (F)	2010 kcal.
	13-15 Y (M)	2750 kcal.
	13-15 Y (F)	2330 kcal.
	16-17 Y (M)	3020 kcal.
	16-17 Y (M)	2440 kcal.
Adult	18-30 Y	
	(M) S	2716 kcal.
	M	3191 kcal.
	H	4078 kcal.
	(F) S	2220 kcal.
	M	2612 kcal.
	H	3337 kcal.
	30-60 Y	
	(M) S	2526 kcal.
	M	2612 kcal.
	H	3797 kcal.
	30-60 Y	
	(F) S	2095 kcal.
	M	2464 kcal.
	H	3149 kcal.
Aged person	60y > above	
	(M) S	2177 kcal.
	M	2564 kcal.
	60y > above	
	(F) S	1936 kcal.
	M	2277 kcal.

S – Sedentary. M – Moderate. H – Heavy.*Table source-ICMR Report.

Food habits and energy requirement are interrelated to each other because of the calorie they provide. So, we should understand that everybody needs right diet with the right proportion according to their work nature.

Adolescents Calorie Intake

Adolescent calorie intake is found different by age group like in 10-12 years is 10800; 13-15 year is 31840 kcal while 16-17 year is 21250 kcal energy.

It has been noticed from the above table that 10-17 year adolescent females in rural areas take a mean value of about 1996.56 Kcal. On the other hand, 10-17 year adolescent females in urban areas take about mean value of 2138 Kcal. It can be observed that mean value of calorie intake is high in urban women as compared to rural women.

Table 5. Distribution of calorie intake in rural and urban adolescents

	Rural		Urban	
Age Group	No.	F	No.	F
10-12 Y	8	10800	8	14840
13-15 Y	14	31840	19	42275
16-17 Y	10	21250	17	36975
Total	32	63890 Kcal	44	94090 Kcal
Mean		1996.56		2138

Adult Calorie Intake

Adults take rich and nutritious diet. They can manage heavy & oily food. Their digestive tract is strong as compared to aged people. Rural females were found to consume total of 279424 kcal energy. They belong to different age group like (18-30) yr. and (30-60) yr. and their dietary intake are different from each other. There are three type of person like - sedentary, moderate and heavy, and their energy consumption is different.

On the other hand, middle class women in urban areas were found to burn 413661kcal of total energy. Mean value of calorie intake is found high in urban women as compare to rural women.

Table 6. Distribution of calorie intake in rural and urban women (Adults)

	Rural		Urban	
Age Group	No.	F	No.	F
18-30yr.				
Sedentary	40	85500	34	73150
Moderate	21	52580	14	34860
Heavy	0	0	21	67980
30-60 Yr.				
Sedentary	46	91800	28	55390
Moderate	33	49544	22	51106
Heavy	0	0	52	131175
Total	140	279424 Kcal	171	413661 Kcal
Mean		1995.88		2419.07

Aged Women Calorie Intake

Aged people cannot intake heavy and oily food therefore they take light food which can be easily digested. Aged women in rural areas take more energy than women in urban areas. Total mean value found in rural women is 2161.66 whereas in urban women, it is 1844.66.

Table 7. Distribution of calorie intake in rural and urban area old age women

	Rural Area		Urban Area	
Age Group	No.	F	No.	F
60y> above				
Sedentary	3	6968	2	3536
Moderate	1	1945	1	1998
Total	4	8913kcal	3	5534kcal
Mean		2161.66		1844.66

Distribution of Diseases in Urban and Rural Women

This section provides data on the women health diseases like anemia, malnutrition, infections etc. Women who are illiterate and poor cannot

afford good and healthy food and suffer many complications in day to day life and often become ill. On the other hand, some women who live in urban areas but having less knowledge of proper nutritious diet, so they do not take good and healthy food and fall ill. If we compare and see the table, then we can assess a huge difference in urban and rural women health.

Table 8. Distribution of diseases in urban and rural women and their relationship with health status

Types of Disease	Urban women (%)	Rural women (%)
Flu	36	38
Water related diseases	32	42
Undernutrition	62	68
Stomach disorder	56	64
Food illness	54	68
Stale Food problems	64	80

Table depicts that flu is a common problem in our society but it is found in 38% rural women and 36% in urban women. Rural women suffer from water related health issues because of unhealthy water. Water related health issues are found 42% in rural women as compared to 32% in urban women. This trend is found similar in undernutrition also because rural women have no idea about proper health and care and they are less educated and belong to rural background. Undernutrition problem is high in rural women (68%) as compared to urban women (62%), whereas food borne illness is way too high in rural women (68%) than urban women (54%). Stale food problem is present more in rural (80%) than urban (64%). There are very less facilities for health care, so rural women suffer more stomach disorder (64%) than urban (56%).

Body Constitution by Anthropometric Data

Physique is a constitution of the human body. Everybody has different types of body constitution according to their genetic and food eating pattern. Each person belongs to different socio-economic status, which is

mainly responsible for differences in eating behavior. This section deals with the data collected on body constitution from both urban and rural areas. All the data pertaining to the physique was further classified and analyzed statistically. It is presented here in tabular form in below table, which shows mean value for rural and urban women. These all mean values show correlation between women health and its impact on their physique.

Table 9. Showing mean value of anthropometric measurements of rural and urban women of Allahabad population

S. No.	Mean Value	Rural women	Urban women
1.	Height Vertex	151.88 cm	152.81cm
2.	Body weight	51.86 kg	53.82 kg
3.	BMI	22.31	23.05
4.	Biceps	106.8 cm	90.26 cm
5.	Triceps	127.6 cm	126.98 cm

Above table shows a comparative picture of rural and urban women. Mean value of height vertex is found high (152.81cm) in urban women as compared to rural women (151.88 cm). It shows that nutrition and growth supplements are far better in urban population. On the other hand, mean value of weight is found high (53.82 kg) in urban population due to their food habit as well as work pattern. It is found lesser in rural population (51.86 kg) because of the calorie consumption and nature of their work. BMI is found high (23.05) in urban women as compared to rural women (22.31). Biceps and triceps are found high (106.8 and 127.6 cm respectively) in rural women due to their heavy work nature.

Women suffer a lot of issues like high blood pressure, diabetes, obesity, and weight problem, high cholesterol, tobacco and alcohol uses, reproductive illness, anemia, malnutrition, asthma etc. They need lot of care and support by their family. They need proper education, nutrition, opportunities, awareness, financial security, moral support to achieve good health.

CONCLUSION

We can say that the health of women has improved as compared to past because of proper education system and awareness about health and hygiene issues. This chapter highlights the women health issues in the present era and how it can be improved in the future. It concludes the following main points:

- Women are not aware about their health issues due to illiteracy.
- They suffer from many diseases due to fewer facilities in their areas and face too many challenges.
- Nutritional status is very low in rural women as compared to urban women because of less income as well as less awareness about health and day to day problems.

Women are often tired and ill, and way too many of them die because of health problems. This is a problem not only for them, but also for the community and the nation where they live. Much of this illness and suffering can be prevented. Even though women's health needs have been neglected in the past, women health conditions are now far better than in the past. In particular, more effort is now being made to train health and family planning workers, provide supplies and equipment, and help women reach medical facilities. Equally important is that governments and non-governmental organizations, including women's groups, are working hard to provide women with the information that will enable them to take better care of themselves. These efforts are paying off, but much remains to be done.

This chapter is one tool in the campaign to improve women's health. The chapter describes the cause of women's health problems, especially those related to their diet and health practice and explain what can be done to prevent or treat those problems. Maternal and child health workers are often the only source of medical care and information women have. It is therefore critically important that they take responsibility for ensuring that women are educated and informed about the full range of health issues

they face. Many health plan and policies are provided by the government to improve women health which is implemented through NGOs and research institutes. In this way, we can improve women's health as well as life expectancy of the children and their mother.

REFERENCES

Ahuja, R. (2006). *Research Methods*, New Delhi, Rawat Publication.

Austin, Ethel Martin (1970). *Nutrition in Action*, 2nd ed., Kolkata, Oxford and IBH Publishing Co.

Aykroyd, W. R., Gopalan, C. & Balasubramanian, S. C., (1963). *The nutritive value of Indian foods & the planning of satisfactory diets,* ICMR, New Delhi.

Babb, Lawrence A. (1970). "Food of the Gods in Chhattisgarh, some structural features of Hindu rituals," *South western journal of Anthropology*, Vol-26,287-304.

Bijli, Heenak (2012). *Women and health–Intersectional issues and social constraints,* Delhi, Authorspress.

Doshi, S. L. (1995). *Anthropology of Food and nutrition*, Jaipur Rawat publication.

Gopalan, C., Rama, shastri B. V., & Balasubramanian, S. C. (2012). *Nutritive value of Indian foods,* revised edition, Hyderabad, NIN.

Harper, Laura Jane and Spencer, Maryellen. (1987). "Food for thought: An Approach to the study of Food in culture" in *Food and Nutrition, Vol. 13 no. 1, FAO,UN p. 1.*

Mudambi, Sumati, R., Rayagopal N. V. (1987). *Fundamentals of Foods and Nutrition.* 4th edition, New Delhi, Wiley Eastern Ltd.

Swaminathan M. (2003). *Food Science, Essentials of Food and Nutrition.* (2$^{nd)}$ Edition, Banglore Printing and Publishing Co-Ltd.

Yuillchriss, Crinson Iain and Duncan Eilidh (2010). *Key concepts in health studies*, California, Sage Publication.

Zaidi, Syed Sajid Husain (1982). *Rural India and malnutrition–implications, problems and prospects,* New Delhi, Concept Publishing Company.

In: Exploring the Opportunity ...
Editor: Surendra Bhaskar

ISBN: 978-1-53616-424-4
© 2019 Nova Science Publishers, Inc.

Chapter 4

IMPACT OF THE 73RD CONSTITUTIONAL AMENDMENT ACT (1992) ON THE EMPOWERMENT OF WOMEN IN INDIA

Shivani Chugh[1,], PhD and Surendra Bhaskar[2,†], PhD*

[1]Amity Institute of Public Policy, Amity University,
Noida, Uttar Pradesh, India
[2]Rajasthan State Commission for Protection of Child Rights,
Jaipur, Rajasthan, India

ABSTRACT

The paper deals with the emergence of the 73rd Amendment act and the provisions related to the disadvantaged section especially the women. Many historical studies cited the deplorable condition of women. The social reformers like Swami Vivekananda, Raja Ram Mohan Roy raised their voice against injustice to the women. It is a fact that their

[*] Corresponding Author's E-mail: advocateshivani9@gmail.com.
[†] Corresponding Author's E-mail: bhaskarsuren@gmail.com.

representation has been reserved for Panchayati Raj but still the majority of rural women are not empowered. The woman continues to have a very low social, cultural and economic status despite their significant contribution to the economic development in of the country. The situation was slightly improved after 73rd and the 74th Constitutional Amendments in 1992 which provided one-third reservation to women in the Panchayati Raj Institutions and the Urban Local Bodies. However, their rights and power are enjoyed by their respective husbands in this setup. Further, the patriarchal set up is deeply entrenched in the rural areas that have led to the subordination of women. The finding of the study highlighted that reservation of seats for women in Lok Sabha and the State Legislative Assemblies would not lead to the real empowerment of women, it is imperative that they should be educationally, socially, economically and psychologically empowered. The conservative, neo-feudal and patriarchal culture need to be changed. To achieve this objective there is a need for strong political campaign that can ameliorate the conditions of women.

Keywords: empowerment, constitutional amendment, women, discrimination, exploitation

INTRODUCTION

India is a land of paradoxes. On the one hand, the women are worshiped as the goddesses while on the other hand, they are killed in the womb in large numbers and are subjected to ill-treatment, discrimination and harassments. They have to face many problems such as eve-teasing, molestation, rape and other forms of sexual harassment. They not only suffer from anemia, large scale illiteracy, and lower life expectancy but also from low esteem. There are historical reasons for such occurrence. It has been recorded that women were accorded high social status in the ancient period but this claim seems to be incorrect. Manu accorded them a low social status and compare them with cattle and fools. They were considered inferior beings in Hindu culture. However, their position became worse during the medieval period when the Muslims ruled over India. It is a fact that in earlier times the man dominance was prevalent at all levels ranging from family to the community services. Women have a meager role to play in politics, only intelligent women use to influence

politics behind the veils. It would not be wrong to say that in the pre-colonial period they had a very low social culture and economic status. Hence it can be said that women were victimized and sufferers in ancient as well as the medieval period. After India got independent many steps were taken by Indian Constitution makers to integrate the social principles that lead to the empowerment of women. The significant milestone was the attainment of legal sanctity of Panchayati Raj Institutions to provide certainty, continuity, and strength to the functioning of democratic foundation.

Accordingly, the 73rd Amendment Act 1992 came into force with effect from 24th April 1993 which lays the foundation for a strong vibrant Panchayati Raj Institutions in the country. While retaining the three-tier system of Panchayati Raj, from social justice, and political mobilization, the aim of this amendment includes:

1. Empowering weaker sections of the society, viz., Scheduled Castes and Scheduled Tribes, Backward Classes and women in local self-government through reservations in elective offices;
2. Strengthening the Gram Sabha for direct participation of the people in identifying their felt needs and fulfilling the same through Panchayati raj institutions;
3. Providing a mechanism (State Finance Commission) to ensure the flow of funds to rural local bodies to enable them to discharge their functions and responsibilities;
4. Ensuring devolution of functions as mentioned in the 11th Schedule of the Constitution; and
5. Providing for regular and timely elections to multi-level panchayat raj institutions through the State Election Commission. Thus, the Constitution 73rd amendment has become a landmark in the Constitutional History of India" (Geeta, 2017, pp.7-13).

Hence it can be said that the 73rd Amendment Act provided legal sanctity to rural areas for devolving democracy at the grassroots. The issue of reservation of seats for women has been significant to empower women.

WOMEN IN PRE-INDEPENDENCE PERIOD

The British abolished the Sati system as per which a widow was required to burn herself with her husband after his death. Raja Ram Mohan Roy, the founder of Brahmo Samaj was a first Indian to raise his voice in favor of improving the condition of the women. Swami Dayanand, the founder of the Arya Samaj also advocates their cause. Both of them were in favor of widow remarriage. But their efforts could not bring transformations in their condition due to the powerful hold of the traditional and conservative elements that were prevalent in the Indian society.

Later on, significant efforts were undertaken to improve their condition during the freedom movement by the moderate leader of the Congress Party like S.N. Banerjee, Justice M.G. Ranade, and Gopal Krishan Gokhle. The leaders were of the opinion that social reforms should get priority over political reform. However, the extremist leaders like B.G. Tilak opposed their efforts as they disfavor the idea of British involvement in Indian traditional system. Even otherwise, the attitude of the British had changed after the Revolt of 1857 because they felt that it had taken place as a reaction against their efforts for the social reforms. Consequently, the agenda for the emancipation was pushed into the back burner. However, it was brought on the center stage by Mahatma Gandhi and Jawahar Lal Nehru. Gandhi inspired them to participate in the freedom struggle during the Civil Disobedience Movement which was launched in 1930. Nehru also took up the cause of the women because he was inspired by the ideology of Liberalism. Further, the issue of plight of women was also taken up by the Socialist leaders like Ram Manohar Lohia and the Communist leaders like M. N. Roy who had later on become a Radical Socialist after his quarrel with the Russian leader, Lenin who was the proponent of the ideology of Socialism. Dr. B.R. Ambedker, the leader of the Dalits in the national movement is also a champion of the rights of women.

As a result, the makers of the Indian Constitutions were able to recognize the need for women empowerment. They included the Right to

Equality that made women equal to men socially as well as politically. In addition, they also made provisions in the Directive Principles of the State Policy for the purposes. All the Five Year Plans and Centrally Sponsored Schemes laid stress on improving the condition of the women and raising their status in Indian society. However the women remained completely underpowered till the emergence of 73rd Constitutional Amendment to the Indian Constitution (1992). Before the enactment of the law they had meager representation in Parliament and the States Legislatures. The implementation of amendment provided them one-third reservation of seats at the village, block, and the district level. Some of the women have also been elected from the general seat. As a result, they were able to get about 40 percent shares in the Panchayati Raj Institutions. In recent times the States like Bihar and Rajasthan have increased it to 50 percent. The effectiveness of these bodies enhanced the legitimacy and accountability of masses towards the relevance of affirmative Indian attitudes.

One of the important questions is about the relevance of these institutions in empowering women folks in countryside. On the one hand, these institutions promoted empowerment strategies for instance states like Kerala where the rate of literacy is very high, the sex ratio is highly favorable for women and the social reform movement had helped the women in acquiring a high social status. On the other hand, some states have conservative outlook towards the acceptance of these democratic institutions. The women continues to have a very low social, cultural and economic status despite their significant contribution to the economic development of the State which has become, from a backward region of Punjab, one of the most developed states of the Indian Union after the attainment of statehood on November 1, 1966.

This leads us to the question: What needs to be done for the empowerment of women in such states. In this context, the following submissions can be made — (Singla, 2017)

1. Women's education should be given priority. Separate Universities, Colleges and Schools should be opened for the girls.

2. The women must be given one-third reservation in the Government jobs.
3. The State Government should ensure that they get a share in the property of their parents as well as the in-laws.
4. A powerful social reform movement should be launched to change the mindset of the males of this patriarchal society.
5. All-out efforts should be made by the civil society and the State Government to change the predominantly traditional and neo-feudal cultural of Haryana's rural society where the traditional institutions like Khap Panchayats continue to remain very powerful.
6. The Haryana Institute of Rural Development, Nilokheri and Rajiv Gandhi State Institute of Panchayati Raj and Community Development, Nilokheri should launch special programmes for building leadership qualities of the women representatives of Panchayati Raj Institutions by developing in them communication skills. They should also organize special training programmes for the women Sarpanches and other women office-bearers.

It may be concluded that if the Government has the political will and the civil society works with dedication, it would not be difficult to achieve these objectives. Otherwise, the empowerment will continue to elude the women in the Panchayati Raj Institutions and their husbands will continue to function on their behalf. There will be only few exceptions to this rule when some educated and psychologically empowered women is able to become a Sarpanch of a Gram Panchayat or Chairperson of a Panchayat Samiti or President of a Zila Parishad. The women had a very low social, economic and political status in Indian in the pre-colonial period due to historical, religious and cultural factors. Even the Sikh religion which sought to improve their status, could not improve it. There was little change in this direction in the colonial period during the 19th Century despite their advocacy by the social and religious reform movements of the Braham Samaj and the Arya Samaj led by Raja Ram Mohan Roy and Swami Daya Nand respectively. These movements did seek to improve the

status of women but could do little for this purpose due to the deeply entrenched patriarchy in Indian society on the one hand and its conservative culture on the other hand.

But the situation underwent a marginal change in the 20th century due to the introduction of the western system of modern education as only a few women were benefitted by it. This started the process of the emergence of an educated middle class from the women in India. However, in spite of it, the Montague Chelmsford Reforms, which led to the enactment of the Government of India Act (1919) and the introduction of the Dyarchy in the provinces in 1921 denied them empowerment as it did not enfranchise women and left it to the Provincial Legislative Councils to decide this issue. This did extend them a limited franchise to women but it did not enable them to contest elections for the provincial legislature councils. But the participation of women in the national movement after their mobilization by Mahatma Gandhi in the 1930s did not help them to get this right. The empowerment, however, continued to elude the women even after the enactment and implementation of the Government of India Act, 1935 which introduced the Provincial Assembly. But they were able to get nominal reservations in the provincial and the central legislative assemblies as a result of these constitutional reforms. It is amply evident from their nominal presence in these bodies at the central and provincial levels (Bohra, 2009).

WOMEN AND THE 73RD AMENDMENT ACT

The process of their empowerment, at least in theory if not in practice, started in the post-colonial period as a result of the adoption of the Constitution of India on January 26, 1950. The women got a status equal to that of men through the Right to Equality and the Right against Exploitation in the Chapter on Fundamental Rights. The Directive Principles of the State Policy too included provisions for the improvement in their status. Government of India initiated welfare measures under the Five Year Plans and the Annual Plans in 1951 but the women could get

only insignificant representation in the Union Parliament and the state legislatures as well as in the Panchayati Raj Institutions and the Urban Local Bodies because, unlike the scheduled castes and the scheduled tribes, they had been denied reservations in these bodies. However despite revealing this dismal situation, the Committee on the Status of Women did not recommend a reservation for them in the national and state legislatures as well as the local bodies because of the following reasons. Firstly, they did not view the women as the homogenous group and felt that women from different strata have different problems. Secondly, they felt that it was against the principle of equality. In the meantime, the issue of women empowerment gathered momentum at the international level and pressure began to be built on the decision-makers of India too for this purpose. Besides, it began to be recognized in India that democracy should be made inclusive for inclusive growth. It was in this context that the then Prime Minister of India, Rajiv Gandhi moved the 64th Amendment Bill in the Lok Sabha in 1989 for giving women up to 30 percent reservation in the Panchayati Raj Institutions. Although the Bill could not gather the needed two-thirds support in the Rajya Sabha at that time. It ultimately culminated in the enactment of the 73rd and the 74th Constitutional Amendments in 1992 which gave one-third reservation to women in the Panchayati Raj Institutions and the Urban Local Bodies. The women were able to get more than one-third share in these bodies due to the election of some of them from the non-reserved seats. And, now it is being proposed that this be enhanced to 50 percent (Bhargava, 2008).

The reservation of 50% seats for women has empowered the male members of their families. According to the authors of this study, it would be more appropriate to say that it was in reality empowering men through Women. Different studies have been conducted in different states and these studies lend considerable support to this particular concern.

Analysis of the data gathered on various aspects of empowerment reflects that the reservation has led only to formal and not real empowerment of women in the Panchayats. It has also been found that the participation of women in meetings is not satisfactory. However, they did get cooperation from their family members. Participation of the women in

preparing budget and plan was also not to the desired extent. It has also come to light that their participation in the mobilization of funds for SGSY (Swarnajayanti Gram Swarojgar Yojna) and role in identifying beneficiaries in the Gram Sabha was highly dissatisfactory. Although their participation in the identification of BPL (Below Poverty Line) beneficiaries is encouraging, participation in the organization of community programmes is far from satisfactory. On the whole, it could be said that participation of the women representatives in the Panchayat is unsatisfactory but not altogether disappointing. It has to be assessed by keeping in view the low levels of education, awareness and social commitment of most of them on the one hand and the social and cultural milieu in which they operate on the other hand.

As far as the involvement of elected women leaders in decision-making is concerned, it has been observed that it was insignificant both in Panchayats and in the household. It may be mentioned that women have little role in deciding even the household activities and logically have a negligible involvement in the decision-making process in Panchayats on account of their low socio-economic status. However, an exception was visible in the case of women from financially sound families. They have a considerable extent of participation in deciding the day-to-day activities. Otherwise, women are usually neither given weight nor consulted to the extent compatible with their being called better half on the domestic matters. This state of affairs is the reflection of the patriarchal and male-dominated rural society of Haryana (Arora, 2016). It has also been noted that elected women representatives are not able to mobilize funds and raise additional income in the Panchayats through the levy of taxes. They, however, do agree that adequate provisions exist for taking effective decisions. But they concede that they are unable to use these effectively due to the nexus among the elected male representatives and the officials, male-dominated social system and age-old social taboos against women among men in general and elders in particular whose ego is badly hurt on being governed by the women representatives.

An overview of the description and analysis of the perception of the elected women representatives reveals that the position in the Panchayats

commands respect and enhances their sense of responsibility. Most of them agreed with the statement that women should be encouraged to participate in these. However, most of them contradicted this in their responses to the next question by holding that men should be leaders and women are followers.

But, an overwhelming number of them could not identify the reasons for accepting the supremacy of males over to women in a leadership position. An overwhelming number of them also felt that women should not be given responsibilities in the Panchayats as they are soft. Besides a larger number of them were of the view that only educated women become better leaders. They also felt that the housework hampered their performance. Three-fourth of them disagreed with the statement that women do not participate in the meetings because of a lack of confidence. The inferences drawn above make us conclude that the perception of elected women representatives is of rather a mixed character. While some of these make us optimistic about their empowerment others drive us towards pessimism. But these perceptions do not seem very discouraging if we keep in view their socio-economic status, on one hand, socio-cultural aspect on the other hand (Joshi, 2012). One-third of reservation for women in the Panchayats at the village, block and district levels is not going to empower them until the attitude of their male counterparts and the official functionaries become positive. Their positive attitude towards women empowerment is most likely to make them encourage, support and help the elected women representatives.

It can be concluded that the officials and elected male members of the Panchayats, despite their reservations, over the years, have begun to develop a positive attitude towards the empowerment of women.

It may be safely generalized, based on the above discussion that the 73rd Constitutional Amendment Act 1992 only gave adequate representation to the women who earlier had only a token representation through a system of co-option but it has not yet led to their real empowerment in most of the cases. Only those women representatives have been genuinely empowered who were well educated, considerably articulate, physiologically strong and we're not only having un-stinted

support from their families but also having linkages with powerful political leaders. Of course, the women with past experience in social work and politics, too, have been empowered. However, a sizable proportion of the women representatives in the institutions of grassroots democracy have been able to get status but not power. Moreover, there is a widespread proxy representation of women by their husbands.

It will also be worthwhile to re-produce the following recommendations of the National Seminar on Women Empowerment organized by the Haryana Institute of Rural Development, Nilokheri on March 2-3, 2010 — (Singh, 2013)

1. The Act is essential for the empowerment of women. Providing them reservations will not be a complete solution.
2. Panchayati Raj Institution can be strengthened by making women leaders so that they can contribute towards the political process.
3. It is imperative that candidates contesting for elections need to be properly trained.
4. Women should be made aware of all political processes by the initiatives of civil society and government.
5. There is a need to opening up of primary as well as higher schools in rural areas so that women receive a proper education.
6. Panchayati Raj Representatives should take effective steps to empower women.
7. The Haryana Institute of Rural Development (HIRD) should organize various workshops for the elected representatives of Panchayati Raj Institutions so that they can transform the rural areas and make them develop.
8. The Panchayati Raj Institutions should be strengthened by providing them enough financial support.

Conclusion

It has been recorded that women were accorded high social status in the ancient period but their status was degraded after the Vedic period. The condition of women was deteriorating in the Mugal period and all their rights had been curtailed. There was a slight change in this direction of women in the colonial period during the 19th Century when social and religious reformer Raja Ram Mohan Roy and Swami Daya Nand Saraswati led their movement for social reforms. After independence, women got a status equal to that of men through the Right to Equality and the Right against Exploitation in the Constitution. 73rd Constitutional Amendment in 1992 guaranteed them 33 percent of reservation in local bodies which are extended up to 50 percent in some states. Though this act changed their picture in rural structure the actual power is enjoyed by their husbands. The one-third reservation for women in Lok Sabha and the State Legislative Assemblies would not be lead to the real empowerment of women. They should be educationally, socially, economically and psychologically empowered. The conservative, neo-feudal and patriarchal culture too will have to be changed. This requires a massive campaign by all the stakeholders in the mission for women empowerment- the progressive political parties, the cultural sections of Indian society, the academic, the media and above all the women movements of India. Hence women should be provided training and awareness by the Gram Panchayats so that they can actively participate in the process of decentralization politics.

References

Arora, A. (2016). *Women's Participation in Panchyati Raj: A Case Study of Haryana*, Chandigarh, New Era.

Bhargava, B.S. (2006). "E-Governance: A Study of the Model Gram Panchayat (Bellandur)" In: Karnataka (*AGRASRI Working Paper No.22*, March 2006), pp. 275-279.

Bohra, O.P. and Rakshit, R (2008). "Women Empowerment through Panchayats in India: An Empirical Analysis of Decision-Making at the Panchayat Level: A Study of Two Villages in Rajasthan" (*AGRASRI Working Paper No.51*, November 2008).

Buch, N., *Panchayats, and Women* In: Mathew, George (Ed.) (2000). Status of Panchayati Raj in the States and Union Territories of India, New Delhi, Concept.

Geeta and Mishra, S. (2017). "Panchayati Raj Institutions and Empowerment of Women: Problems and Sovereignty," *IOSR Journal of Humanities and Social Science*, Vol.22, No.9, September, pp.7-13.

Joshi, Y. (2012). Women Leadership and Panchayati Raj System, New Delhi, Pragun Publication.

Kaur, J. (2011). *Women Empowerment in India*, Singh, Ranbir and Singh, Surat (Ed.), Local Democracy and Good Governance in India, Five Decades of Panchayati Raj, New Delhi, Deep and Deep Publications.

Kaushik, A., and Shaktawat, G. (2010). "Women in Panchayati Raj Institutions: A Case Study of Chittorgarh District Council," *Journal of Developing Societies*, Vol.26, No.4, pp.473-483.

Singla, Pamela (2017). *Women Participation in Panchayati Raj: Nature and Effectiveness*, New Delhi, Rawat publication.

Singh, R. (2013)."*Empowerment of women in PRIs: Issues and Challenges,*" Institute of Social Science, Vol.XX, No.2, pp.1-7.

Singh, S. and Singh, M.(2006). *Rural Development Administration in the 21st Century: A Multi-Dimensional Study*, New Delhi, Deep and Deep publisher.

In: Exploring the Opportunity ...
Editor: Surendra Bhaskar

ISBN: 978-1-53616-424-4
© 2019 Nova Science Publishers, Inc.

Chapter 5

FINANCIAL CONNECTIVITY OF WOMEN IN RURAL INDIA: THE ROLE OF THE MANN DESHI BANK

Vinita Shrivastava[*], *PhD*
Department of Commerce,
Indira College of Commerce and Science,
Savitribai Phule Pune University, Pune, Maharashtra

ABSTRACT

India, being a male dominated society; women have a secondary status and a lower level in the family and society. Especially in rural India, women are suffering from discrimination in each step of life. In the Indian villages, young girls are considered as the burden of the family. Women physically, mentally and financially depend on the men of the family. They do not have the authority to give consent or views about their life, marriage or education. Early marriage causes a big hurdle on

[*] Corresponding Author's E-mail: vinitabhishek@gmail.com.

their education, and because of this they are not able to become self-reliant in their own lives.

Although, the 2018 Findex data reflects that 77% of Indian women have a formal bank account, this number is lesser in rural India. Rural women are not getting basic financial services when required. It is essential to make all the women economically strong and self-reliant for giving equal status to them in the Indian society. If women can have access to their own account and source of earning, they will have more bargaining power and can be a stronger participant in the family's decision-making process.

If a female member of a family will be economically powerful, they can raise their children holistically. Usually women spend all of their resources in the improvement of their family only.

Financial connectivity with any formal financial institution is an important step towards women empowerment. Women empowerment is essential for the development of an Economy.

Mann Deshi Mahila Sahakari Bank Limited is a co-operative bank only for rural women of Satara, present in a district located in Maharashtra. The model of doorstep banking of Mann Deshi Mahila Sahakari Bank Limited is becoming successful for the financial connectivity of rural women. The author is trying to highlight the financial status of rural women and the model of Mann Deshi Bank in solution for improving the condition of women.

Keywords: financial connectivity, financial inclusion, women empowerment

INTRODUCTION

Men and women are the two wheels of a vehicle. For the free flow of an economy, both the wheels should have an equal balance. If one wheel becomes weak then the movement of the vehicle suffers. The same instance follows for any economy. Gender equality in our society is mandatory for a smooth functioning of the economy. Women empowerment is very significant for the country.

India is a male dominated country. It is based on the paternal hierarchy system. The male member of the family is considered to be the head of the family and the only one responsible for getting the bread and butter for the

family. Females look after the house and the children. Because the sources of economic earnings are in the hand of the males, the decision-making power automatically goes to the males and the women end up getting a secondary status in every aspect of life. Especially in the rural India, women's consent for their marriage, education and on any other part of their life is not considered. Women in the family are completely dependent on the male members for every decision either physically, mentally, or financially. This leads to women having a low level of confidence. A Girl's marriage is the most important agenda of the family in rural India. Literacy level, economic independence and health are considered secondary for women. Women are not able to become economically self- reliant because of early marriages. Women face many problems because of this gender bias.

Economic Independence and self-reliance can provide women with equal status in the family and society. Economically independent women can raise their voice for the betterment of their children. Economic empowerment is the most important step towards women empowerment. If women are empowered socially and economically, they will be able to bring up children in a very holistic manner. So, the future generation will be more qualitative and prolific.

Financial connectivity (inclusion) can become an important tool for improving the level of women empowerment in several ways. Financial connectivity, as used by the author, is a linkage with any formal financial institution for savings, credit, loan, insurance, and other financial services. If women can have access to their own account and to the source of earning, it can surge women's bargaining power for effective use of money and other resources. Financial inclusion increases the opportunities for earning money or of controlling assets outside the household. It can be helpful in the time of emergency or medical treatment and reduce the level of helplessness amongst women. These are all key factors for economic empowerment and can also help to empower women more broadly (GIZ, 2013).

In rural area of Satara district of Maharashtra, due to very less rainfall most of the agricultural land becomes barren so production is not taking

place properly. Numerous males in the rural area are moving out of the village to search for jobs. Women are the ones taking care of the family. In this type of a scenario, for the financial inclusion of rural women in the Satara district, founder Mrs. Chetana Vijay Gala Sinha started Mann Deshi Mahila Sahakari Bank Ltd in 1997.

Mann Deshi Bank is a co-operative bank only for rural women. Mann Deshi Bank's task is to offer women an essential tool for financial independence and self-competence. The bank believes that women empowerment will expand the growth and development of India. Mann Deshi is becoming one of the favorite banks for rural women in the district of Satara. This bank is playing a dominant role in the financial inclusion of rural women, as women are facing a lot of hardships. The rural women are only able to save very small amounts of saving in the banks, but they were not allowed to do so in the formal banking system.

Mrs. Chetna Sinha has been an active a social worker. She started a bank for taking small savings of rural women. The Mann Deshi Bank started providing services at the doorstep of women. These rural women are so poor that they are not able to leave their work for a single day as they are earning and spending daily on basic needs. These women are trying their best to at least save some amount of their earnings. Mann Deshi Bank is taking efforts to educate rural women.

Chetna Sinha in her speech in the World Economic Forum in October 2017, "I set it up because one day a lady called Kantabai, who was a welder, wanted to save a little out of her earnings every day to buy a tarpaulin sheet for her roof before the monsoons. But no bank was ready to accept her meager earnings. It was just too expensive. So, I decided to set up a bank that would be for women like Kantabai and Mann Deshi Bank was the first one set up for and by rural women. We started not with credit but with giving women a safe place to save either on a daily, weekly, or monthly basis. It wasn't because we wanted to instill a sense of fiscal discipline for eventual credit repayment, but because it was simply a facility that women wanted and needed right at their doorstep" (Sinha, 2017)

Mann Deshi Bank is the first cooperative bank for rural women, to get a license from the Reserve Bank of India.

WOMEN EMPOWERMENT

Women empowerment means that all the women should have an equal opportunity to develop them and should be able to take all the decisions of their life. In the case of any kind of exploitation, women should be able to raise their voice. Women should be able to educate men and build up a sense of respect for women.

For the all-inclusive development of the country, women empowerment is important. If we consider the demographic dividend, women constitute half of the world's population. Although they are not at a minority level, we still need women empowerment because men have dominated and discriminated women for centuries. Women had to face many types of antagonism and injustice all over the world.

For the full utilization of women's skill and potential, they should become economically self-reliant, so that they can take part in the decisions of the family. Their bargaining power will increase, and they will be able to take decisions relating to their life. Their skill and caliber will become fruitful for the country.

Traditional Indian society is male-dominated and paternal society. The male member is considered as the head of the family. Every type of decision is taken by the male member of the family. Even decisions relating to a female's life are taken by her father or brother. The most important challenge faced by women is the gender prejudices of the Indian society. Due to social and cultural prejudices from the initial stage, women are being treated differently from men. Women are considered physically weak in society. They have restrictions on acquiring economic resources and opportunities. This is leading to women feeling less confident and competent. They have low financial knowledge and skill as compared to men. They are not using financial products, so they are economically weak, with low investment, low income, and low returns.

As of India, from centuries, the Indian customs and traditions used to worship women as a goddess, respected women as a mother, wife, sister, daughters, and other female relatives. Women were getting equal power to men in ancient India. There are references to women Sages, like *Maitrayi* in the Vedic period, who was a highly respected philosopher. Every religion of India treats women with admiration and pride. In medieval India, due to the cultural invasion of outsiders, the women's status got affected in the Indian Society. Women were kept under the guardianship of a male member of the family. At the time of medieval India, all types of malpractices started, like parda-pratha, sati-pratha, child-marriage, Nagarvadhu, Devadashi, etc. Because of these malpractices, women's authority to education, to work and authority to take decisions were taken away. In the time of Muslim rulers, the situation got worse, especially for the rural woman of India as they were reduced to a secondary status in the society, depending on the mercy of males of the family.

The leaders of the freedom struggle started efforts for equalizing rights of women. They stopped malpractices like sati-pratha, child marriage, and parda-pratha. They gave motivation for widow remarriage and women education. In the Indian society, the basic reason for prejudices is the men's superior complex and paternal system of the society. Although, so many legal and constitutional rights are made for women, women rights are not being implemented deliberately. In a society, people are not ready to accept women with an equal status because of a deep-rooted mindset made up of prejudices. For a change, social reforms and sensitive programs need to start.

Legally, The Indian Constitution has provided all the rights to equally men and women and time to time the government is making amendments towards gender equality. Gender equality is one of the most important fundamental rights under the Indian constitution. Article 14 provides the right to equality, Article15 (1) controls discrimination based on gender. Article 15(3) authorizes the state to make positive steps in service of women. Article 16 gives equal opportunities for all inhabitants for employment. Article 39 instructs that the state should provide men and women equally the right to means of living and equal salary for identical

work. Article 42 stipulates the state for ensuring humane conditions of work and maternity relief. Article 51 (A) imposes a fundamental duty on every citizen to abandon practices derogatory to the dignity of women. Implementation of the amendment 73rd and 74th in the constitution, Indian women get 33.33 percentage of reservation in local bodies of the government, panchayats, municipal corporations etc. (Women and Men in India 2011).

Besides gender equality, the Government made specific protective laws for women in India. For giving equal remuneration, a law was passed in 1976, for dowry control an act was passed in 1961, for Traffic Prevention in 1956, For Medical Termination of Pregnancy in 1971, for maternity benefit rule passed in 1961, for Sati prevention in 1987 and protecting child marriage rule passed in 2006. Government made an act for protecting women from sexual harassment in 2013.

The government of India has made a national policy for women empowerment in 2001. The ministry of women and child development is responsible for all the issue of women's welfare, development, and empowerment. It is making schemes and policy for women empowerment. These schemes are including the concern of women's need for shelter, security, safety, legal aid, justice, information, maternal health, food, nutrition etc., as well as their need for economic up gradation through skill development, education, and access to credit and marketing.

Financial Inclusion

Financial inclusion of women is very important because when women have control on household finances, they spend more money on children, education, healthcare, and other important domestic items. The financial strength of women will speed up the growth and development of rural India, thereby creating a better life for future generations (Mani, 2015). If women will have access to economic resources that will trigger betterment of children, women can become self-made entrepreneurs and can increase the level of income for the family and the economy. Financial connectivity

makes women productive and the potential of human resource can be fully utilized. This leads to an increase in the national income. For women empowerment financial independence is very much essential.

MANN DESHI BANK

MDMSB (Mann Deshi Mahila Sahakari Bank) was the first institution to set up a rural bank in India in 1997. Many banks are working on doorstep banking with BC model, but Mann Deshi Bank's doorstep banking includes a system of tiny (weekly or daily) savings and payment services for the women. With the options of tiny savings and repayments, it has become very popular among rural women.

The head office of Mann Deshi Bank is in Mhaswad, a village in the district of Satara. Now this bank is functioning in seven districts of Maharashtra, namely Satara, Sangali, Sholapur, Ratnagiri, Raigad, Pune, and Kolhapur. Mann Deshi foundation has also expanded to one district each in Gujarat and Karnataka. MDMSB (Mann Deshi Mahila Sahakari Bank) is working in a systematic manner and the model of the MDMSB can be easily implemented as a part of the financial inclusion program.

Mann Deshi Mahila Bank consists of three different organizations- Mann Deshi Bank, Mann Deshi foundation which was earlier named as Mann Vikas Samajik Sanstha, and Mann Deshi Mahila Bachat Gat Federation. Mann Deshi foundation provides non-financial services to clients, like girl's education, health services, vocational skill training etc. Mann Deshi Mahila Bachat Gat Federation (Self-Help Group Federation) is a nonprofit association which organizes self-help groups.

The mission of this bank is to provide a distinctive and novel combination of financial and non-financial services to poor women in the backward and drought-prone areas in Maharashtra. The basic objective of the Bank is to make rural women financially sovereign and self-sufficient. Mann Deshi Bank is providing services to the poor women at their doorsteps as they cannot go to the bank from their workplace. Rural women are uneducated too. Mann Deshi Bank is helping uneducated

women by giving them financial literacy and the Field Service Assistant keeps all the records of women account holders. Indeed, it is becoming popular among rural women. In the rural area, weekly market occurs where women are getting all the services.

DOORSTEP BANKING

The unique feature of MDMSB is doorstep Banking. All the formal financial institutions do not accept a small amount of savings. Rural women of Satara wanted to save their daily earnings somewhere safe. But the rules of formal financial institutions do not allow this. So, Mrs. Chetna Sinha has given the idea of Mann Deshi Mahila Bank, for small savings for women.

It was observed by the founder of MDMSB that when she started a bank, especially for rural women, they were not ready to come daily for saving a nominal amount of 5-10 rupees. They were not able to bear a loss of 1 day's work. Their economic condition was critical. They were able to cover their necessities only after earning daily. The normal commercial banks were not accepting 5-10 rupees as a saving. So, for solving this problem, Mrs. Chetana Sinha had come up with the idea of doorstep banking. Mann Deshi Bank's Field officers daily visit the market and collect small savings from customers. They are using a specific electronic device to do this. This machine keeps records of every customer. Pigmy system is also very popular in this area.

Uneducated women are unable to manage their bank account. The formal procedures of loans, deposits, calculation of deposits and interests, and other banking transactions are very difficult to process for illiterate and rural women. They are unable to maintain their bank accounts properly and unable to understand different plans of savings. Doorstep banking is really becoming a boon for rural women. Field officers of the bank consult these women properly and maintain their record of bank accounts and small savings. Maximum rural women of Satara are vegetable and fruit vendors. Women are buying fruits and vegetables and selling them daily in the

market. Whatever income they earn daily, are saved in a pigmy. Field service assistants of MDMSB visit the marketplace and collect their small savings.

Every branch of MDMSB has one loan officer and 6-7 field service assistants (FSA). These FSAs search for potential customers in the weekly market. They contact needy customers and counsel them. They motivate women to make self -help groups of 3-4 women. The FSAs suggests women to take loans for self-employment. FSA can fill the form with KYC norms directly in the field. Loan officer checks the eligibility and KYC norms. On the market day, FSA provides loans to vendors. Even for recovery and collection of EMIs, these FSAs visit the market daily. They counsel women and give them training for self-employment. Normally installments are paid weekly. It is easy to collect installments directly from the markets. There are fixed weekdays for markets in different areas. FSAs are playing a major role in the implementation of Doorstep Banking. Normally they belong to a local area and perform their duty efficiently. As FSAs are getting commissions per clients, a greater number of clients give them more commission. So, FSAs are ready to work hard for getting more income.

The author visited on the day of the weekly market in surrounding areas of Lonand, Satara and Mhaswad and talked to sellers & buyers, housewives and other working women to get the extent of MDMSB. The Researcher had also visited six branches of this bank and organized interview of rural women of this area on the basis of structured questionnaire.

Doorstep Banking Model of Mann Deshi Bank

The doorstep banking procedure can be explained with help of a model made by the author given below. This procedure is unique and feasible for the bank as well as the customers.

Financial Connectivity of Women in Rural India

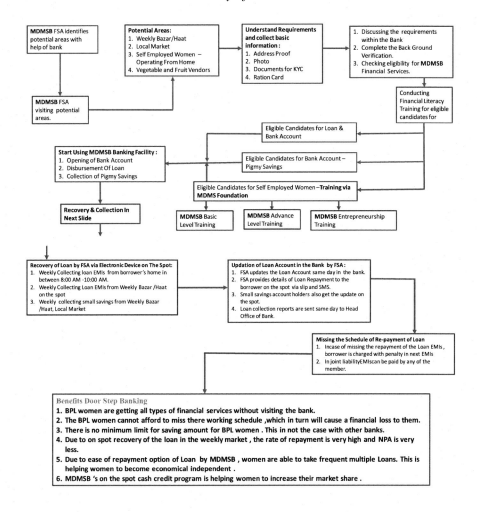

The weekly market occurs in the rural areas regularly. Small vendors need immediate cash as per requirement to buy products. But they are not able to visit the banks on the same day. Normally, the vendors borrow cash from local money lenders or buy goods on credit. In both cases interest rates are very high. Many times, while taking goods on credit vendors must compromise on the quality of the product. MDMSB started Weekly Market Doorstep Cash Credit (DCC) for the arrangement of working capital of business for the small vendors. This scheme does not require any collateral and this scheme leads to more business opportunities for vendors and

thereby their turnover goes up. The same facility can be applied everywhere in the country with the help of a business correspondent.

MDMSB and Deutsche Gesellschaft for Internationale Zusammenarbeit (GIZ) GmbH, jointly conducted a study to make a product which serves micro-entrepreneurs in Satara district in rural Maharashtra. MDMSB observed that in 2013, the regional weekly market was lively with a lot of commercial activities. Vendors were still not using formal financial services. MDMSB conducted a survey with a short questionnaire at 4 places (namely, Dahiwadi, Pilliv, Mhaswad, and Gondawale) in 2013. It was observed that every place had one big market of 500 vendors. There were three types of vendors existing in the weekly market, being the retailers who have a permanent shop, visiting traders and farmers who sell their produce.

According to the survey, 77% of total vendors were selling fruits and vegetables in weekly market (report on cash credit product, 2013). This study was trying to get a model of the cash credit product through an individual business correspondent. The survey reflected that, although with a high interest rate of 1.4%, vendors normally purchased goods on credit from wholesalers. Buyers did not have bargaining power because of credit, and they got poor quality of products as compared to cash buyers. Retail vendors were dealing with different types of products and customers. The study suggested that for these types of vendors, joint liability groups would not be suitable. Field Service Assistants (FSA) search for potential loan applicants in the market and make inquiries regarding them. When getting to know about the regular vendor, the FSA approaches them and provide them with loans. Once, a vendor from the market gets a loan and repays it, automatically the other vendors will start doing the same. The FSA gathers clients in groups of three (as guarantors) and explains about the facility.

Eligibility Criteria for the Cash Credit Facility

Only females between the ages of 21 to 59 have been eligible in the market for a cash credit product in the last three months. They should also pursue their business activities throughout the year. There is another requirement, of two guarantors, from the same business. In a joint liability group, every member should be able to pay the interest of other members. The cash credit limit ranges from INR 10,000 to INR 20,000 and loan tenure is for three years (Mann Deshi report on cash credit product, 2015).

- *Loan approval-* The FSA gathers a group of three people (as guarantors), collects their details and explains details about the product. I the eligibility criteria are met then the application of loan is filed. The branch official visits for verification. After verification, the file is sent to BLC (Branch Loan Committee) for approval. After approval, an applicant is called for the loan agreement. Loan disbursement takes place in a market area where all the three guarantors operate (Mann Deshi report on cash credit product, 2015).
- *Transactions-* Clients can make dealings with their assigned FSAs or visit a branch of the bank in working hours. Details of transactions are recorded in the client's passbook, as well as authentication is done by using fingerprint at an offline point of sale (POS). Repayments and fresh borrowings take place mostly in weekly market areas. Once the core banking system is enabled, the Bank allows any FSA to go to any market. Clients can deal with multiple markets and can-do multiple transactions.
- *Distribution-* Mann Deshi Bank's weekly product facility is also provided by the business correspondents (FSAs). Previously, FSAs were salaried people working on cash credit product. After cash credit product, FSAs were completely redirected on the field of this product. They work on commissions now. FSAs get 20% interest on revenue as their commission. More clients they catch,

more loans they disburse, more commission they get. This way MDMSB has increased the number of loan applicants.

Each FSA is associated with three or four markets and is supposed to deal with 150 to 250 clients. Each branch has four to five FSAs working under the supervision of one loan officer. The Loan Officer works under one head office staff.

Table 1. Cost assumptions of the cash credit facility

Cost estimations	
Average loan amount per client	10,000
Limits of clients under one FSA	150-250
Number of FSA under one loan officer	5
Revenues	--
Annual rate of interest	24%
Monthly rate of interest	2%
Bank's share from income	80%
Costs	
Commission of FSA	20%
Salary of loan officer per month	8000
Monthly salary of head office staff	10,000
Cost of GPRS enabled POS machine	12,000
Cost of CBS enabled POS machine	25,000
Cost of Funds	5%

Source: Mann Deshi Bank's Cash Credit Product for Micro-Entrepreneurs-A Case Study published by GIZ NABARD Rural Financial Institutions Program.

Advantages of Cash Credit Product

As per the study, maximum customers earned an increase in profits ranging from 30% to 100% on cash credit product. With the cash in hand, customers were able to buy more goods at a lower price with higher quality. Customers were getting cash whenever they required. Cash credit

product made customers buy a high-quality product, and their bargaining power also increased. It was observed, by the withdrawal and repayment patterns, that clients were ready to more loans. They repaid their first two loans quickly and expected to get more amounts of loans in the third term. So many customers are not using cash credit product itself, but simply are using it for the loan. Clients are paying installments on time. This cash credit product is ideal for women. At the time of losses in business, payment can suffer.

Recovery by FSA

Every morning, before going to workplace, FSA visits borrower's place and collects installments from them. Normally installments are collected weekly. Every specific area has fixed weekdays. After giving loans and collecting installments, FSAs come in the branch of the bank and deposit the recovery amount. In some branches, FSAs takes recovery four days a week. Two days in a week, they devote for verification of forms for loans. Norms laid down by KYC are followed. Loan Officer checks eligibility criteria. They use Electronic Machine for collecting installments. An electronic machine is connected to the computer in the branch of the bank; all transactions are updated on the computer by branch manager than he sends a complete report to the head office daily in the evening.

Collection of Small Savings as a Daily Recurring Scheme

The bank is taking small savings from the customers. FSA daily visits the market, whatever extra saving customers can give after earning; they give it to the Field officer. People can save any amount of money (up to 2000 rupees daily) in pigmy. Agents get the commission on every customer. If a woman withdraws money before six months, then she gets amount after charging a penalty of 3%. So, the Field officer encourages the customers daily to save more and more. Thus, Women save their extra

earnings. This is an easy way of providing bank services at the doorstep of customers. It is really becoming very helpful for rural women. Although women hardly fulfill their basic requirements, they are forcibly saving a small amount of money. The author contacted large number of women who are becoming habitual of small savings regardless of whatever economic conditions they face.

Loan Repayment Responsibility on the Group

MDMSB gives loan to a group of 5-6 women. The bank suggests the women to make a group of 5 or 6. Then the bank provides them loan together. Responsibility of repayment of the loan is on the whole group not on the individual. If, for any reason, a woman fails to pay the installment, the other women in the group can pay on behalf of her. In this way, the bank gets installments on time. Due to this, Bank's NPA is very miniscule, around 2% only.

Taking Installment Directly in the Market

FSA Collects Installments directly in the weekly market as women get income from selling their commodities. This method of collection is very convenient for women as well as for the bank. Women pay installments immediately after earning money from selling. Whatever income women are earning, they are prioritizing the payment of installments first. So, the number of loan defaulters is very less. The author found that many women took loans 2-3 times, after paying their previous loan. Women are also taking loans to help their husband's business as well.

Financial Services

Mann Deshi Bank is providing many kinds of Financial Services which are as follows:

- *Individual Loans-* Individual women can take loans up to 15,000 without collateral with the signature of two women guarantors. Now, as per RBI's instructions, Mann Deshi customers can take 40 to 50 thousand rupees worth of loan without collateral. If the woman wants a loan which amounts to more than 50 thousand, then they are supposed to keep some collateral- A house, farm, or livestock. Women can submit gold as collateral as well.
- *Property-Collateral Loans-* Normally, Property ownership belongs to the men of the family. So, it is believed that women cannot provide collateral for taking any kind of loan. MDMSB encourages women to have their own property. The Bank is giving 1% rebate on the interest of loan, if the woman owns a property. This step motivates husbands to take Mann Deshi credit program for building enterprises including startup businesses and training. Women thus started to own property. Around 20,000 women have taken loan with collateral. MDMSB provides different types of loans as per the requirement of women.

 Today, more than 100,000 women keep their deposits with the Bank and their accounts have become their assets. Crucially, if women get a loan from the Bank, their husbands should make them co-owners of all the family's property. More than 36,000 women have taken group loan; this motivates husbands to register properties in women's name.
- *Savings-*The Bank needs all its borrowers to open a long-term savings account and save regularly, either daily, weekly, or monthly. One of the Mann Deshi customers launched one saving product, in the month of June; every household must spend 3000-4000 rupees on admission and school material. Most of the families cannot bear this expenditure. She suggested saving a product that will mature in June, so women can save throughout the year.
- *Insurance-* Mann Deshi Bank provides life insurance product for women. Women aged between 18 and 60 (Mann Deshi 2013-14) can get insurance ranging from 5,000 Rupees to 50,000 Rupees.

- *Pension Scheme-* Mann Deshi Bank is the first Financial Institution in Maharashtra which is following the Pension Scheme. MDMSB, along with UTI mutual funds, provides a pension program to give financial security to its clients. Women between ages 18 and 55 years (Mann Deshi 2013-14) can save weekly, monthly, quarterly, or annually. At the age of 59, they will start getting a pension; depending on their accumulated saving and compound interest.
- *Financial literacy-*MDMSB runs three types of financial literacy programs. These programs are free of cost. Basic literacy program is for a first timer borrower. It is for one day, having a duration of two to three hours. This course provides information about savings and loans, repayment mode. Most of the study material is picture based, as maximum customers are uneducated. Advanced program is for taking loan more than once. This program takes two to three days, duration being two-three hours daily. There is a special literacy program for self-entrepreneurial for women. Business financial literacy gives marketing tips, budgeting of business, financial negotiation, debt management etc. MDMSB provides complete information about the loan, rate of interest, repayment mode, in case of non-payment of installments etc.
- *Training for self-employment-*Every branch of the bank is having Mann Deshi Foundation, which is giving training for many skills. A diverse range of courses are provided by the Mann Deshi Foundation. Some of which are: Basic computer skills, tailoring, Mehndi, screen printing, photo Lamination, making cotton and Leather bags, fast food preparation, Repair household equipment, Making blankets etc. Women learn these skills and can start to employ themselves. MDMSB agents suggest forming a group of 5-6 women for starting self-businesses. Bank provides loans for the group.

Mann Deshi Udyogini - Business School on Wheels for Rural Women

Mann Deshi Bank started Mann Deshi Udyogini business school on wheels with The Deshpande Foundation and Ashoka Foundation in Karnataka, in 2007. This school is providing a bus full of equipment and customized training space. The business school on wheels is reaching out to the remotest places which are lacking behind. Sometimes they are using common public places like temples and school classroom for training. Especially these mobile buses are moving in Hubli and Dharwad districts in Karnataka. The leader of the SHG (self-help groups) from the respective villages will be responsible for the training sessions. Courses for training are full-screen printing, tailoring, fast food production, basic computer literacy, goat rearing, milk production, financial literacy, and marketing literacy.

Mann Deshi Kiosk Center

First kiosk center started in 2006 in Pusegaon. Objectives of the kiosk are to provide information about market price, training opportunities, and additional resources. Training experts impart training via the internet which is quite helpful. The kiosk is established to give information about market price, training opportunities, additional resources, technical help via the internet etc. These centers are running successfully.

Mann Deshi Marketing Center

Mann Deshi Bank had started marketing centers as a new initiative with the help of federations. The center brings products and services to the remote area. These centers sell enterprise products, personal consumption items, oversized umbrellas that are protecting women from sun rays that previously was not available to the customers. By using a mobile hat or umbrella women, can protect their health in the summer, and save themselves from potential sunstrokes. The center trains women to market their products to classy clients. The center connects local grower to the national wholesale market that is beyond their capacity.

Mann Deshi Mahotsav

Every year in the month of March, Mann Deshi Bank celebrates Mahotsav, in which customers sell their products in the market. In this way, MDMSB is giving recognition to the creativity of customers and spread the message of schemes of Mann Deshi bank. This year Mann Deshi Bank organized Mann Deshi Mumbai Mahotsav to showcase the locally produced crafts, dance, and food of Mann Taluka. 20,000 thousand Mumbaikars attended this Mahotsav and 25 lakh rupees was generated through this celebration. Every evening there was a show portraying local dance and songs. Women wrestlers also showcased their skill and talent in the Mahotsav.

Business School

MDMSB started the Business school program with the collaboration of HSBC for rural women in 2006. More than 46,000 women have benefited from the Business School graduation programs. Graduated women entrepreneurs from the Business School will get services from the Chamber of Commerce to conduct their business.

MDMSB Chamber of Commerce for Rural Women in India (MCCRW)

MDMSB Foundation, partnered with "President Clinton Foundations" initiative- Clinton Global Initiative (CGI) based in New York, USA, created the first MDMSB Chamber of Commerce for Women in rural India (MCCRW). Mann Deshi Bank provides financial, marketing and legal advice through Chamber of Commerce. The Chamber of Commerce organizes various events also. In Jan 2017 COC organized Mumbai Mann Deshi Mahotsav.

- *Include Women's Names on Stamp Papers*- The MDMSB Bank convinced the Revenue Department of Maharashtra to include women's names on stamp papers. Stamp papers are duties levied

on transfers of immovable property. By including the names of women, the papers recognize a woman's right to household property. By this step, women become partners in household property along with their husbands. Now, the husband cannot sell the property without the consent of his wife. In the case of a divorce, husband cannot claim the whole property to his name. This policy helped a very large number of women. Around 7000 women have been able to get their share in the household property. MDMSB has also created an incentive for women to become homeowners by giving them a 1% rebate on interest paid on loans. So many husbands transfer the property their wife's name for getting an extra rebate on loan. Mann Deshi Bank helped one village to win as "the cleanest village in state government-sponsored competition" by convincing all the males to share legal rights with their wives.

- *Mann Deshi Tarang Vahini-* Mann Deshi Foundation started a radio program, called "Mann Deshi Tarang Vahini" for local people. The radio program is broadcasting programs related to agriculture — including the interview of the farmers, success stories of farmers, information about soil-testing, seeds, cultivation, child education, local information, bank's financial services, Women and Self-help Groups, personality development, local and cultural & entertainment, various Government and non-government programs etc. Tarang Vahini has 1, 50,000 listeners in 110 villages. This service Broadcasts a wide range of programs that bring to light the achievements of women and local communities, government schemes, services from farmers in nearby villages. It also broadcasts songs, and traditions of the Mann Region. The channel is accessible to anyone within a 50-kilometre radius.

At the time of demonetization, MDMSB helped women for getting a small amount of cash. MDMSB took all State Bank of India's small notes and created individual pouches worth Rs 500. MDMSB converted mobile

business school to a mobile bank and traveled to different weekly markets and exchanged the old 500 notes. Nearly 5000 people got advantage from this facility.

CONCLUSION

The Researcher has contacted rural women of Mhaswad village. She has used a structured questionnaire and has filled the data personally. The data collected is as follows. These ladies are self-reliant. They are doing small businesses on their own. This makes them confident. They are now making the financial decisions on their own without any influence from the male family members. This also makes them participate in the social activities of the town.

It connotes that there is a high level of financial inclusion which has a positive effect on their social status. Out of these women account holders, so many women are becoming members of the Mann Deshi bank, especially the customers of Mann Deshi have taken loans 2-3 times. This means that they have now gained creditworthiness, which is one of the signs of their empowerment. They have availed the loan facility repeatedly. The respondents are financially literate. Mann Deshi Bank is providing financial literacy.

The reflection of the above concludes that MDMSB is working thoroughly towards financial connectivity. The numbers of customers at Mann Deshi are increasing very fast. This bank is working effectively for women empowerment. Mann Deshi Bank model can be used as a role model for financial connectivity of women in rural India.

REFERENCES

Bank, M. D. (2005-17). *Annual Report.* Satara: Mann Deshi Bank.

Bank, M. D. (2015). *Mann Deshi Bank*. Retrieved from www.mann deshibank.com: http://www.manndeshibank.com.

Mann Deshi Bank's Cash credit product for micro-Entrepreneurs-A case study. (n.d.). Retrieved from www.researchgate.net: http://www.researchgate.net/publication

Monga, P. (2015). Cruelty against Women & Remedies avialable for it. *International Journal of Law ISSN 2455-2194*, Page No 64-67.

Mani, M. (2015). *Financial Inclusion in India-Policies and Programmes*. New Delhi: New century Publication.

Office, C. S. (2011). *Women and men In India*. New Delhi: Government of India.

RBI. (2016-17). *Annual Report*. Retrieved from www.rbi.org.in.

Shrivastava, v. (2015). Financial Inclusion of rural women In India -A case Study of Mann Deshi Bank. *Dawn*.

Sinha, M. C. (2017). *It's Too Costly for Bankers to Ignore India's Rural Women*. Retrieved from www.weforum.org/agenda: http://www.weforum.org

Zusammenarbeit, D. G. (2013). *Promoting Women's Financial Inclusion: A Toolkit*. (GIZ).

In: Exploring the Opportunity ...
Editor: Surendra Bhaskar

ISBN: 978-1-53616-424-4
© 2019 Nova Science Publishers, Inc.

Chapter 6

THE ROLE OF EDUCATION IN GENDER SENSITIVITY

Ravi Jhajharia[1,] and B. L. Bhamoo[2,†], MD*
[1]Department of Nursing, Devi Institute of Nursing, Jaipur, India
[2]Sunrise International School, Nechhwa, Sikar, India

ABSTRACT

The status of women all over the world is a cause of serious concern. Women, irrespective of societies, experience varying forms of discrimination and oppression. In almost all societies men are superior to women. From the early times, women were deprived of their legitimate social, economic and political status mainly due to the patriarchal form of societies. A woman goes through physical and psychological violence throughout her life i.e., from cradle to grave which is the most painful and disgusting for a civilised society of the 21st century. Gender Sensitivity is defined as the ability to recognize gender issues and to understand women's different perceptions and interests arising out of the differences

[*] Corresponding Author's E-mail: ravi.jhajhria7@gmail.com.
[†] Corresponding Author's E-mail: blbhamoo@gmail.com.

in biological attributes, social position and gender-based roles. Gender sensitivity often coincides with gender awareness. Gender sensitization theories have emphasised on modification of the behaviour of people towards gender which impacts the mindset of masses regarding equality of gender in the societies. Issues related to gender can be seen and experienced in Indian society at all levels. To overcome the gender related problems, we have to start from scratch and aim at minimising the gender issues. The minds of younger generations need to be filled with positivity, as they are the ambassadors of change. A school can play a crucial role in shaping the young minds.

Keywords: gender sensitivity, ambassadors, school

INTRODUCTION

The diversity of women's needs and interests vary from basic survival to aspirations of power and prestige. These diversities hinder the collective participation of women in public life. In spite of the few signs of progress made towards the emancipation of women, power remains a male prerogative, with men retaining social, economic, political and religious control. Women are restricted to give birth and do household chores. In spite of substantial progress made in the field of education over a while, the public space is limited to men and a few elite women. Declaration on Fourth World Conference on Women held at Beijing in 1995 has not only highlighted the problems of the women but participants like Mrs Hillary Clinton had called 'a spade a bloody shovel' and used it to dig up dirt. The conference had issued a warning that the days of treating women as second or third class citizens or mere commodities are over. The Beijing declaration points out that "crimes against women are crimes against humanity and the failure of governments to prosecute those responsible for such crimes implies complicity". It is a very sad commentary on Indian government that rapes and female infanticide are very frequent. Most crimes go unreported and the culprits are rarely punished suitably.

Status of women all over the world is a cause of serious concern. Women, irrespective of societies, experience varying forms of

discrimination and oppression. Women are singled out in one form of oppression or the other. In almost all societies men are considered superior to women. Since the ancient times, women are deprived of their legitimate social, economic and political status. They are looked upon as men's accessory and are always confined to the domestic ambit. In India, women still suffer under the patriarchal form of society. Firstly, female foeticide is prevalent and a girl is not allowed to be born. Her very conception is only a biological consequence and not at all, a result of the parents wish or a planned design. As soon as the medical report (Ultra-sound examination) announces that a girl child is venturing to find her way into the world, the mother a little hesitatingly but the father doggedly and designedly decides for abortion of the foetus. This exercise continues until a male child occupies the mother's womb. It is reported that more than 90% of the abortions performed in India are of female foetus. Every year about 40-50 million girls and women are missing from the Indian population because they are not allowed to be born, and even if born, they face discrimination, challenges and fear.

GENDER SENSITIVITY

Gender biased situations have given birth to the idea of Gender Sensitivity which can be defined as the ability to recognize gender issues and to understand women's different perceptions and interests arising out of the difference in biological attributes, social position and gender based roles.

Gender sensitivity is often used as synonymous to gender awareness. But, in reality, gender sensitivity is the beginning of gender awareness, which is more analytical and critical. It is related to gender disparities. Gender sensitivity is the act of being aware of the ways people think about gender so that individuals rely less on assumptions about traditional and outdated views on the roles of men and women. In general, it is expressed through people's language choice. The concept of gender sensitivity has been developed as a way to reduce barriers to personal and economic

development created by sexism. Gender sensitivity ensures individual respect irrespective of sex.

By gender sensitivity, we mean to increase the awareness amongst masses to maintain reasonable levels of gender differentiation between the male and female and that should be the only biological difference. It is true to some extent that what a man can do, a woman is equally capable to do it, but it is not expedient that women should insist on doing everything the man does even at the cost of nature's assigned roles of motherhood. Gender sensitization refers to the modification of people's behaviour by raising awareness of the concerns related to gender inequality. It is directly proportional to women empowerment. Gender sensitization theories have emphasised modification of behaviour of people towards gender, which affects the mindset of masses regarding equality of gender in the societies. The gender sensitivity theories put a question mark on inherited attitude and beliefs of a person and compel him to challenge himself regarding realities related to gender which he believes as absolutely right. Gender sensitization makes men and women familiarise with each other's needs, limitation, strength and very existence. Their mutual understanding and respect of each other yield result at every level whether it is an organisation or home. Gender is determined by socially constructed roles, behaviours, activities and attributes that a given society considers appropriate for men and women. Their roles are decided by society according to society's needs and assigned accordingly. Gender sensitivity helps to generate respect for the individual irrespective of sex.

GENDER AND SEX

It is a well known fact that sex defines the biological and physiological characteristics that further distinguish between men and women. Therefore, sex refers to the natural distinguishing variable based on the biological characteristic of being a woman or a man. It refers to physical attributes about a person's body contours, features, genitals, hormones, genes, chromosomes and reproductive organs. Gender refers to the roles,

behaviours, activities, and attributes that are designed by the society, which considers most appropriate for men and women. These roles, attitudes and values decide the behaviours of different genders and further the relationship between them. These attributes are nurtured and monitored by social institutions such as families, governments, communities, schools, churches and media.

Certain roles and responsibilities are assigned or ascribed distinctly and strictly to a person based on his/her gender which is a biological distinction.

In all societies, men and women play different roles, have different needs, and face different constraints. Gender roles differ from the biological roles of men and women, although they may overlap in nearly all societies. Historically, gender roles are socially constructed. Genders encompass socially and culturally based roles of members of societies and study of these roles gives an insight about the unequal distribution of powers amongst different sexes. These power relations are further carried forward by the institutions of society i.e., family, schools/colleges, religious institutions etc. Therefore, gender relations and social institutions have a direct correlation and it will not be an exaggeration if one calls gender relations as the very product of social institutions as these relations do not flourish in a vacuum. Gender roles demarcate responsibilities between men and women, social and economic activities, access to resources, and decision-making authorities. Biological roles are static, but gender roles can and do change with social, economic, and technological change. Social factors underlie and support gender-based disparities. According to Monica S. Fong, Wendy Wakeman & Anjana Bhushan (1996) these factors include:

- Institutional arrangements that create and reinforce gender-based constraints or, conversely, foster an environment in which gender disparities can be reduced.
- The formal legal system that reinforces customs and practises giving women inferior legal status in many countries.

- Socio-cultural attitudes and ethnic and class/caste-based obligations that determine men's and women's roles, responsibilities, and decision-making functions.
- Religious beliefs and practices that limit women's mobility, social contact, access to resources, and the types of activities they can pursue.

PRESENT SITUATION IN INDIA

Studies suggest that in all the patriarchal societies, gender bias starts from womb and girls are subjected to discrimination in almost every area ranging from nutrition to childcare and education to work and India is no exception in this regard. In a patriarchal system, men occupy positions of dominance and control over women. Men as husbands and fathers, rule with unchallenged authority over the lives of women and children in their family. A woman goes through physical and psychological violence throughout her life which is the most painful and disgusting for a civilised society of the 21 century. Patriarchy is the creation of a social system and not an instinct of human beings. Nature made us complementary, human beings made us unequal. Patriarchy is a social system which considers male superior, gives them more rights and more access to resources and decision making process.Sexual differentiation pervades all activities, experiences and opportunities. The public sphere is usually regarded as the domain of men and perceived to have a primary status in society because they perform what are considered as major functions. Men's exposure in the public sector makes them the dominant gender in all spheres of life. They can participate fully in economic, political and cultural endeavours. Women, however, are relegated to the private arena of their home. They take on reproductive functions which are regarded as secondary pursuits. There is no ritual in the family which makes sure the equal partnership of men and women. Subordination of women to men shows that decision making is the prerogative of men. In such a social setup women are not allowed to speak out in public, they are expected to not speak anything

against men and accept the decisions of men without any opposition or a fight. Generally boys are grown up and socialized to look down upon girls and to view them as secondary. Boys carry the attitude that girls are not capable to make a decision and not strong enough to take up challenges. Distribution of work within the household is allocated keeping in consideration the sex of the member which is completely biased against girls. Whereas boys are encouraged to go to school and also to the playgrounds and on excursions and tours, their sisters are made to stay at home and assist in domestic chores. The sex ratio in our country is extremely poor. Against 1000 men there are 940 women born in India. During the last 50 years, the ratios have been 1000:934 to 1000:940. In the beautiful Chandigarh city which has been rightly called the town of the educated and civilized citizens, the rate is as low as 1000:818. Punjab and Haryana, the most prosperous state of India, are biased against girls (Gupta,2011). In many traditional families, girls are not welcomed.Parents, relatives and neighbours alike feel sad. The mother and the God both are cursed; even the routine lamp is not lit in the house on the birth of a baby girl. The child is fed only now and then deliberately ignored, her death is prayed for. Out of 12 million girls born every year 1.5 million dies (or killed) before their first birthday, another 85,000 before their fifth year and only nine million remain alive at the age of 15 (Govt. of India 2007-2012).

The UNICEF report on India has observed that anti-female bias is reflected in the frequently higher number of deaths among girl babies and children, greater malnutrition among girl children and lower female enrolment and higher drop-out rates among girls in schools. Differential treatment to girl children is also reflected in the fewer consultations with the health care system in the event of illness. The life expectancy at birth of a girl child has gone down drastically. In India, there has been a continuous rise in the total incidence of crimes committed against women over the years. It has also to be noted that only 9-10% crimes against women and girl children are reported (Government of India 2007-2012).

SCHOOL AND GENDER SENSITIVITY

Issues related to gender can be seen and experienced in Indian society at all levels. It is high time to give a mindful thought and transform India's patriarchal system which is deeply rooted in our society. To overcome the problem related to gender, we have to start from scratch and minimise gender issues. The mindset of younger generations needs to be changed with positivity, as they are the ambassadors of change in every society, with their ideas, thoughts and practices suited to the changing times.In this, a school can play a very important role, which has a responsibility of shaping the young minds. To reshape this, priority intervention by well-educated teachers who have thorough knowledge in this regard, is much-needed. The transforming effects on young minds provided by these intellectuals will have a vital role as the upbringing of the children shapes the future citizens. The ethics and morals learnt by children with the help of their teachers in developmental years are always with them. It is clear from researches that children from different socio-economic background come to school with their inherited gender role identity and carry it throughout their education. The environment provided in schools and homes is the primary source of interpretation about gender and its relations. The influence of teachers and educators, as change agents, in the cognitive development of a child during the early stages of life cannot be underestimated. Top leadership, educational institutions as well as social institutions must contribute to attain gender equality. The thought process of the tender minds and the character of children towards gender sensitivity can be unconsciously moulded by the direct influence of gender awareness provided in their academic content.

It is high time to think about educating our children without any discrimination. In the age of globalization, equality in education is an important issue, as gender equality guidelines improve education for both men and women.

The goal of providing better education to women should not be misunderstood with neglecting or suppressing men. By placing men and women on an equal level, the relatively increased valuing of women will

also benefit men by informing them of the strengths, capabilities and contributions of members of the opposite sex. It may also decrease the pressure that many boys feel to conform to the traditional roles, behaviours and ways of thinking. Eventually, the stereotypes may be counteracted and eliminated, so education will be more gender-balanced.

Our present educational system needs to be reformed under the guidelines of gender experts. Gender training and counselling should be mandatory for teachers. Education authorities and schools must be provided with a budget to promote and sustain the gender-sensitive agenda. Gender sensitivity progress must be constantly reviewed by gender experts. For this, Creation of gender-responsive schools where the specific needs of boys and girls are taken into account is necessary. Gender sensitivity often gets expressed through people's language choice.

So, gender-neutral and more inclusive language should be used in school. Parents should be made aware not to discriminate, at any stage or for any reason whatsoever and treat both sons and daughters as equals. The partnership between school and parents should be strengthened and they both should be aware of children's right. It is important that women should be respected by men in the family and girl child should be brought up in such an environment where all mothers, aunts and grandmothers should stop telling the young girls that they need to learn how to cook and serve the husband and in-laws exclusively and nothing else. This will make a change and every girl will feel like she has more choices and access to freedom in societal norms.

Gender sensitivity tries to ensure that people rely less on assumptions about traditional and outdated views on the roles of men and women. The stereotypical image of women will no longer exist and gender sensitivity will create a positive mindset of men towards women. Women will no longer be considered weak and men will be benefited with a more suitable partner in social and economic fronts. The historical contribution of women will be recognised. Women empowerment in the form of increased calibre, roles and responsibility will make society more proud. Gender sensitized individuals will become change agents as far as the improvement of the status of women in society is concerned. The whole

process can encourage and promote the ultimate integration of women empowerment and can lead to a better impact on society.

ROLE OF TEACHER AS CHANGE AGENTS

Gender issues are prevailing in all facets of social life. Therefore, it is our basic social responsibility to reduce gender inequalities. We need to focus on educating the young minds of society regarding gender issues as they will be responsible for further changes in society in the times to come, with their unconventional concept and reasoning. To do this, we need trained teachers who are aware of the adverse effects of gender insensitivity and have a sound knowledge regarding gender issues. Teachers are regarded as the reforms owing to the key role they have in the processes of education as the sole executors of the teaching and learning processes. It is a well-known fact that educationists and intellectuals considerably affect gender socialization and contribution of students in gender sensitivity. Thus, having a great impact on the quality of life, status and power-sharing. The role of teachers in the cognitive and intellectual development of adolescents is very important and their ideas and teachings can influence the entire thought patterns of young students. A teacher therefore, must constantly be aware of the fragile state of minds of young boys and girls which needs to be handled constructively. A teacher may use suitable strategies and methods to ensure that students have enough and equal opportunities to create and obtain their social goals. Apart from other necessary issues, teachers are required to be serious about the gender issue. If we expect that our teachers to play their constructive role than they should be given pre hand knowledge over such an issue by incorporating nitty-gritty of social aspects as part of their training. Teachers can serve as role models for the students along with gender-sensitive curricula and textbooks.

CONCLUSION

Gender sensitivity is not about pitting women against men. On the contrary, gender-sensitive education benefits both the sexes, it helps them determine which assumptions in matters of gender are valid and which are stereotyped generalizations. Gender awareness requires not only intellectual effort but also sensitivity and open-mindedness. It opens up the widest possible range of life options for both women and men. As universally recognized at the World Conference on Women in Beijing in 1995, countries will neither prosper nor thrive unless they are equally supportive of women and men in their quest for a fulfilling life. The present need of the hour is to provide gender training in schools. It is a practical tool for analysing gender differentiation and provides adequate knowledge regarding major factors that influence and are responsible for maintaining or changing the structure of gender differentiation.

There is a need for a multi-pronged strategy which focuses itself on the effectiveness of state action, promotion of social awareness and generating self-confidence and self-esteem among women. The education system should be gender-friendly and gender-sensitive. It is necessary that the school curriculum should be free of gender inequality and pictures in textbooks should be gender-sensitive to promote gender equality. Gender-neutral language should be promoted in the schools at all levels. School should advise parents to strengthen and address gender issues at homes. Gender-sensitive counselling must be organised from time to time by gender experts for teachers and students. Promoting female education and raising their economic status are crucial factors towards achieving the equal status of women. Empowerment through 33% job reservations and 33% seats in the Parliament and State Legislature assemblies would go a long way in making a woman realize her potentialities fully and live a life of esteem and peace. It is very much necessary to strengthen women's issues for the betterment of future society.

REFERENCES

Fong, Monica S., Wendy, W. and Bhushan, A. (1996). *Gender Issues in Water and Sanitation*, World Bank.

Government of India (2007-2012). *Child Protection in the Eleventh Five Year Plan*, Ministry of Women and Child Development, New Delhi.

Government of India (2007-2012). *Eleventh Five Year Plan*, Social Sector Vol. II, Planning Commission, New Delhi Oxford University Press.

Gupta, S.P. (2011). *Census of India* – 2011, Chandigarh, ESS Pee Publications.

In: Exploring the Opportunity ... ISBN: 978-1-53616-424-4
Editor: Surendra Bhaskar © 2019 Nova Science Publishers, Inc.

Chapter 7

WOMEN ENTREPRENEURS IN INDIA: OPPORTUNITIES AND CHALLENGES

Hemlata Mahawar[*], *PhD*
Maharana Pratap Government College, Chittorgarh, Rajasthan, India

ABSTRACT

Entrepreneurs play an important role in the economic development of a nation. But the field of entrepreneurship has been largely dominated by men, in India since ancient time. During ancient times, almost all traders were men because women were not given the opportunities of trading basically owing to social and cultural restrictions. Now, in the 21stcentury, because the entire social hierarchy is under transformation where women's role is gradually increasing worldwide, India is no exception. It has been realized that without women's participation in the field of entrepreneurial, societies will not be able to achieve the Millennium Development Goals set by the UNO. Women are accepting the challenges equal to their counterparts and their skills, knowledge, talents, abilities and financial independence of women are increasing day

[*] Corresponding Author's E-mail: hemlatamahawar78@gmail.com.

by day. Increasing participation by women in various fields and their proven result has attracted more and more women to become entrepreneurs. Global changes have created economic opportunities for women who want to own, operate and grow businesses. Increasing the role of women in the economy is part of the solution to the financial and economic crises and critical for economic resilience and growth. Rural women are key targets for achieving the transformational economic, environmental and social changes. But there are many problems faced by women at various stages beginning from their initial commencement of an enterprise, in running their enterprise. Women Entrepreneurship in India faces many challenges and requires a radical change in attitudes and mindsets of society. Much knowledge is not found about the economic relevance of women in entrepreneurship programs and the effect of these programs on society and the economy. Therefore, programs should be designed to address changes in attitude and mindset of the people. In this paper, an attempt has been made to explore the opportunities and challenges related to entrepreneurship that the woman of our country faces in the global scenario. It will also suggest the way of eliminating barriers of the women entrepreneurship in Indian context.

Keywords: entrepreneurship, women empowerment, globalization

INTRODUCTION

The word "entrepreneur" has come from the French language 'entreprendre' in the 19th century which means to undertake. It refers to those people who "undertake" the risk of new enterprises. An enterprise is shaped by an entrepreneur and the process of shape is called "entrepreneurship". Mainly Entrepreneurship could be methods of legal proceedings doing something toward the goal of enterprise and entrepreneur a person continuously in search of one thing new and exploits such concepts into paying favorable conditions by accepting the possibility and insecurity with the enterprise. Entrepreneurs are often known as starters of change and a process maker for creating new wealth. Health and survival in World Economic Forum Report 2018 revealed the broad principle of entrepreneurs varies from nation to nation across different time periods as well as on the level of economic development set of ideas and

impression. It has also played an important part in the economic progress of a nation.

According to a British Council study on the social enterprise landscape in 2017; Entrepreneurship had been a male dominated phenomenon in early ages, but family earning and consumption styles have been changed in the past decade, so time has changed the circumstances and brought women as today's most encouraging entrepreneurs. The women entrepreneurs can't solely contribute opinion to the values, but can also play an important role in solving communal challenges. The situation and condition of women in any society are a mirror image of its development and advancement. Without the involvement of women, entrepreneurship societies will not be able to achieve the Millennium Development Goals and their full development targets.

In India revealed that 27% women receive secondary education, 12.2% parliamentary seats held by women, 80% need permits to visit a health center and only 14% Entrepreneurs are women in India. Now, it's imperative to comprehend what is enterprises?

A study needs to do one thing optimistic is, to the inherent excellence of entrepreneurial female, who is capable of doing something well of contributing her standards in family and social life, both with skills, knowledge, talents, abilities, desire and financial need for themselves, their children and their family are some of the reasons for the women to become entrepreneurs. Worldwide changes have created economic conditions for women who want to operate and grow their own businesses. A family earning and consumption patterns have been changing in the past decade.

The woman is no longer bound to being a homemaker, with duties restricted only to household work and taking care of her children. By entering the field of business, she can be financially independent as well as hold a unique identity of her own, not only just a life partner. Hence, women can target on career and business by earning for her home as well as getting independence of income which was previously in the hands of males. This truth is believed to be better than all the benefits of being a female interpreter. That's probably because in this way, a woman is her own boss and does not have to rely on any other person's income or

security, to manage her life. Women are their own whole and sole boss and they also do not have to depend on males of their family for every petty expense. Escalating the role of women in the economy is also the solution to the fiscal and economic crises. Women entrepreneurs are key for achieving the transformational economic, environmental and social changes.

As a sort of "sociology of women" in business seeks to know, however these socio-cultural, economic and political services represent business challenges to infantile feminine entrepreneurs.

Women entrepreneurs in India face several challenges and needs a change in psyche of society. The prejudice of women in business is that there appears to be a world view in which business roles are stereotyped and socially earmarked for men.

Society demands women to choose the jobs to fit in the categories suitable for women rather than doing something of their choice which includes innovation and challenges.

Such situation is possible, for example, if the woman entrepreneur comes from a special religion, color, or race that falls in the minority of that industry.

Table 1. Discrimination of women in entrepreneurship: A glance

	Women In India
27%	Received Secondary Education
12.2%	Parliament Participation
80%	Need Consent to Visit Health Centre
142 Rank	Out Of 144 Countries on the Healthiness and Survival Issues
14%	Entrepreneur's Participation of Women in India

Source: British Council study on the social enterprise landscape 2017.

A lot of knowledge is not available about the economic importance of women in entrepreneurship programs and the effect of these programs on civilization and economy because programs should be designed to suit changes in outlook and mindset of the society. Women entrepreneurs

represent an immeasurable untapped source of improvement job creation and economic growth in the developing world; the several hurdles in the pathway of women's entrepreneurship.

The World Economic Forum shows very little improvement in declining the economic gap between woman and man. The concealed entrepreneurial potential of women has been gradually changing with the growing understanding of the role and economic position in the society. It suggests that female has the potentials, expertise, understanding and flexibility to run a business successfully. The present paper is based on the secondary information. This paper focus on the model of women entrepreneurship in India, behavior, favorable conditions, opportunities and challenge they are facing by the establishment and make some suggestions for future identification of maturity of women entrepreneurs.

OPPORTUNITIES AND ADVANTAGES OF WOMEN ENTREPRENEURS

1. **Miscellaneous and Ground-Breaking Workforce:** Variety in gender, culture, age, and race stimulates originality and creativeness. Crown corporations across the world endeavor to collection and get pleasure from various and innovative menu. Male and female from totally different backgrounds herald varied experiences with them, which figure their approach to the company. Demanding and collaborating with one another helps them in performing productively and taking the company frontward.

2. **Potency in Soft Skills:** Technical skills and awareness are necessary for success, but malleable skills are equally important. People with high emotional intellectual quotients realize their own emotions as well as the emotions of their fellow beings and utilize the information to help, to lead, to think and grip the circumstances. Affecting intelligence in leadership means self-

awareness, understanding and the aptitude to listen. Women can employ their experiences and malleable skill quality with emotional intelligence for appropriately leading their companies. Leadership studies make public that having the high emotional aptitude might get a bonus in the company and the women, on average, have an edge over men when it comes to this.

3. **Skills to Create a Woman-Responsive Environment:** The corporate traditions of many companies can work in opposition to women, but when a woman leads her individual company, she has the capacity to create a suitable atmosphere for other women working in the company. A Creature associate enterprise, a woman can live a more genuine life and can create a commercial culture more appropriate by her own morals.

4. **Strong Point in Expressive Intellect:** Leadership studies project that is having high expressive intellect may prove to be advantageous inentrepreneurship. It is a key factor in leadership and studies have found that female on average have an edge over men in this arena.

5. **Multi-Tasking Skills:** Women are well-known for multi-tasking at the similar time and still being capable to create excellent results whereas, the men are specialists at focusing on one thing. They love to talk, mingle, and rub elbows. As a result this help in today's distracting the atmosphere goes to women. Women are extra likely to get extra work done per point in time than their male colleague.

6. **Strong Sixth Sense:** An accurate sixth sense is a great advantage for entrepreneurs associates. In today's mega-fast-paced trading environment, we need the capability to quickly identify thewell-wishers and the foes. In spite of whether you are a male or female, you need to have faith in your feelings.

7. **Teamwork Skills:** Generally, women tend to feel affection for group up and work jointly. They naturally gravitate towards creating interaction and partnerships. Women prefer to do work in groups; they have a preference to engage people in what they're

doing. Functioning with others and building lasting relations may be a strong attribute among many women and will help within the achievement of replacement dealing. Creating new partnerships among entrepreneurship creates an ocean of opportunities for his or her entrepreneur to grow up with their competitors, rather than compete against them.

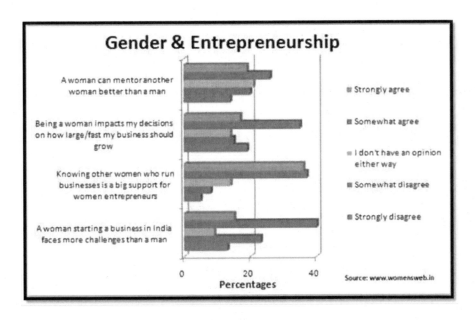

Figure 1. Women & Entrepreneurship in India 2012. Source: www.womensweb.in.

8. **Experience Higher Well-Being:** Gallup Health-ways Well-Being Index found that women entrepreneurs understanding a higher level of "purpose well-being" than male entrepreneurs and other workers. Purpose well-being implies learning or doing something which is fascinating, liking what you do, and using your potency to do what you do best. In general Entrepreneurs and particular women entrepreneurs are more likely to understand these mechanisms of purpose well-being on a daily basis. Women entrepreneurs tend to expertise physical well-being. In addition having higher levels of well-being, the Global Entrepreneurship Monitor (GEM) U.S. Report-2013 revealed that women

entrepreneurs reported higher happiness and pleasure levels. For maximum women entrepreneurs choosing to run their own businesses or entrepreneurship can show to be a highly contenting career choice for them.
9. **Personal-Branding Style:** Woman entrepreneurs are exceptionally passionate by nature and wholehearted about their choices, conversation about them and sharing their thoughts. They tap the benefits of their services to their budding clients and are attentive of how to highlight the positive features.

GROWTH OF WOMEN ENTREPRENEURS IN INDIA

In India, as a result of customs & mores, women are supposed to execute household activities & pay attention of her family, which is one of the most important reasons that women entrepreneurship in India is very short. Thanks to the awareness influenced by education, social wakefulness and the development of globalization over the last three decades now women are showing more and more concentrated in starting their own ventures.

Thus, there's a significant growth of women entrepreneurs. Increase in the price tag of living standard has encouraged the Indian women to accept economic tricks in order to shore up their families. They are persistent forward to bear risks, face challenges and attest to the world that their position in the society is not only buyers but they can also be unbeaten sellers.

In present there are thousands of superb examples where women have shown industrial skills fruitfully. Problems are that the most motivated women entrepreneurs face is more and more effort in choosing the right business plan. In favor of some budding entrepreneurs, ideas flow liberally, but never get off the position.

CATEGORIZATION OF WOMEN ENTREPRENEURS IN INDIA

- Women with enough education & specialized qualification get engaged in business.
- Middle-class women who have an education but need of training.
- Women who take up a business enterprise face financial difficulties.

CHALLENGES OF INDIAN WOMEN ENTREPRENEURS

According to upper criteria in India for women deciding on the correct business proposal has as much to do with creating a business plan and achievability study. At this point there are some reasons that why we have a common opinion that there is a dearth of women founders in the entrepreneurs circuits:

1. **Indian Civilizing Beliefs:** The family unit acting a more central role on condition that business opportunities for young women entrepreneurs. Communal boundaries in India, just like a woman's duty to look after the children and other members of the family. A Man plays a less important role only. In case of married women, she has to strike a very good balance between her business and family unit. The education level and family surroundings of husbands completely influence women's entrance into entrepreneurship.
2. **Requirement of Financial Investment:** The financial investment is regarded as "lifeblood" for every enterprise, whether it is small, medium or big. Generally, women entrepreneurs are adversely affected from a shortage of finance on two levels. First, female don't usually have assets on their names to use them as security for getting financing from outside sources. Hence, their access to the outside sources of funds is restricted. Second, the banks also think

about the women less credit-praiseworthy and deject women borrowers on the belief that they can at any time left their business. Insuch a scenario, women are bound to rely on their individual savings, if any, and loans from friends and relatives who are very insufficient and negligible. As a result, women entrepreneurs do not succeed because of the shortage of finance.

3. **Requirement of Education:** Women are commonly denied of higher education, especially in rural areas. Women don't seem to be allowed to counterpoint their information in mechanical and analysis areas to introduce new merchandise. Around three-fifths (60%) of females are still illiterate In India and Illiteracy is the main cause of socio-economic problems. Due to the lack of education and that too good education, women are not aware of technology and market knowledge. Also lack of education causes low action, motivation among women therefore; lack of education creates one or other troubles for women in the setting up and running of the enterprise.

4. **Men are Considered More Respected than Women in Entrepreneurship:** Men entrepreneurs are looked at as the fortune - hunter of business and women could work inthe same position or even higher than men but get paid less. Men are seen as stronger, knowledgeable and very decisive counterparts than women, hence, being of more value.

5. **Basic Nature of Women:** Women generally have kindness, sympathy and emotions of others. Entrepreneurship involves risk factors and women entrepreneurs get disappointed very easily when there is loss in business.

6. **Lack of Market Awareness:** Entering a business without adequate market awareness usually leads to failure of the business. Women are not generally aware of the subsidies and incentives available for them. Lack of market awareness may prevent them from making use of the special schemes. Most of the business women are in a dilemma when there is a shortage of raw material and essential consultancy. Additionally, in this, there are the high

prices of raw material and on the other hand, getting raw material at the least amount of concession. The collapse of the many women co-operatives in 1971 engaged in basket-making is a case in point how the dearth of raw material sounds the death-knell of a business run by women. With this the Women entrepreneurs do not have executive build-upto insert in a lot of money for canvassing and commercial advertisement.

Hence, they require facing a bother some competition for promoting their manufactured goods with organized sector and their male connects. Such a challenge at last leads to the liquidation of women enterprises. Due to limited mobility, financial crisis, less education and other are coming from cultural issues they find difficult to match strength with men. Moving in and around the market place, is again a backbreaking job for middle class Indian women entrepreneurs in the Indian social system.

REMEDIAL ACTIONS

The Indian society is shifting from a conservative perspective to progressive perspective. So, women are having a lot of opportunities not solely in entrepreneurial work, however conjointly in different domains of social life also. Government and different agencies are taking varied steps in the up-liftmen of women enterprises by creating the women entrepreneur a section of thought of the financial system. The remedial actions for women entrepreneur that can be undertaken to encourage women entrepreneurship in Indian background are as follows:

1. **Assistance Help:** Indian Government, NGOs, individual personality and other helping bodies must give assistance to business women both in economic and non economic areas.
2. **Entrepreneurship Guidance:** Women entrepreneurs must be given guidance to manage, run and grow a business profitably.

Guidance has to be given to women who are silent, afraid and hesitant to start the industrial task.
3. **Choose Machines, Skill and Technology:** Women need backing in choosing of machines, skill and technology. Cooperation must be provided to them in industrial areas so that the production unit becomes booming.
4. **Funding Matter:** Funding matter is one of the most important troubles faced by budding women entrepreneurs. Both family unit and government organizations should be broad minded in providing financial help to them.
5. **Selling Issues:** As a result of limited mobility and Indian cultural values women are not capable of marketing their goods. Booking must be provided to help them to sell their goods successfully in the profitable field.
6. **Family Unit Encouragement:** Familyunit should assist women entrepreneurs and give confidence them to construct and run industry successfully.

SUGGESTIONS

Today's women entrepreneurs are blossoming and shining forth with the brilliance of a thousand suns. India has its share of legendary business women starting from Vandana Luthra of VLCC, Kiran Mazumdar Shaw of Biocon, Ekta Kapoor of Balaji Telefilms etc. Women have hereditary and operated businesses for decades, but they were not for all time recognized or given recognition for their labors and pains. Women entrepreneurs still face greater complications to realize right of entry to money making acknowledgement and bidding on government contracts than do their male colleagues, and this is the reason to pockets of protection for women business owners remain strong in some industries and geographical regions.

Many women entrepreneurs have a median age of forty – sixty years. As a result they had preceding careers in different areas. Their most

important goal isn't financial return, however rather personal pleasure and the public association. The challenges and opportunities provided to the women in this period of globalization are increasing fast fantastic rather job seekers. They are escalating as interior decorators, designers, publishers, exporters, garment manufacturers and silently exploring new avenues of profitable participation.

Independence and sovereignty brought the assurance of equal chance in all areas to the Indian entrepreneur women. Laws gives guarantee for their equal rights of participation in social, political and economic process, equal opportunities and rights in education and employment were enacted. Several women lead communal enterprises effort on empowering women and solving women particular issues also. Sorry to say that, the government sponsored development program have benefited only an undersized section of women. The bulky majority of them are still untouched by change and advancement programmed. Women in entrepreneurship can add large to the richness of the society in a most well-organizedand efficient manner. But they require categorizing fully the role and importance of entrepreneurship. So the forthcoming days are unquestionably meaningful, favorable, constructive and determination to the Indian women entrepreneurship. And last but not least, the door for the larger sections of women in democracy of India lies in crossing the brink, overcoming barriers and discovering their own capability and uniqueness.

REFERENCES

Annual Report (2015). *Ministry of Medium, Small and Minor Enterprises*, Government of India. Retrieved from www.msme.gov.in.

Cohoon, J. McGrath, Wadhwa, Vivek and Mitchell L. (2010). *The Anatomy of an Entrepreneur- Are Successful Women Entrepreneurs Different From Men?* Kauffman, The Foundation of Entrepreneurship.

Devi, A. A.and Subramanian, K. (2014)."Women Entrepreneurship in Tirunelveli: A Study" *Southern Economist*,52 (22) pp.5-7.

Gallup, I. (2019). *How Does the Gallup-Share care Well-Being Index Work?* Retrieved from https://www.gallup.com/175196/gallup-healthways-index-methodology.aspx.

Initiative, A. (2019). *The Brilliant Women Entrepreneurs of India: The Roles They Play and the Challenges They Face.* Retrieved from https://www.thebetterindia.com/ 111511/ entrepreneurship- landscape- for-women-in-india/.

Mathew, V. (2010). *Women entrepreneurship in Middle East: Understanding barriers and use of ICT for entrepreneurship development*, Springer Science Business Media.

Ramasethu, A.(2015). A study on problems and challenges faced by urban working women in India. *Global Journal for Research Analysis,* 4(10), 10-11.

Saini, S. (2016). Rajni Bala (Ed.) Globalization and Women Professionals is an Industrial City. *Journal Philosophy and Social Sciences,* 42(2), Delhi: Journal And Book.

Salini, C.R. and Lawrance A. (2014) "Women entrepreneurs in SSI's in Kerala: An Assessment." *Southern Economist*, 52(23 and 24), pp. 13-14.

In: Exploring the Opportunity ...
Editor: Surendra Bhaskar

ISBN: 978-1-53616-424-4
© 2019 Nova Science Publishers, Inc.

Chapter 8

ELECTRONIC GOVERNANCE AND WOMEN IN INDIA: CHALLENGES AND PROSPECTS

Yogendra Singh[*], *PhD*
Amity Institute of Public Policy, Amity University, Noida, India

ABSTRACT

The concept of e-governance stands on the principle of the usability of information and technology for the functioning of the governance process. Further, this became relevant during the neo-liberal regimes with the emergence of Liberalization and Privatization. With the introduction of technology, many transformations have taken place at the national as well as international level. It has been an important platform through which the ideology of good- governance can be promoted. The status of women is improving with the passing time. Information technology has been a powerful source to transform their life. Women have been beneficiaries of the system in the governance process. The chapter highlights the fact that E-governance is one of the important mediums to empower women socially, economically as well as politically. However, the paper discusses the impediments faced by women in making use of

[*] Corresponding Author's E-mail: ysingh3@amity.edu.

these technologies. The study concludes with the fact that although it has some negative implications, prospects of the technology cannot be ignored.

Keywords: electronic-governance, women, technology, good-governance, citizen-friendly

INTRODUCTION

Governments all over the world are in pursuit of Information and Communication Technologies (ICT)-based solutions for facilitating good governance. The phenomenon is popularly known as e-governance or e-government as per varying country contexts. In the recent past, different terms have been coined to re-brand it alongside with the emerging technological developments. Some of the buzzwords in this context are joined-up government, whole-of-government, one-stop government, connected government, and open government; the latest being the digital government. Irrespective of the various terminologies used to describe the phenomenon, practitioners across the world continue to experience serious challenges in their efforts to connect government and citizens for achieving good governance. This is particularly so in the context of developing countries. There have been more failures than successes in terms of achievement of intended outcomes. The peculiarity with the ICT-based systems is that they get matured over a period of time with increased participation of end-users. Further, due to various operational constraints, the government departments generally prefer 'As-computerization of traditionally established systems. For example, even though the National e-Governance Plan (NeGP) and the Second Administrative Reforms Commission (ARC) of India emphasized on reengineering of government processes and rationalization of organizational structures, there are only a limited number of e-governance projects where such an approach could be said to have been methodically adopted. This prevents innovative usage of ICT to improve system performance. It is also experienced that

expectations of end-users of such systems keep rising as they gradually become accustomed to technology usage and become more and more aware about the power of ICT as being practiced in the corporate sector. As a result, the objectives and scope conceptualized before the launching of such projects generally fall short of matching the growing levels of user expectations.

It was in the period of 1970s that Indian government established the Department of Electronics and further in 1977 they established the National Informatics Centre (NIC). Since the period of 1980, the majority of the offices have computer and internet facilities. In 1990 NICNET extended their state headquarters to the various states in India. Finally, in 2000 the Indian Government launched Ministry of Information technology and year 2006 National e-Governance Plan was formulated (Kumar, 2014, pp. 975). Hence historical evolution highlights the fact that India was certain to develop its technology for bringing transformation in the administrative system

The U.S. e-government Act, 2002 delineates e-government as the use of government and internet application to enhance the access to and delivery of government information and services to the public, other agencies, and government entities or bring about improvements in government operations that may include effectiveness, efficiency, service quality, or transformation;". Whereas the European Union defines it as "e-Government is the use of Information and Communication Technologies in public administrations combined with organizational change and new skills in order to improve public services and democratic processes" (Grönlund,2004, pp. 713-729). Hence the definitions suggested that through the use of information technology the quality of public services can be improved.

Satyanarayana defines "e-governance as the modernization of processes and functions of the government by inculcating ICT tools whereas citizens are treated as passive recipients of digital information and services. Nevertheless, e-governance is a decisional process which involves ICT in governance with the objective of wider participation and a deeper involvement of citizens, institution, NGOs and other companies"

(Satyanarayana, 2004). He gave emphasis on the modern conception of the use of information technology for the easy processing of the internet system.

While Kalam believes that e-governance is a decisional process that involves ICT in governance with the objective of wider participation and a deeper involvement of citizens, institution, NGOs and other companies (Kalam, 2008, pp.3-7). It has been also visualized that it is one form to bring transparency, accountability in the governance process.

Hence the above definitions highlighted the importance of information technology in bringing transparency, good governance, and accountability in the functioning of the governance process. E-governance is the use of technology to reform government organization and making it more responsive to the people. It is consumer-friendly and business-friendly technique. Further through the medium of e-governance people can use government information online without being physically harassed by the government organization.

CHANGING CONCEPT OF E-GOVERNANCE IN INDIA

As been stated earlier that e-governance is one of the important medium to provide people information and delivering services to the masses. Although many national, as well as regional projects, are operated in various states of India. Some of the important experiments are Gyandoot of Madhya Pradesh, *Friends* of Kerala government and *Bhoomi* of the Karnataka government, Twin tower Andhra Pradesh that has provided benefit to the masses at large. It is not just administrative innovation but it is a new evolution that provides larger benefits to promote the common good in Indian society. Hence Electronic governance is a system that empowers people by giving them the power to be independent in exercising their freedom. However, after having such a wide domain the problems still exist in its implementation such as many of the projects lacks efficient skills to be operated, people have also complained about the lack of resources to manage such projects. Further, there is a wide gap

between expectation and implementation. Majority of the people residing in the rural areas are unaware of such programs and they lack basic skills and technicalities to use it in a proper way. There have been many transformations, such as with the use of technology work processes, that have become easier than before. People are not harassed by the government officials, and it is a time-saving mechanism. Overall, it has benefited technocrats but also has a negative implication on the non-technocrats present in the society.

Objectives of the Study

The major objectives of the study are:

(a) To understand the impact of technology on women
(b) To highlight the role of computers in empowering women
(c) The challenges faced by women in the usage of Information Technology
(d) To highlight the E-governance schemes for women

IMPACT AND NEED OF TECHNOLOGY FOR WOMEN

In India, from the ancient times only women were deprived of their rightful position in society and they were not permitted to participate in social, economic and cultural practices of the country. Even after independence steps were taken by the government to empower women but still deficiencies could not be removed due to the deep entrenched existing patriarchal norms and values. According to Census 2011 out of 637 female populations only 66% are educated and empower to take independent decisions. It is a fact that it is the men who are much inclined towards the use of Information and Communication Technology. It is to be noted that technology can be used by anyone but women are also the equivalent beneficiary to the prospects of technology. The overall debates of

technocrat's haves and haves not have been debated at a deeper level. Further it is presumed that the technology can be used by the upper classes but the scope of areas needs to be widened. ICT is trying to reach the women who were ignored by the media houses. The biggest challenge is the promoting and encouraging women towards the benefits and use of the technology in their daily lives. Further the emergence of liberalization and globalization has opened new avenues and opportunities for women. The advantages differ in relation to their use and implication. The urban women have been using technology in market, fashion, child care, education and employment as well as for career advancement. The. The women are using technologies in urban spaces for transforming their work processes and promoting the conception of good–governance. India claims to fulfill its promise of integrating digital inclusion in the lives of common masses and to bridge the gap between rural as well as urban areas. Women faced many societal problems when it comes to the use of technology such as they are not allowed to go out or visit any government offices. They are relegated to the domestic household works by fulfilling their responsibilities towards their family and managing family relations and norms. Many of the people believe that the basic problems of poverty, violence against women should be taken care of before bringing such schemes for empowering women. One of the basic aim of electronic governance is to encourage gender equality by encouraging women to participate equally in the process. Hence fund allocations, connectivity, access via networking are imperative for bringing out the full capacity for such initiatives. Though, there are large training camps organized by the government to encourage women to use such technology for their welfare.

WOMEN EMPOWERMENT THROUGH ICT

A nation can only develop when their women are empowered and independent. Technology has a deep connection with the development of women. Technology is not limited to the national sphere but it also has international accreditation. As women are an important part of society so

they should be integrated into the governance process. The condition of women residing in rural areas is miserable as they are dependent on agriculture and conduct all the household and tradition practices leading to their negation of the use of technology by them for their empowerment. However, it has been observed that women who belong to the young generation are active to use such technology in an efficient manner. While on the other hand, urban women are more inclined to use it at all levels. "The Platform for Action of the Fourth World Conference on Women 2000 states that women should be empowered by enhancing their skills, knowledge, and access to information technology. This will strengthen their ability to combat negative portrayals of women internationally and to challenge instances of abuse of power of an increasingly important industry" (Arrawati, 2012, pp.99-104). Many women who are the users of technology highlighted the fact that it has increased their confidence and they are able to expand their horizon by outreaching to the outside world. Majority of women have not been trained they have used online sources to be informed and empowered. Further, there were some case studies that also highlighted that the rural women have seen it as an opportunity to establish a connection with other people. Further urban women have taken advantage of technology to enhance their career prospects. So overall it can be said that e-governance is an important medium through which women are empowered politically, socially as well as economically.

GOVERNMENT SCHEMES

Some of the programs run across by the government to promote empowerment are as follows:
1. **E-Kranti:** It is one of the mission mode models and it proved electronic services to the masses to utilize the opportunity to be knowledge-empowered. It was approved by the Union Cabinet to transform the functioning of administrative systems. This was based on the provision of a back end system that ensures service delivery to citizens. The best part of the scheme is the availability

of software in different languages. The basic objective of the programs was to enhance the portfolio of Citizen-Centric Services as there was a lack of integrated services. Hence it emphasized on delivering government services to the people online to maintain a level of efficiency, accountability, and transparency.

2. **E-Jaalakam:** This is an important initiative of e-governance program which has 106 delivery centers. This was started as an important benchmark for empowering women. It is an important approach for building the capabilities of women and includes women in the process of e-governance. Through this program, women can easily access computers and derive all authentic information online. There were some reasons responsible for the emergence of this program one of being the condition of women residing in Kerala. They lack behind in the process of autonomous decision making. Hence the basic objective of this scheme is to open windows for them to access any kind of information and address any kind of deficiency in the administrative systems. Some of the services available are the accessibility to utility centers, information on E-district, Birth, and death certificates, registration of the complaints, agriculture and police facilities.

3. **E-Sampark:** This is an important step to make the connection of people with the government directly. Through this platform, public service messages can be shared on public forums. Further, it also maintains a database of contacts of the nodal officers, representatives, and citizens. The mission of the project was to send messages through SMS and emails. The women benefitted from the project as they were able to use smartphones to access information related to the government's departments.

4. **E-Seva Centres:** It is a known fact that women residing in rural areas are semi-literate or illiterate and they are struggling to earn their livelihood. One of the critical issues is the non-accessibility of government services to the people in rural outskirts. This project is intended to uplift and empower women. This project is run by Andhra Pradesh and has established self-help centers to

economically empower the women segments. Hence with this project women are able to access and reach to government authorities without any technical or physical harassment.

CHALLENGES FACED BY WOMEN IN USING E-GOVERNANCE PROJECTS

The aim of the e-governance projects is to bridge a gap between citizens and the government by the use of internet technologies. A country like India which is a developing economy suffers from many socio-economic problems such as illiteracy, poverty, communication gap, corruption. In order to reform the administrative system, the government has taken an important step and initiated National E-governance projects in India to make government services online and connecting to the people directly. Women have been sufferers of the patriarchal structure that subordinated and negated them into the larger framework. There are many impediments for women to use the services of electronic governance some of them are: (Mittal, 2013)

(a) **Illiteracy:** Illiteracy has been an important problem that had to have a negative impact on India's economy. The basic issue is the there is no proper uniformity between the patterns of education in all the Indian states. For instance, Maharashtra is the leading states in the overall status of primary education as well as literacy. This can be due to the existence of intra-state as well as inter-disparities in the political system. To take figures of 2001 it can be recognized "that in 20% of districts, the average literacy rate is below 50%. When female literacy is considered, more than 40% of districts are found to show less than 50% literacy rate. Around 65% of illiterates are found concentrated in 7 states, and 67 districts across 9 major states have million-plus illiterates which together account for around 30% of the illiterates in 2001. In rural

areas women are illiterate so they are mode dependence on non – productive works" (Jailtly 2012, pp.10-15). Hence it can be analyzed that due to this uneven uniformity it impacts the functioning of educational systems. Women due to their low position suffer on the account of their status in the rural outskirts.

(b) **Lack of Awareness:** In India, women are not able to contribute to the growth of the nation due to their low status in society. This fact is reflected in the existing disparities in the rural sectors. The major concern is their lack of awareness programs for their socio-economic development. Majority of the women residing in rural areas are not aware of the existing electronic governance program and their beneficial impact on their lives. One of another reason is their poor situation and as well as lack of education that made them handicap in deriving any government information.

(c) **Patriarchal Setup:** Patriarchy can be defined as a system in which man is dominant in political, social as well as the economic sphere. Further, it is a set of ideas that are based on the gender difference in society that makes a man more dominant and women subordinate to them. Women have limited choices in terms of their accessibility to technological development. It is only the male who plays a dominant role in controlling technology. Even in one of the study, it was observed that women were not permitted to keep mobile phones with them so that they are not accessible to the outside world. For instance in one of the Bollywood movie namely Secret Superstar that depicts the story of a young girl who is eager to fulfill her dreams to become a superstar and posting her music videos online to reach to a larger audience despite the patriarchal structure that exists in a conservative family. Hence women have been sufferers of this problem that negates them to be accessible to the use of technology and building their self-confidence.

(d) **Language Barrier:** India is a multi-cultural society where there is the existence of people belonging to different culture and religion. Hence fore they prefer their regional language over the English language. It has been observed that all websites and application of

electronic governance are in English medium that becomes difficult for citizen understanding of the aspects.

(e) **Lack of Infrastructure:** Lack of necessary infrastructure such as electricity, availability of internet sources are also lacking due to the financial crunches by the Central government. Hence these constraints impact the functioning of electronic governance projects.

(f) **The Attitude of Government Departments:** There is a lack of efficiency in government departments and non-responsive behavior of the higher authorities that negates them to their contribution towards technological development. Such initiatives by the government are very slow leading to the slow processing of the projects.

Finding of the Study

It has been observed from the study that women have been deprived of their rightful place in society for centuries. The concept of gender inequality has been a critical concern. Due to the existing patriarchal structure women have been negated from the functioning of government processes. The real challenge is to empower women so that they can participate in political processes. Further, it has been observed that as compared to the rural areas the women residing in urban areas have to use the internet to access the government services. One of the reasons for this difference is due to the increase in the number of professional women working in different companies and organizations. While in rural areas they are dependent on agriculture and are expected to perform all domestic works that make their condition worse. Due to the overburden of work the rural women are not able to receive education leading to their backwardness in terms of their level enhancement. In addition, there have been many technical problems in the functioning of electronic governance projects. However many steps have been taken by the government to reform the condition of women by initiating many projects but the success

ratio is not appropriate due to many technical issues and their implication on the women community

SUGGESTIONS

Due to the existing loopholes in the e-governance projects, it is the responsibility of the government to take effective steps to monitor the programs timely. Further, women should be given opportunities to develop their skills and capabilities by the use of technology and integrating them into the decision making process. One of the important steps can be the active role of NGOs, media, as well as other organizations that can help in raising all serious concerns and making women aware of the latest development in technological innovations. In addition, women should be encouraged to be a participant in the government schemes and contribute toward the growth of the economic system as well as their economic, political and social empowerment. Despite this, the government should organize awareness camps and workshops to monitor and access the functioning of the projects. Deficiencies should be rectified at the administrative level so that people can use the services in a transparent manner.

CONCLUSION

E-governance is one of the medium for bringing transparency and accountability in the functioning of the governance process. Many projects have been implemented at the national as well as state level. The core mission of government in bringing such reformation was to enhance the quality of life of the masses. Further it is one of the platforms that leads to growth and development of the nation economy. As far as women empowerment is concerned, rural women have to face lots of constraints such as illiteracy, poverty, dependence on agriculture, social-cultural

constraints and patriarchy that negates them to utilize technology for their empowerment. However, with the transformation, many young rural women are using these technologies for reaching out to the government organization. Urban women have been active in registering complaints, incurring information related to their birth certificate, schemes, programs and are using technology to enhance their career opportunities. However no technology is free from various deficiencies that needed to be dealt by the government seriously. For the success of mission it is imperative that all infrastructure and strategy should be focused on accepting this technological revolution in administrative system. The emphasis should be given to monitoring and assessment of the programs so that loopholes can be tackled in a significant manner. Twenty first century is a kind of technological world where technology is an integrated part of any society. Without the development and empowerment of women, no nation can be progressive and prosper to build a strong foundation of social justice.

REFERENCES

Arrawatia, M. & Meel, P. (2012). "Information and Communication Technologies and Woman Empowerment in India", *International Journal of Advanced Research in Computer Engineering & Technology (IJARCET),* Volume *1*, Issue 8, October, pp.99-104.

Bedi, K., Singh, P.J. & Srivastava, S. (2001). *Government net: new governance opportunities for India*, New Delhi, Sage.

Grönlund, A. (2004). Introducing e-GOV: History, Definitions and Issues, Communications *of the Association for Information Systems*, pp. 713-729.

Heeks, R. (2001). "Understanding e-Governance for Development" Working government Papers series, *IDPM Working papers*.

Jaitly, D., Prasad, A. & Singh, D.B. (2012). "Illiteracy and India", International *Journal of Transformations in Business Management*, Vol.*1*, No.5, Jan-March.

Kalam, A. P. (2008). A Vision of Citizen-centric e Governance for India, R. Bagga, and G. Piyush, *Compendium of e-Governance Initiatives in India*, Hyderabad: SIGeGov Publications.

Keohane, R.O. & Nye, J.S. (2000). (Eds) *Governance in a Globalization World*, Washington DC, Brookings Institution Press.

Kumar, P., Kumar, D. & Kumar, N. (2014). "E-Governance in India: Definitions, Challenges and Solutions", *International Journal of Computer Applications*, Volume *101*, No.16, September.

Mittal, P. & Kaur, A. (2013). "E-Governance - A challenge for India", *International Journal of Advanced Research in Computer Engineering & Technology (IJARCET)*, Volume 2, Issue 3, March 2013).

Pathak, R. (2003). *Empowerment and Social Governance,* New Delhi, Isha Publication.

Prabhu (2012). *E-governance: Concepts and Case Studies*, New Delhi, Prentice.

Satyanarayana, J. (2004). *E-Government: The Science of the Possible,* New Delhi, Prentice Hall.

In: Exploring the Opportunity …
Editor: Surendra Bhaskar

ISBN: 978-1-53616-424-4
© 2019 Nova Science Publishers, Inc.

Chapter 9

B. R. AMBEDKAR'S VISION OF WOMEN'S RIGHT IN INDIA WITH REFERENCE TO THE HINDU CODE BILL

Avneet Kaur[*], *PhD and Dilpreet Singh*

Department of Public Policy, Amity University, Noida,
Uttar Pradesh, India

ABSTRACT

This paper intends to study Ambedkar's contribution to women's rights with special reference to the Hindu Code Bill. Ambedkar has been regarded as the 'Champion of Women's Rights'. This paper intends to study the role of Ambedkar in providing recognition to the rights of women through the interpretation of various social rights movements. He instilled a sense of confidence among Indian women. Further, the paper intends to highlight the fact that Ambedkar's struggle was not just limited to empower Dalits to frame the Indian Constitution but also supported in empowering and uplifting women's position in the country. This paper is divided into five sections. The first section deals with the introduction

[*] Corresponding Author's E-mail: akaur5@amity.edu.

that looks into the issues of the whole norm of human rights and their linkages to the women's movement. The second section elaborates on the status of women in the historical times ranging from pre-independence to post-independence era. Further, this section also discusses the constitutional provision related to the concern of women's rights. The third section highlights Ambedkar's views on the women's question. Fourth section deals with the major provision, debates, adoption, and weakness of the bill and its implication of bill on contemporary women. Further, it concludes with a brief analysis of the theme.

Keywords: women rights, Hindu Code Bill, empowerment and discrimination

INTRODUCTION

Ambedkar believed in the principles of equality for all humans regardless of their position in the social system. Every citizen deserves equal treatment and the objective of social justice is to eradicate all the existing inequalities for building up a sustainable society (Purohit, 2003, p. 189). If the rights of women are taken into consideration, it has been observed that historically, women have been oppressed and subordinated under the patriarchal Indian society.

From time immemorial, women have been demanding their rights and identity. The rights of women have been infringed leading to their dignified life. The concept of human rights is based on the notion that humans should have certain basic rights. In the Indian Constitution, many steps are taken to uplift and empower women. Ambedkar always believed in the equality of sexes. He emphasized the dignity and identity of the individual associated with the promotion of social and economic justice. His philosophy was based upon the concept of equality, freedom, and emancipation of the downtrodden classes. An observation was made by Justice Aharon Barak: "To maintain real democracy and to ensure a delicate balance between its elements in a formal constitution is preferable. To operate effectively, a constitution should enjoy normative supremacy, should not be as easily amendable as a normal statute, and should give

judges the power to review the constitutionality of legislation. Without a formal constitution, there is no legal limitation on legislative supremacy, and the supremacy of human rights can exist only by the grace of the majority's self-restraint. A constitution, however, imposes legal limitations on the legislature and guarantees that human rights are protected not only by the self-restraint of the majority but also by constitutional control over the majority. Hence, there is a need for a formal **constitution**" (Desai, 2000, pp.164-167).

According to his view, for the operation of real democracy, the Constitution should impose a limitation on the working of the legislature and executive that can protect the human rights of individuals. Therefore, Dr. Ambedkar integrated many constitutional provisions that can benefit disadvantaged sections. The basic objective behind such an approach is to reserve seats for them in political space so that they can be empowered (Incidents of Atrocities, 2000).

There were many practices of gender inequality that have deep roots in the patriarchal setup of Indian society. One of the most controversial among them is the notion of property rights for women in Hindu law. In 1956 Indian parliament implemented Hindu Succession Act that provided those property rights to women that can build their independent position in society. Initially, the trend was that women can only inherit property only by acceptable social values and norms. The main objective of the Act was to improve the economic condition of Indian women. Since the question of woman's inheritance rights is concerned with immovable property, especially land, the Indian patriarchal structure does not permit women to inherit the landed property. Indian customs have also limited the scope of women's property only up to the movable contents e.g., ornaments and clothing given to them at the time of marriage. These customs have allowed them to inherit from very near relation like the father and mother or some time from the mother only otherwise it denies the right of inheritance to cognate kindred (Dancan, 1970, p.193). It can be analyzed that the whole concept of women's property rights has been related to the inheritance rights of women. The infringement of women's rights is

associated with the context of human rights so it is important to understand the notion and the relevance of human rights, especially for women.

The first concrete step towards human rights was taken by the United Nations on 10th December 1948 by adopting the Universal Declaration of Human Rights (UDHR). The UDHR defines human rights as universal, inalienable and indivisible which are important for women's human rights. The universality of human rights demands that the rights of women be acknowledged. The idea that human rights are universal also challenges the contention that the human rights of women can be limited.

Today women's rights are given more importance than any other rights in society. Women rights are an integral part of the struggle for and the study of human rights. There are many bills and declarations by the United Nations where it is stated that in cases of conflict between women's rights and cultural or religious practices, the human rights of women must prevail. For example- The United Nations Declaration against Women passed in 1993 (Nair, 2011, pp.172-177). In India, the women's rights movement is not very old but the struggle for equal status to women has historical linkages. Many leaders have contributed a great deal towards this subject and have made sure their struggle gives a positive result. The next section highlights the status of Indian women in Indian society.

STATUS OF WOMEN IN INDIA

Women in Pre Independence India

Women in pre-independence times were not very empowered. Although there were women who took active part in politics and the activities in the social sphere but these women were extremely few in number. The majority of women in India were treated as subordinates. They were suppressed and oppressed in one way or the other at every point of time.

The concept of women as subordinates was deeply rooted in Indian culture. The orthodoxy against women continued since ancient times and

was strengthened with the arrival of the foreign invaders and rulers, for example, Mughals and Aryans. Women were kept in more safeguards, new policies like the purdah system, child marriage and sati came into existence because the dignity and honor of women were at stake.

They were supposed to be taking care of the kids and the household and would be confined within the four walls of the home. They were not considered capable enough to have an opinion and voice it in the family matters. The identity and thinking of a woman were not considered at all. There was discrimination against women. Not just in terms of education, healthcare, etc. women were not treated on an equal platform with their male counterparts.

Many authors were concerned about the plight of women. They took various steps and did considerable work to improve the condition of women. The Britishers, who were extremely surprised to see the subordinated condition of women in India, also contributed towards the empowerment of women in India. Although the Britishers were unable to bring about a crucial change in the overall status of women, they played an important role as catalysts of change by abolishing various social evils prevailing in the country. Some people even accused the British Colonizers of using the barbaric and pitiable condition of women in India for their supposed role of 'civilizing mission.'

The first reaction towards this pitiable state of women in India was from the Indian social reformers consisting of Raja Rammohan Roy, Ishwar Chandra Vidyasagar, Keshav Chandra Sen, Mahatma Jyotiba Phule, M. G. Ranade, and Swami Dayanand, etc. They urged reforms of the customs which they considered to be distortions or aberrations. Raja Rammohan Roy who was the founder of the Brahmo Samaj helped in the abolition of the Sati system and the legalization of widow remarriage with the help of the then Governor-General of Bengal, Lord William Bentick in the 1829s. This period was also known as 'The Renaissance of India.'

Another eminent personality who worked for improvement in women's position was Mahatma Jyotiba Phule. He not only stood for bringing improvement in women's position but also supported gender equality. Phule actively campaigned for widow remarriage and child

marriage in the 1860s. He believed that education was the only means to liberate women from her oppressive condition. Phule along with his Satyashodhak Samaj worked for women education. He even opened girl's schools to facilitate and encourage the people to send their girls to school (Bandopadhyay, 2004, pp.139). There were other leaders like Gandhi and Ambedkar who worked to establish equality in Indian society and to improve the condition of women in India.

Women's Contribution to the Independence Struggle

Women, in spite of being in a barbaric condition, did contribute a great deal to the struggle for independence. The first major contribution was by Rani Lakshmi Bai of Jhansi who fought bravely against the British in the First War of Independence 1857. After this, the women's participation was not in a considerable number. It was after the arrival of Mahatma Gandhi that women came to the forefront and participated in the National Independence Movement in huge numbers. Gandhi not only encouraged women but also the guardians of women- their husbands, fathers, and brothers. In fact, among the three mass movements initiated by Gandhi, i.e., Non-Violence Movement, Civil Disobedience Movement and The Dandi March, the most successful was 'The Dandi March' because this was the first movement where women from all walks of life came in huge numbers to participate. Some British women also participated in the nationalist struggle such as Annie Besant, Margaret Cousins, and Sister Nivedita, etc.

The Indian National Congress formally took the position on women rights in 1917 at the Calcutta session of the Congress demanding equal rights for both women and men. Women were partially enfranchised under the Government of India Act 1919. Women also formed various organizations such as The Women's India Association (1917), The National Council of Women (1925), All India Women's Conference (1927) and Rani Jhansi Regiment in the 1940's (Bandopadhyay, 2004).

The participation of women in politics legitimized women's claim to a place in the governance of India. However, the participation was only limited to upper and middle-class women out of which most of them were Hindus. Even though such women were valorized for their active role, still they were not considered as 'respectable women.' Patriarchy was the major problem in Indian society. Although some women participated in large numbers, the majority of them were still in an exploited condition.

Women in Post-Independent India

Independence came as a ray of hope for women. The Indian Constitution provided various rights to women and established equality, as is mentioned in The Preamble. Some women who were active during the freedom struggle were given important positions and held crucial offices in the Indian Government. Women scripted new roles. Although they were expecting equality at each sphere still they did not feel the need for any particular movement as they were optimistic about the policies of the government, since India emerged as a welfare state. Women took up the roles of decision-makers. Many women who actively participated in the freedom struggle, held important offices after Independence. Some of these women were Sarojini Naidu, Rajkumari Amrit Kaur (only female cabinet minister in Nehru's cabinet), etc. The Central Social Welfare Board was established to deal with the problems of women.

According to Neera Desai, "In the post-independence period, the development strategy initially benefited middle and upper-class women, who, being beneficiaries, did not assume the leadership of a strong women's movement. They appeared to have blinkers concerning women's problems. The limited changes that had taken place looked significant, if not unbelievable. Things, it appeared, had started to move. The realization that it was a false start came later" (John, 2008, p.495-501). Hence women attained a special status for her stability and empowerment.

Constitutional Provisions for Women in India

The Indian Constitution grants various provisions to women to empower them. Some of the constitutional provisions for women are as follows:

a) **Article 14-** This provision provides equal protection to women against any women based crime. This provision also paves the way for the introduction of various laws and acts to ensure protection and enforcement of legal rights of women of India.
b) **Article 15-** There should be no discrimination based on religion, caste, race, sex or place of birth or any of them within the territory of India.
c) **Article 15(3)-** According to this act of the Constitution, the state has the authority to make any special provision for women and children
d) **Article 16-** This act ensures equal employment opportunity to every citizen of India. According to this act, there should not be any discrimination in respect of employment opportunity under the state on the grounds of religion, race, caste, sex, descent, and place of birth, residence or any of them.
e) **Article 39-** This act ensures the benefit of the Directive Principles of State Policy to the women. Article 39(a) of the Directive Principles of State Policy ensures and directs a state to apply policies that focus on men and women having equal rights of adequate means of livelihood and article 39(b) ensures equal pay for equal work for both women and men.
f) **Article 42-** This act casts a duty on every employer to ensure just and humane conditions of work and for maternity leave
g) **Article 243-** This article of The Constitution of India ensures reservation of seats in gram panchayat for women. This opportunity of being a part of the local level arbitration process has improved the social conditions of women in village areas (Constitution of India, 2000).

From the above analysis it can be observed that constitution-makers were aware of the problems faced by women and to improve or uplift them, they took major steps in the form of the provisions of the Constitution.

AMBEDKAR'S VIEW ON THE WOMEN'S QUESTION

Many eminent scholars like D.K. Mohanty (Mohanty, 2002, pp.425-450) have noted the contribution of Ambedkar towards the women's movement and women's struggle for human rights. Ambedkar has more than often been referred to as 'The Champion of Women Rights.' Dr. Ambedkar said that "I measure the progress of a community by the degree of progress which women have achieved."

The growing adversities on women and their sufferings under the veil of caste and religion were not acceptable to Ambedkar. His contributions to modern Indian feminist discourse are significant because he worked upon the class and caste divide emphasizing on the oppression that woman had to face due to the socio-political structure prevailing in our country. Ambedkar is a source of inspiration for many social workers who are working for the uplifting of women. His ideas and thoughts on women empowerment are significant and crucial for the struggle for women rights and equality even in modern-day India.

Ambedkar blamed the whole concept of women subordination to the ancient texts that ruled the religious discourse. He believed that the whole idea of treating women as beneath men was a discourse created by the ancient religious texts. He said that "till the time we don't use our rational thinking we can't get over this orthodox thinking." Ambedkar was particularly against the ideas of Manu. He blamed Manu for not just the creation for the whore of the caste system but also the degraded position of women in the society. According to Manusmriti, women could not study Vedas; they were kept away from all religious activities in the Brahmanical culture and also deprived them of social freedom. Hence, Ambedkar worked for the betterment of the condition of women.

He worked for women rights both for upper caste and Dalit movement. Dr. B.R. Ambedkar introduced the concept of 'maternity leave' for women. He also proposed the legislation for the universal adult franchise and opposed the British government's proposal of partial voting rights with restrictions for certain people. Among his various contributions to the fight for justice for women, the most significant one is The Hindu Code Bill. This was a bill proposed by Ambedkar in the Parliament which mentioned certain changes in the Hindu Property Act, Hindu Marriage Act, etc. This Bill was largely debated in the Indian Parliament but due to the disagreement of many leaders, it could not be passed in the Indian Parliament. Following this, Ambedkar resigned as the law minister from Nehru's cabinet. However, this bill was passed as a series of separate bills in 1955-56.

HINDU CODE BILL: MAJOR PROVISIONS

Although the Hindu Code Bill was presented to the parliament by Ambedkar in 1948, its ideological inspirations can be traced back to various other legislation passed in the colonial times. It was inspired by the various legislations passed in the past such as The Government of India Act 1945, The Government of India Act 1936, etc. Dr. B.N. Rao, who was the Chairman of The Drafting Committee also worked towards this Bill along with Ambedkar.

The Hindu Code Bill was introduced by Dr. B.R. Ambedkar in 1948 in the Indian Parliament. This bill was passed to avail certain amendments in the Hindu Law. These changes were in the field of the Succession Act, Property Rights, and Marriage Rights, etc. The major provisions of the Bill are as follows:

a) Codification of law related to the rights of property of a deceased Hindu, dead intestate without making a will, to both female and male heirs.

b) The same rank in the matter of inheritance to be given to the widow, the daughter, the widow of a pre-deceased son as the son.
c) The daughter also to be given a share in her father's property; her share prescribed as half of that of the son.
d) The woman is heir to the property despite all restrictions of being rich or poor, married or unmarried, with an issue or without issue, etc.
e) In the rule of inheritance, the mother would succeed the father.
f) All 'stridhan' is put under one category with a uniform rule of succession.
g) Son is also given a right to inherit half of the stridhan as the daughter.
h) Conversion of the limited estate of a woman to an 'absolute estate' and the abolition of the right of revisionist to claim the property after the widow.
i) Dowry given to a girl will be treated as 'trust property,' which she can claim at the age of 18.
j) The dependants of a deceased shall be entitled to claim maintenance from those who have inherited the property.
k) Rights of a wife to claim separate maintenance when she lives separate from her husband.
l) A wife is also entitled to maintenance from her husband in the following circumstances:
 - If he is suffering from a loathsome disease
 - If he keeps a concubine
 - If he is guilty of cruelty
 - If he has abandoned her for two or more years
 - If he has converted to another religion or any other cause of living separately
m) Marriage will be irrespective of caste or sub-caste
n) Identity of 'gotrapravara' is not a bar to a marriage
o) Monogamy is to be prescribed in the new law unlike polygamy which was practiced previously
p) Marriages can be dissolved under certain prescribed circumstances

q) There would be seven grounds on which divorce can be availed:
- Desertion
- Conversion to another religion
- Keeping a concubine or becoming a concubine
- Incurably unsound mind
- Virulent and incurable
- Venereal diseases in communicable form and
- Cruelty

r) If the husband wants to adopt, he will have to take the consent of his wife.

s) If the widow wants to adopt, they have to be positive instructions to be left by the husband either by a registered deed or by a provision in the will (Rodrigues, 2002, pp.495-535).

DEBATES AND AMBEDKAR'S DEFENCE FOR THE BILL

Marriage and Divorce

The First Debate around Marriage and Divorce Was the Abolition of Caste Restrictions

To this, Ambedkar replied that there are people from two different schools of thought among Hindus also, the orthodox and the reformist. According to Ambedkar, for all the Hindus who want to keep caste restrictions in place, they can follow it. This law will help those who do not want to abide by traditional norms. The reformists will not be punished for doing something that they feel is good for them in terms of marriage. He defied his point by declaring that they are allowing two parallel systems of marriage to be operative in the country. Anyone can take their course of action there will be no violation of any religious text or set of rules.

The Second Point of Controversy Was the Prescription of Monogamy

In defense of this law, Ambedkar cited the traditional Hindu norms where there is no particular prescription that Hindus can practice polygamy. He even gave the example of Nattukottai Chettiyars of South India, who could not marry a second time without the consent of his first wife; and if the consent is given, he would have to give her certain property which ultimately becomes her absolute poverty. Ambedkar also gave the example of Kautilya's 'Arthashastra' where a person can't marry the second time without returning the 'stridhan' she had acquired at the time of marriage. Another example of some Indian provinces was given where monogamy had been prescribed such as Bombay, Madras, and Baroda.

The Third Part of the Controversy Was the Permission for Divorce

Ambedkar did not even consider divorce as an innovation. He informed the House that the 'Shudra' communities have customary divorce and constitute almost 10% of the Hindus. He questioned the House whether they wanted to have the law of the 90% or the law of the 10% people remaining. He even cited the examples of the Narada Smriti and the Parashara Smriti which talked of divorce when he has abandoned her or has died. He finally asserted that all the laws have been made keeping in mind the scriptures and shastras followed by the Hindus.

Adoption

There were again three major controversies regarding the laws concerned with adoption in the Hindu Code Bill.

The First Debate around Adoption Was That Unlike Old Hindu Traditions, Caste Is Not a Barrier to the Process of Adoption

Ambedkar says that it depends upon each's own choice if they do want to follow it or still stay in the world of orthodoxy. According to Ambedkar,

if somebody is as enlightened, being a Brahmin to adopt a shudra child, then it is appreciable. He said that this is no kind of an imposition.

The Second Debate is Concerning the Question of the Limitation on the Right of an Adopted Son to Challenge All Alienations Made by the Widow before Adoption

According to Ambedkar, this is not a matter of controversy at all. He thinks that adoption should be simultaneous with the vesting of property. He feels that no son has the right to deprive his mother of the property which is her mainstay.

The Third Debate Was with the Regard of Customary Adoption

Ambedkar, here, defends that the concept of 'godha' adoption, etc. are not adoptions at all because The Privy Council has stated that adoption is a purely religious affair. He even says that this type of adoption is only a means of keeping the property in the family. If someone would have genuine wishes to adopt they can do it through the 'dattak' system which is permitted by law.

WOMEN AND PROPERTY

a) On the question of women having the right of their property before and after marriage, Ambedkar states that women have a right to distribute their property acquired before marriage, which is known as 'stridhanam.' Ambedkar argues that if women can distribute the 'stridhanam,' so do they have the ability to distribute the property acquired after marriage i.e., 'stridhan'. Therefore, Ambedkar concludes that the property acquired by a woman after marriage should be named as her absolute property.

b) The second case was the share of the daughter in the property. Ambedkar cites the example of the old 'Mitakshara' and 'Dayabhaga' schools in Hindu thought and says that a daughter

does have a right to property under both these laws. He proposed an equal share of the daughter along with the widow and the son.

LAPSE OF THE BILL AND AMBEDKAR'S RESIGNATION

There was opposition from various leaders of the House. The very first voice of opposition came from Dr. Rajendra Prasad. He believed that passing such a law would mean that the opinion of a minority will be imposed on the majority. Another major question that rose was about the choice of the Hindu law as the first such religious law to be changed. People questioned why an amendment is made in the Hindu law and not any other religious law. This question initiated a lot of debates both in and outside the House when various leaders of the religious associations and organizations came to the forefront to question the Bill.

Initially Jawaharlal Nehru was in favor of the bill but later on, he also backed out. There can be various reasons for it, but the most favorable would be that he did not want any agitation in the country because of the change in the laws of a particular religion. Nehru was extremely heartbroken by the outcome of the partition, which he was confident of before. He feared that no such unrest should happen if he passes this law. Therefore, he took a side to it and did not support it.

The backing out of Nehru was the most immediate reason which infuriated Ambedkar and he decided to resign from Nehru's cabinet. As is the custom in the Indian parliamentary tradition; if a bill is not accepted and the term of the parliament is over, then the Bill lapses and has to be presented again. Therefore, The Hindu Code Bill lapsed from the Parliament for that period.

THE PASSING OF THE BILL AND ITS IMPACT

In the first general elections held in India in 1952. Ambedkar became a member of the Upper House i.e., The Rajyasabha. The Hindu Code Bill

was again presented to the parliament but it was now fragmented to separate bills. Nehru decided to play it safe and hence, he decided to go about it carefully. The first bill which was passed was the Hindu Marriage Act 1955, The Hindu Succession Act 1955 followed by The Minority and Guardianship Act, The Adoption and Maintenance Act, etc. The law minister at that time was Nibaran Chandra Laskar who framed and got these legislations passed. Ambedkar saw the bills passed in front of him before his death in 1956.

Therefore, we can say that although the bill was not passed under the heading of 'The Hindu Code Bill', the essence of the bill formed by Dr. Ambedkar can be seen in all the women-centered bills passed later. The impact of the bill was really strong. People started considering the women's question of human rights in all the bills which were passed later on. The Bill, which aimed towards a Uniform Civil Code for all the citizens of the country, was a stepping stone towards achieving this goal.

The struggle for women rights has come a long way since the passing of The Hindu Code Bill. Women are demanding their rights more affirmatively and have been successful in many cases. For example- The Shah Bano Case in 1985, this granted women a right to maintenance after divorce in the Muslim Law. There was a major debate between The Uniform Civil Code and the Religious Personal Laws as to how to bring uniformity in the country's law concerning all the religious laws. This bill was a positive step in that direction as well. It was after The Hindu Code Bill was passed, that various other religions also made amendments in their laws. For example- the Muslim Law gave women a right to divorce from marriage and also the right to maintenance (Dube,2015, pp.436-465). Along with this women have got better job opportunities and recognition in both the public and private arena. Various schemes and programs such as the Mother and Child Tracking System (MCTS), the Indira Gandhi Matritva Sahyog Yojana, Conditional Maternity Benefit plan (CMB), Rajiv Gandhi Scheme for Empowerment of Adolescent Girls- Sabla, etc. have been launched by the Indian Government to empower women. But still, a lot of work needs to be done to achieve equality in society. Women are also struggling for reservation in the parliament, safety issues, etc.

CONCLUSION

Women are a crucial part of any civilization and the maintenance of their dignity and honor is the responsibility of all individuals and governments. Women had a high position in ancient Indian culture, but later on their position both in the family and in the society degraded. They were being subordinated and discrimination was very common in the Indian culture. Many people recognized this disparity in our society and decided to work to completely eradicate it. Many eminent personalities worked in the field of women rights and have helped achieve empowerment for women. The efforts which these people made in the past, changed the present for the better. Not just through protests and agitations but also through lawful legislations, these people have sought to establish parity in the Indian context. These people opened free schools to provide education to women and also encouraged their family members about the need for women empowerment. Dr. B.R. Ambedkar also worked towards women empowerment. Right from the beginning of his struggle for equality, women had been a crucial part of his concern. Ambedkar's philosophy and ideas have inspired several people and his laws and legislations have formed a base to the present day rights that are availed by us. Ambedkar's contribution to this movement is priceless and will always be appreciated in Indian history and polity.

REFERENCES

1st LokSabha, http://en.wikipedia.org/wiki/.aspx visited on 10.10.2015 at 9:45 pm.

Bandopadhyay S., (2004). *From Plassey to Partition: A History of Modern India*, New Delhi: Orient Longman.

Bannerjee, I. and Dube (2015). *A History of Modern India*, Noida: Cambridge University Press.

Chakravarti, U. (2009). *Gendering Caste through a Feminist Lens*, Kolkata: Stree.

Constitution of India (2000). http://www.indiastudychannel.com/resources/ 155065- Legal- Constitutional- rights- women- India. aspx visited on 10.10.2015 at 9:00pm.

Dancan, J. and Deeret, M. (1970). *A Critique of Modern Hindu Law*, Bomaby: N.M. Tripathi Pvt. Ltd.

Desai H., Ashok and Murlidhar S. (2000). *Public Interest Litigation: Potential and Problemsin B.N. Kirpalet*. Al(ed), New Delhi: OUP.

http://www.mospi.nic.in.aspx visited on 10.10.2015 at 9:30 pm.

Incidents of atrocities on women, Scheduled Castes and Scheduled Tribes, Ref: http://shodhganga.inflibnet.ac.in//bitstream/10603/10806/8/08_chpter%201.pdf accessed on 9.10.2015at 2:30 pm.

John E. Mary (2008*). Women's Studies in India, India:*Penguin Books.

Mohanty D.K. (2002). *Indian Political Tradition*, New Delhi: K.K. Publications.

Nair P, Sukumar (2011). *Human Rights in a Changing World*, Delhi: Kalpaz Publications.

Purohit B.R. and Joshi S. (2003). *Social Justice in India*, Jaipur: Rawat Publication.

Rodrigues, V. (2002). *The Essential Writings of B.R. Ambedkar*, New Delhi: Oxford University Press.

In: Exploring the Opportunity ...
Editor: Surendra Bhaskar

ISBN: 978-1-53616-424-4
© 2019 Nova Science Publishers, Inc.

Chapter 10

MULTIPLE ROLES OF WORKING WOMEN: AN IMPACT OF PSYCHOLOGICAL DISTRESS ON WORKING WOMEN IN INDIA

Suman Dhaka, PhD and Nilanta Mukherjee*
Department of Humanities and Social Sciences,
National Institute of Technology, Rourkela, Odisha, India

ABSTRACT

Women in millennial India wear multiple hats and accomplish varied tasks ranging from both home and work front. Of late the percentage of working women has seen a rise. There has been the elimination of gender disparity to a certain extent but still, there is a long way to go. With a minimal guarantee of job security, discrimination in levels of salary and positions and issues of verbal and sexual abuse at workplaces, working conditions for women remain gravely unpleasant. Apart from that women have to justify the assigned role of nurturers by taking care of the family members and accomplishing various household tasks. Women essaying

* Corresponding Author's E-mail: dhaka.ssuman@gmail.com.

multiple roles have a detrimental effect on their mental health and results in stress and anxiety, thereby questioning their optimal functioning. The change in societal dynamics, giving rise to nuclear families has aggravated the issues, where the women are left with no supporting aid in the form of the elderly. The stereotypes that prevail in the society in forms of childcare being the primary responsibilities of the mothers, add on to the agony rendering them feeling guilty about them being engaged in professions. Therefore there is an increasing need to eliminate gender disparity in society, adopt strategies like problem-based coping, and stress alleviating interventions to help the women of 21st century balance well between work and family and make optimal use of their abilities.

Keywords: working women, gender disparity, stress

INTRODUCTION

According to the American Psychological Association, "Stress is often described as a feeling of being overwhelmed, worried or run-down." Stress can affect people of all ages, genders, and circumstances and can have ill effects on both physical and psychological health. By definition, stress is any uncomfortable "emotional experience accompanied by predictable biochemical, physiological and behavioral changes" (Baum, 1990). Some stress can be beneficial at times, producing a boost that provides the drive and energy to help people get through situations like examinations or work deadlines. However, an extreme amount of stress can have health consequences and adversely affect the immune, cardiovascular, neuroendocrine and central nervous systems (Lee, D.Y.; Kim, E. & Choi, M.H., 2015). A working woman can be roughly considered as "a woman who earns a salary, wages, or other income through regular employment, usually outside the home". The industrial revolution played an important role in fueling an exigency for the married and unmarried women to gain financial independence outside their home front. But, there is still a long way to go in finding parity between the men and women in terms of the labor force. According to the report of Catalyst, in 2017, the percentage of women in the labor force participation was 28.5 against the participation

of men which accounted for 82%. In 2011-2012, in India, the salaried positions and regular wages contributed around 17.9% to the total employment. The recent years have experienced a decrease in the gender disparity in the employment sector.

India reports of 11.7 million urban working women. There was a hike in the percentage of working women in urban areas from 28.5% in 1993-94 to almost 43% in 2011-12 in case of employment concerning to salaried positions and regular wages. An evident shift has been noticed from traditional professions like education and medicine to non-conventional professions like communications, etc. According to estimates, $700 billion could be added to India's GDP by 2025, with a 10 percent increment in women's labor force. Though the situation in India is improving, there is still a long way to go in achieving parity in terms of women employment and their contribution as compared to other nations.

The new-age women who are coming to pursue their dream career, but their lives are no bed of roses; they had to play a part by being on par with their male counterparts. Working women have many roles where they have to cater to the demands of both the home and work front. With the change in societal dynamics, there have been modulations in the gender stereotypes, men have started contributing to the bringing up process of the children at par with the mothers. Yet, women have to essay multiple roles of a cook, maid, tutor, and nurse along with managing the work front. This takes a toll on their mental health and they become prone to stress and anxiety. With unsupportive families, there is an add-on to the entire situation. Since time immemorial women have played a key role in human development, higher and respectable status of women, vis-à-vis employment & work factored by women is a significant indicator of overall social and national environment development.

STATUS OF WOMEN IN HISTORICAL PERSPECTIVE

In primordial India, although the patriarchal system prevailed, women enjoyed a status of reverence, loyalty, and power. A plethora of

inscriptions signifies the important status enjoyed by the women where they had the freedom to devote themselves to the religious activities of their choice and not just look into the welfare of their families. The education of women was a subject of great importance in this era. Women were placed highly in social positions in ancient Indian society. They participated in the assemblies and had a say in the decision-making process. Pieces of evidence suggest the projection of strength and power of women dismantled numerous mighty emperors and kingdoms. Elango Adigal has vividly enlightened about how Madurai, the capital of Pandya's was burnt when Nedunchezhiyan, the Pandyan ruler mistakenly killed a woman's husband. The tale of the fall of Kauravas due to the humiliation of Draupadi in Mahabharata, the obliteration of Ravana after the abduction of Sita and trial of Rakshasa Vivah, the superfluity of Goddesses in the ancient period were fabricated to instill respect for women. "Ardhaneshwar" (God is a half-man and half-woman) was highly worshiped. We can also sight the example of Prajapati Daksha who lost his head to Lord Veer Bhadra (Avatar of Lord Shiva) after ridiculing his daughter goddess Sati resulting in her suicide by torching herself and the birth of fifty-one Shakti Peethas in various parts of India.

However, this status enjoyed by women was at stake during the later Vedic civilization. The right to inheritance of paternal property was curbed from women; they were subjected to social evils like child marriage and dowry system. Aitreya Brahmana, the collection of sacred hymns describes a daughter as a source of misery and Atharva Veda adds to the view by deploring the birth of a daughter. However, there has been evidence of the prevalence of matrilineal elements. The fact that wives of the King are supposed to be a part of the "Rajasuya Yajna" is an indicator of the significance assigned to women through matrilineal influence. However, in this period there was a robust tendency to stratify the social set-up based on gender. As the Vedic ideals of parity and balance began to fade away by the transition of time resulted in the gradual diminution of the position of women. During the Smriti period, women were bracketed with the Sudras and were debarred from the right to study the Vedas, utter Vedic shlokas and perform Vedic rituals.

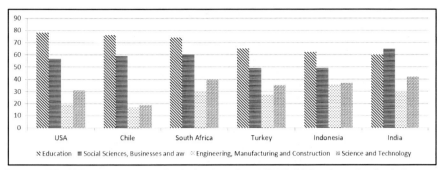

Source: World Bank Education Statistics based on UNESCO Institute for Statistics

Figure 1. Percentage of women in tertiary sectors.

Marriage or domestic life became mandatory for them with unquestionable subjection to husband became their sole duty. The Mauryan period of Brahmanical literature was particularly severe towards treating women as dispensable and assigned them a very low status in the society similar to destitute, but the Buddhist texts were much more denominational and considerate in envisaging proper rights to women. Megasthenes testifies the increasing multiple wedlocks, engagement of women as place guards, bodyguards to the Kings, spies, etc. granting permission for widow remarriage and getting liberty for divorce as improvements in the social status of women. Thus, although the assigned social status of women was insubstantial, it was not as bad as it became in the later ages. Several epics, smritis, and puranas depict women and property in the similar brackets thereby considering them as properties and striving towards owning them. The *Brahmanical* law did not entrust the right to property on women. The concept of "*Stridhana*" was of a very limited nature and did not extend beyond the wife's rights to jewels, ornaments and presents made to her at the time of marriage. The tradition of women using veils by women of higher caste families was in practice. In southern parts of India, extensive prejudices that stimulated the diminishing status of women was also there, widow remarriage was not favored, women had to shave their heads after their husbands expired, were debarred from wearing any kind of ornaments, and were allowed to take food once a day. This was done to make the widows devoid of attractions to the worldly affairs. If someone

going out for work faced a widow, it was considered disdain. Widows were debarred from social functions or gatherings such as marriage, the birth of a child, etc. except for rendering domestic labor. According to Robin (2002) "Sexism is the root oppression, the one which, until and unless we uproot it, will continue to put forth the branches of racism, class, hatred, ageism, competition, ecology, disaster, and economic exploitation. No other human differentiation can be similarly powerful in reproducing oppression, and so, women are the real left".

During the Colonial era, many social reformists and enlightened thinkers such as Raja Ram Mohan Roy, Ishwar Chandra Vidyasagar, and Jyoti Rao Phule initiated agitations for women empowerment. Their efforts lead to the abolition of "The Practice of Sati" in which a woman was burnt alive with her expired spouse and then later the formulation of the Widow Remarriage Act was initiated. Later, stalwarts like M.K. Gandhi, J.H. Nehru advocated in favor of women rights and with their consistent efforts, the status of women in social, economic and political aspects experienced an upward trend in the Indian society. The consolidating and meliorating position of women in India has levied in a great manner towards the socio-political, economic, and legal spheres in contemporary India; people and influential leaders of our country have ingrained in themselves undoubtedly that without active participation of women in a nation's social, economic and political activities, progress of a country will be at stake and rather it will mark the deterioration of progress and symbolize the stagnation and crippling of the overall growth model of a nation. In the present scenario, women are regarded as assets where they entail the right to get educated, inherit and own property in public life. They have become economically liberated; society has started seeing women from a different perspective. Women are creating a niche for themselves in every employment sector including the army, engineering, etc. thereby diminishing the gender disparity at a faster rate. But to uproot the stereotypical concept from the minds people that women can only serve as homemakers is a herculean task. It has been rooted so deep that incessant efforts took almost seventy years to create a situation that is prevailing and is progressive for good reasons. "India's patriarchal society thinks of

women only as homemakers and sexual objects and is generally subjected to exploitation & torture (Dube, 2001)". The discussion about feminism, equality across gender, education of women, reformation in the societal norms to facilitate the development of women, and the participation of women in politics and numerous social legislations have contributed towards the change in the status of women in the society. People have started to acculturate and acclimatize the prevailing social change. The ground norm of the country i.e., the Constitution provides for the fundamental right of *'Right to Life and Personal Liberty'*, under Article 21, which encompasses within itself the right of *'Right to Dignity'*. The above constitutional principle has been carried forward and implemented through various statutes which accord protection to several aspects of the dignity of a woman. Some of the prevalent statutes have been mentioned below:

- The Hindu Widow Re-marriage Act, 1856
- The Child Marriage Restraint Act, 1929
- The Hindu Women Right to Property Act, 1937
- The Hindu Marriage Act, 1955
- The Hindu Succession Act, 1956
- The Suppression of Immoral Traffic in Women and Girls Act, 1956
- The Dowry Prohibition Act, 1961
- Domestic Violence Act, 2005
- Sexual Harassment at Workplace (Prevention, Prohibition and Redressal) Act, 2013

Albeit there are several legislations, programs, schemes of central and state governments, and demographic attributes which are also taken into consideration while evaluating the status of women by international standards. The notions like Female-Male Ratio (FMR), Maternal Mortality Rate and Girl Child Mortality Rate help in assessing the current scenario of the female population at large within a society. Despite all the constitutional efforts, there has been a decline in the sex ratio since the last five decades. The sex ratio in India has depicted gender disparity for six

decades i.e., 1951-2011. This is also exhibited over the fact that there is a consistent prevalence of unwillingness for the birth of girl child and that many women have to undergo the process of abortion because of this reason. The uprooting of this issue has been included in the New Millennium Declaration. A study in Andhra Pradesh (2000) reveals that two hundred women die in every one lakh delivery. One of the reasons could be the lack of adequate medical facilities which aggravates the current situation. Another cause being lack of independence assigned to women, this has actively and passively added to the distress of numerous women. Economic independence is one of the many criteria to assess the stance of an individual in a society. This attribute fosters attributes like access to opportunities, stronger stand in the process of decision making and being enabled to utilize their rights. Even though women work throughout their lives in the home front, catering to the demands of the entire families, the percentage of them being engaged in salaried positions is minimal.

WORKING WOMEN IN MODERN INDIA

According to the reports, in 1991, only 30.44 percent of women were positioned in salaried jobs. 35.1 percent contributed to the workforce where 38.90 worked in the rural set-ups while in urban areas it was 18.7 percent. Most of the women are working in unorganized sectors which render them with minimal guarantee of job security adding to their distress level. In the rural areas, most of the women are engaged in the agrarian set-ups while in the urban areas they find employment in the form of housemaids, daily laborers, etc. The percentage of women in the organized sectors though has been on a rise, yet there is a long way to go in achieving gender parity. The percentage of women holding executive positions and in technical, professional and managerial professions redefine women empowerment for all positive causes. Yet, the working women across all sectors are exposed to maltreatment and discrimination which multiplies their distress levels. This is showcased by the fact that the contribution of

women in managerial positions is lower than that of men with almost all the top-notch positions being occupied by the men. According to UN reports there has been consistent evidence to support the fact that across times, women have been engaged in low paid jobs as compared to men, but they tend to work for longer hours as compared to their male counterparts; which is approximately 7.6 hours per day for women and 6.5 hours per day for men. There is a staggering difference in the non-market activities done by men and women. It is sixty-five percent for the women whereas only eight percent of men contribute to this category of work. This situation suggests that achieving women empowerment and gender equity is a far-cry situation for Indian society. All these factors add to the distress levels of women making them susceptible to various kinds of physical and psychological illnesses.

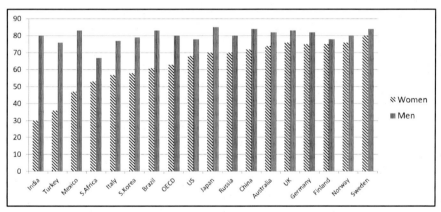

Source: Yale University.

Figure 2. workforce participation rates for women and men in selected countries – 2016.

Occupational hazards pose a threat to the physical and psychological well-being of women. For example, the people working in the Beedi (Indian cigarette) factories are usually women, who are supposed to sit for long hours in a similar posture leading to neck and backache. Due to the process of intricate folding of the Beedi, they develop clipped fingers; visual impairments and exposure to tobacco for long hours over the years

make them susceptible to lung-related disorders. Apart from this, they are paid meagerly assuming them as unskilled laborers. Apart from issues like these, many of these women bear the responsibility of being the sole bread earner of their families, which leaves them with little choice but to work with such limited facilities and bear the responsibilities of their families both on the financial front like earning money for smooth functioning, and domestic front like taking care of family members and other household chores. This intensifies the levels of stress and strain for them leading to increased levels of distress among them. Sen (2000) opined, even though women are highly educated and hold salaried positions, yet in the Indian society they are expected and many a time compelled to shoulder the responsibilities of the family and household chores, even if they have challenging jobs in terms of work timings and responsibilities. Ultimately, urban women also are left with little time to look at their personal needs in terms of leisure and are over burdened with work, the majority of the time. The aggravating agony of women when they had to perform multiple roles in their professional, social, and personal life has resulted in various psychological disorders starting from sleep disorders to post-traumatic stress disorders to anxiety and frustrations. The change in the societal dynamics and the family system has aggravated the distress levels of women to a great extent. In the Indian society, there had been a long term prevalence of the joint family system in which elderly individuals of the family used to take care of the children and there was a distribution of responsibilities among the other members of the family leading to the lessened amount of work pressure and stress. Contrarily, in the nuclear family system which is a relatively recent phenomenon, the women of the family have to look into all the intricate details with no one around; resulting in increased pressure on women for managing both the home and work front. The altruistic nature of women towards their family has resulted in unemployment and job dropouts, etc. Full-time working mothers perform second shifts at home, and they have little free time comparing to their husbands, but this disparity has started to decline as men have prudently started showing a sense of chivalry towards their wives.

All the above problems have ravaging effects on the mental health of working women resulting in mental health disorders. World Health Organisation describes mental health as a "state of well-being in which the individual realizes his or her abilities, can cope with normal stresses of life, can work productively and fruitfully, and can contribute to his or her community". The agency has also recognized the inter-relation of mental, physical and psychological health (WHO, 2005). Therefore, it can be assumed that women who experience societal and physical stress are susceptible to psychological distress thereby making them prone to varied kinds of psychological disorders. The World Health Report (2001) stated that women face a host of psychological and physiological illnesses including behavioral disorders which are the outcomes of a complex interaction between biological, psychological, and social factors. Women engaged in shift work where they have to work in odd hours of night shift or early morning shifts, managing home and work become a herculean task for them which manifold the distress levels adversely affecting their physical, psychological and social well-being. It also affects their concentration, memory, and alertness. To understand more precisely we can segregate the life of women into majorly two parts, professional life or work life and personal life or family life.

In the economic or employment field the situation is such that many women who are ready to contribute towards the workforce are finding it difficult to get a job that will satisfy their demands and those who are employed are the victims of exploitation and harassment. Latest trends in women studies come up with the following issues that have negative repercussions on the contribution of women in the labor force participation:

- **Decreasing Economic Participation of Women**: With technological advancements, there has been large scale replacement of labor force with machines that overpower human beings with their effectiveness and speed. This has resulted in large scale unemployment in the case of women particularly in agrarian sectors, weaving, handloom, etc.

- **Harassment at the Workplace:** In recent years, fortunately, there has been an increase in the constitution of women in the workplace. But unfortunately, there has been an increase in the harassment of women in the workplace. Nearly 1/3rd of our labor force (32%) is women. Working women constitute 16.43% of the female population of the country; the number of working women was around 278.35 million, representing a growth rate of 26.12% over the previous decade. They undergo violations of their rights and are often victims of sexual assault.
- **Economic Exploitation:** The unequal payment for women for the same amount of work has been an issue for decades. "Equal pay for equal work" is a distant dream to be fulfilled, particularly in the unorganized sectors, where women are assigned more work and paid meagrely as compared to their male counterparts. "Equal Remuneration Act, 1976" has just been a law in pen and paper with adequate instances of economic inequality based on gender across all sectors of employment.
- **The Threat of Removal from Job:** Given the assigned societal status to women, many women succumb to varied types of exploitations inclusive of sexual assaults. Given their helpless situation, they are many times threatened of job loss if they raise a voice against it. This adds to the already prevailing distress levels in the case of women who shoulder both the responsibilities of managing their home and work.
- **Discrimination in Giving Opportunities:** Women are often subjected to discrimination in terms of increment, promotions, training, additional perks and allowances as they are regarded as being less capable than their male counterparts. They are often categorized as 'non-serious' employees where the profession is of secondary importance to them. Many times the contribution made by women to the GDP is not even taken into consideration. These types of discrimination can be considered as one of the major factors in boosting up the stress levels leading to various physiological and psychological disorders.

Now if we focus on the personal dilemmas of a working woman we will grasp some issues with which we are well acquainted but as escapists we try to withdraw ourselves from the inevitable truth that our unsupportive nature towards working women especially working mothers or single mothers have led to them to accumulating various mental health disorders resulting in physiological disarray. It becomes increasingly difficult for women to function optimally in the management of dual roles. With high levels of stress, it is often observed that there is little scope for them to ventilate their emotions. Around sixty percent of working women find their family members as their ventilation agents; it tends to aggravate the situations of family discord. Almost half the population of working mothers revealed that given an opportunity they would like to essay the role of full-time mothers. Around one-fifth of the women preferred the option of 'work from home'; while merely four percent of the women revealed that they would prefer a full-time working schedule along with motherhood. A staggering eight out of ten women revealed that they would quit their jobs if given an opportunity.

CHILD'S PROSPECTS

Mothers have been considered as the nurturers of the families and are needed the most when their children fall sick. This, on the other hand, leads to a situation of disequilibrium where the women find it difficult to take care of their children and cater to professional needs. Although there are provisions for sick leaves for the employees, no special leaves are granted for the mothers that would allow them to take care of their sick child. This state of disequilibrium leads to a host of issues. In cases where both the parents are working, the mother is usually bestowed upon with the responsibility to take care of the child.

In India, given the patriarchal social system, the male members are usually the ones who earn more in terms of money. As a result of this, their jobs are considered to be more important than their spouses. Another reason that can be taken into consideration that women primarily playing

the role of nurturers, employers usually grant leaves to them to take care of the sick child, whereas it is difficult on the part of a man to get the same. With increasing work pressure of the corporate sectors, one in every ten women reports of feeling guilty about being unable to take adequate care of the children at the time of their sickness. Therefore, flexible work schedule and facilities like work from home, facilities in the workplace to take care of the unwell children, permitting parental leaves to mothers with children below the age of ten might contribute significantly towards alleviating the problems of working mothers to a great extent, thereby reducing their stress levels.

SEX LIVES

A study conducted by *The Centre for Labour Research at Adelaide University* on 150 working women using the interview method found that lack of sexual intimacy and satisfaction was a major grievance among the working women. The key findings suggested:

- Fatigue and stress are among the top causes of hampering the sexual lives among working women.
- Resentment of working women towards their spouses regarding their non-participation in the household work hinders their sexual partnership.
- The feeling of guilt and sadness over having spoiled their sexual lives already aggravated the prevailing situation.
- According to the researchers, the participation of men in accomplishing the household chores regularly would facilitate the levels of understanding between the couple, thereby leading to improvement in the sexual lives.
- Flexible work timings would give women the freedom to manage the home and work front effectively. This will alleviate the stress levels thereby contributing to improving the sex lives.

India also echoes the finding where work-related stress takes a toll on the sex lives of women. By the end of the day, when women have accomplished the responsibilities of both the home and work front, they are left with little energy. They also need to sleep and prepare themselves for the next day's work. Therefore, in many cases, the sex lives of women are hampered which adds on to the distress levels.

HOUSEWORK AS THE PRIMARY RESPONSIBILITY OF WOMEN

Research evidence suggests that married women with children report the highest levels of distress and are the ones who initiate the decision of taking a divorce as they choose the option of a liberated life. Some of the related facts that can be concluded:

(a) Working mothers still perform most of the household chores.
(b) Full-time mothers and women who work full-time have similar working hours.
(c) Working mothers work more hours (paid and unpaid) than working fathers.
(d) Part-time working mothers are reported to have the longest working hours.
(e) Most divorce-related decisions are initiated by women.

The only way by which this problem can be alleviated and can refurbish the mental health of of working women is by chivalry and support from both family and corresponding workers at the workplace, this time they should be the recipients of unconditional love, compassion, and empathy which should be paradoxical to apathy, exploitation, and harassment.

STRESS MANAGEMENT STRATEGIES

Adopting certain strategies can help women deal with the high levels of stress of personal and professional lives and help them strike the right balance thereby leading a fulfilling life.

At a professional level, working women can gain from

(i) Stress management training
(ii) Problem-based coping
(iii) Stress interventions
(iv) Employee Assistance Programs (EAP)
(v) Social support programs

At a personal level, they can be benefitted if

(i) Maintain regular stress-relieving habits
(ii) Quick stress relievers must be within your reach
(iii) Prioritization and elimination of what can be and cannot be done
(iv) Understand gender differences in stress
(v) Alter or change of perspective

Attempts to motivate, inspire, and assist women workers should be made at all possible levels. Proper counseling should be given to working women so that their stress level could be reduced and counseling centres to be established so that whoever in need can visit and can opt for mental health-enhancing activities.

CONCLUSION

India has seen an upscale in the population of working women in recent years. The working women undergo a difficult life in a patriarchal

society like India where high gender disparity prevails and there exist strict gender stereotypes where the roles of men and women are designated and leave them with very little chances of modulation. Even with the change in the societal dynamics in the current era, there has been a little change in the mind-set of people where the men have started to contribute in the household chores; the disparity remains loud and clear. In the majority scenario, women take up the responsibility of the children, elders and other members of the family. The paradigm shift from the joint family culture to the nuclear family set-up accelerates the issues of women to a great extent. Unlike yesteryears where, the elderly individuals of a family had a pivotal role to play in taking care of the children, in the nuclear families of the current day, the children are either left alone with no one to take care, or the mothers have to sacrifice their job life in order to take care of them. Issues that add on to the distress of women are equally prevalent in the professional setup. Women in the work field are assured minimal job security, discrimination based on gender that prevails in the work environment in the form of job positions, promotions and salary for the same work that they do as their male counterparts. These varied issues become the cause of high levels of distress and questions the mental health of working women who try their best to maintain a balance or equilibrium in the home and work front. Many women who are unable to strike the right chord have to give up their profession which acts as another major stressor in their lives. They are prone to mental health issues like anxiety and depression. In the process of trying to maintain a balance in the home and work front, women often tend to neglect their health; they become susceptible to various physical ailments like hypertension, cardiovascular diseases, etc. Therefore, there is in an increasing need to incorporate certain steps like encouraging on and providing training on problem-focused coping, stress alleviation strategies, flexible work timings, and facility of work from the home which can help to address the problems to a great extent. Apart from this, a change in the mindset of people is imperative where an understanding that both men and women share the responsibilities of the home front can help to solve the problems to a great extent.

REFERENCES

Ayas, N. T., White, D. P., Manson, J. E., Stampfer, M. J., Speizer, F. E., Malhotra, A. & Hu, F. B. (2003). A prospective study of sleep duration and coronary heart disease in women. *Archives of internal medicine, 163*(2), 205-209.

Basu, J. (2010). Development of the Indian gender role identity scale. *Journal of the Indian Academy of Applied Psychology, 36*(1), 25-34.

Baum, A. (1990). Stress, intrusive imagery, and chronic distress. *Health psychology, 9*(6), 653.

Chakravarty, S., Kumar, A. & Jha, A. N. (2013). Women's Empowerment in India: Issues, Challenges, and Future Directions. *International Review of Social Sciences and Humanities, 5*(1), 154-163.

Dashora, K. B. (2013). Problems Faced by Working Women in India. *International Journal of Advanced Research in Management and Social Sciences, 2*(8), 82-94.

Derne, S. (1994). Hindu men talk about controlling women: Cultural ideas as a tool of the powerful. *Sociological Perspectives, 37*(2), 203-227.

Do Yup Lee, E. K. & Choi, M. H. (2015). Technical and clinical aspects of cortisol as a biochemical marker of chronic stress. *BMB reports 48*(4), 209.

Evetts, J. (2014). *Women and Career: Themes and Issues in Advanced Industrial Societies: Themes and Issues In Advanced Industrial Societies*. Routledge.

Facts and Figures: Economic Empowerment. (2019). Retrieved from http:// www.unwomen.org/ en/ what-we-do/ economic-empowerment/ facts-and-figures.

Hamid, I. (2015). International instruments Related to Women Rights and their Implementation in India. *Social Sciences International Research Journal ISSN*, 2395-0544.

Harnois, G., Gabriel, P. & World Health Organization. (2000). *Mental health and work: impact, issues and good practices.*

Kumari, A. (2016). Self Evident-The Place of Women in Today's Modern Society. *Social Sciences International Research Journal ISSN*, 2395-0544.

LaFromboise, T. D., Heyle, A. M. & Ozer, E. J. (1990). Changing and diverse roles of women in American Indian cultures. *Sex Roles*, 22(7-8), 455-476.

Lama, P. (2014). Women empowerment in India: Issues and challenges. *International Journal of Multidisciplinary Approach and Studies*, 1(6), 387-399.

Michelsen, G. & Wells, P. J. (2017). *A Decade of progress on education for sustainable development: reflections from the UNESCO Chairs Programme*. UNESCO Publishing.

Panigrahi, A., Padhy, A. P. & Panigrahi, M. (2014). Mental health status among married working women residing in Bhubaneswar City, India: a psychosocial survey. *BioMed research international*.

Quick Take: Women in the Workforce—India. *Catalyst*. (2019). Retrieved from https:// www.catalyst.org/ research/ women-in-the-workforce-india/.

Ramchurjee, N. & Paktin, W. (2011). "Tourism" a Vehicle for Women's Empowerment: Prospect and Challenges. *Research Gate*, 1-12.

Sachdeva, D. G. (2009). Women Empowerment in India: Issues and Challenges. *Social Sciences International Research Journal ISSN*, 2395-0544.

Sadiqi, F. (2008). Facing challenges and pioneering feminist and gender studies: women in post-colonial and today's Maghrib. *African and Asian Studies*, 7(4), 447-470.

Schauben, L. J. & Frazier, P. A. (1995). Vicarious trauma the effects on female counsellors of working with sexual violence survivors. *Psychology of women quarterly*, 19(1), 49-64.

Shettar, D. & Rajeshwari, M. (2015). A study on Issues and challenges of Women Empowerment in India.

Sigel, R. S. (1996). *Ambition and accommodation: How women view gender relations*, University of Chicago Press.

INDEX

A

abolition, 139, 145, 158
access, xi, 12, 15, 26, 27, 28, 37, 72, 73, 77, 99, 100, 103, 116, 123, 126, 127, 128, 129, 131, 132, 160
accessibility, 12, 128, 129, 130
accountability, 61, 124, 128, 132
adolescents, 45, 50, 104
advancement, 30, 109, 119, 126
age, 39, 42, 45, 49, 50, 65, 88, 101, 102, 111, 119, 145, 155, 166, 173
agencies, 13, 23, 117, 123
agriculture, 28, 30, 49, 91, 127, 128, 131, 133
ambassadors, xii, 96, 102
anemia, 29, 39, 46, 51, 53, 58
anxiety, 154, 155, 162, 169
aptitude, 16, 17, 112
assets, 12, 17, 73, 87, 115, 158
attitudes, xii, 40, 61, 99, 100
authorities, xi, 71, 76, 99, 100, 103, 129, 131, 142
awareness, xi, 14, 27, 30, 36, 53, 54, 65, 68, 96, 97, 98, 102, 105, 111, 114, 116, 130, 132, 173

B

banking, 72, 74, 78, 79, 80, 83
banks, 8, 12, 16, 74, 78, 81, 116
bargaining, xi, 72, 73, 75, 82, 85
barriers, 97, 108, 119, 120
beneficiaries, xii, 65, 121, 141
benefits, 27, 28, 29, 30, 105, 109, 114, 124, 126
bias, xii, 73, 100, 101
budding, 17, 114, 118
businesses, xii, 3, 6, 7, 12, 13, 15, 87, 88, 108, 109, 114, 118
buyers, 80, 82, 114

C

calorie, 45, 50, 51, 53
cash, 26, 81, 82, 83, 84, 91
Census, 1, 19, 106, 126
challenges, vii, viii, ix, x, xii, xv, 2, 7, 11, 12, 35, 36, 41, 42, 54, 69, 97, 101, 107, 109, 110, 114, 115, 119, 120, 121, 122, 125, 129, 134, 138, 170, 171
childcare, xii, 100, 154
children, xi, 10, 14, 26, 36, 38, 39, 40, 45, 46, 55, 72, 73, 77, 100, 101, 102, 103,

109, 115, 142, 155, 162, 165, 166, 167, 169
citizen-friendly, 122
citizens, 96, 101, 102, 122, 124, 128, 129, 150
civilization, 110, 151, 156
clients, 78, 80, 82, 83, 84, 85, 88, 89, 114
color, iv, 36, 110
commercial, 79, 82, 112, 117
communication, 26, 62, 129
community, 11, 23, 25, 29, 54, 58, 65, 132, 143, 163
competition, 12, 91, 117, 158
computer, 28, 85, 88, 89, 123
conception, 97, 124, 126
connectivity, xi, 25, 72, 73, 77, 92, 126
consent, xi, 71, 73, 91, 146, 147
Constitution, 13, 52, 59, 61, 63, 68, 76, 135, 136, 137, 141, 142, 143, 152, 159
constitutional amendment, vii, xi, 57, 58, 61, 64, 66, 68
consumption, xii, 38, 39, 45, 46, 47, 53, 89, 109
corporate sector, 22, 123, 166
correlation, 42, 53, 99
cost, 9, 13, 15, 88, 98
counseling, ix, 2, 17, 168
culture, xi, 6, 21, 25, 26, 27, 29, 39, 55, 58, 63, 68, 111, 112, 131, 138, 143, 151, 169
customers, 79, 80, 82, 84, 85, 87, 88, 89, 90, 92

D

deaths, 22, 35, 101
decision-making process, 16, 65, 72, 156
deficiency, 37, 39, 45, 47, 125, 128, 133
democracy, 24, 59, 64, 67, 119, 136, 137
developing countries, x, 21, 23, 25, 39, 122
diet, x, 14, 36, 37, 38, 39, 45, 46, 47, 50, 52, 54
diet plan, 36
dignity, 77, 136, 139, 151, 159
discrimination, xii, 27, 29, 58, 71, 76, 95, 97, 100, 102, 110, 136, 139, 142, 151, 153, 160, 164, 169
diseases, 9, 37, 45, 51, 52, 54, 146
distress, 160, 162, 163, 164, 167, 169
distribution, 15, 42, 99, 162
dominance, 5, 58, 100

E

earnings, 73, 74, 79, 86
economic development, ix, 1, 2, 58, 61, 98, 107, 108, 130
economic growth, 8, 9, 21, 111
economic independence, 22, 26, 73
economic status, 2, 45, 52, 58, 59, 61, 65, 66, 105
educated women, 22, 42, 66
education, xi, xii, 3, 10, 17, 18, 28, 39, 42, 53, 54, 61, 63, 65, 67, 71, 73, 76, 77, 78, 91, 96, 100, 102, 104, 105, 114, 115, 116, 117, 119, 126, 129, 130, 132, 139, 140, 151, 155, 156, 159, 171, 173
electronic-governance, 122
employees, 15, 164, 165
employment, xiii, 4, 8, 10, 19, 22, 23, 28, 29, 38, 76, 80, 119, 126, 142, 154, 155, 158, 160, 163, 164
employment opportunities, 8, 11, 22, 29
empowerment, vii, xi, 3, 4, 5, 8, 11, 18, 22, 57, 58, 59, 60, 61, 62, 63, 64, 66, 67, 68, 69, 72, 73, 74, 75, 77, 78, 92, 98, 103, 105, 108, 127, 132, 133, 134, 136, 139, 141, 143, 150, 151, 158, 161, 170, 171
empowerment and discrimination, 136
encouragement, xvi, 2, 16, 118
energy, 38, 45, 46, 47, 48, 49, 50, 51, 154, 167

Index

entrepreneurs, ix, xii, 1, 2, 3, 4, 6, 7, 10, 11, 12, 13, 15, 16, 17, 18, 19, 77, 82, 90, 108, 109, 110, 111, 112, 113, 114, 115, 116, 117, 118, 119, 120
entrepreneurship, xii, 2, 3, 5, 6, 7, 13, 18, 19, 20, 107, 108, 109, 110, 111, 113, 114, 115, 116, 117, 118, 119, 120
environment, 9, 11, 24, 30, 39, 99, 102, 103, 112, 155
equality, 19, 26, 64, 72, 76, 96, 98, 102, 136, 140, 141, 143, 150, 151, 159
equipment, x, 54, 88, 89
evidence, 38, 156, 161, 167
exercise, 48, 49, 97
expertise, 3, 111, 113
exploitation, 58, 63, 68, 75, 158, 159, 163, 164, 167

F

families, 8, 14, 15, 17, 29, 40, 46, 64, 65, 67, 87, 99, 101, 114, 154, 155, 156, 157, 160, 162, 165, 169
family members, xv, 64, 92, 151, 153, 162, 165
family planning, x, 37, 54
financial, ix, xi, 2, 4, 8, 10, 12, 16, 18, 53, 67, 72, 73, 74, 75, 77, 78, 79, 82, 88, 89, 90, 91, 92, 107, 109, 115, 117, 118, 119, 131, 154, 162
financial connectivity, vii, xi, 71, 72, 92
financial inclusion, xi, 72, 74, 77, 78, 92, 93
food, 37, 39, 40, 42, 45, 46, 47, 48, 50, 51, 52, 53, 77, 90, 157
freedom, xiii, 30, 60, 76, 103, 125, 136, 141, 143, 156, 166
fruits, 45, 79, 82
funds, 12, 59, 65, 88, 116

G

GDP, 2, 5, 155, 164
gender disparity, xiii, 5, 7, 16, 19, 153, 154, 155, 158, 159, 169
gender equality, 22, 76, 77, 102, 105, 126, 139
gender inequality, 98, 105, 131, 137
gender role, ix, 2, 17, 99, 102, 170
gender sensitivity, viii, xii, 95, 96, 97, 98, 102, 103, 104
gender-sensitive, 103, 104, 105
globalization, vii, x, 21, 22, 23, 24, 25, 26, 27, 28, 29, 30, 31, 32, 33, 45, 108, 114, 119, 120, 126, 134
good-governance, 122
governance, x, xii, 24, 121, 122, 124, 125, 126, 127, 128, 129, 130, 131, 132, 133, 134, 141
governments, 36, 54, 96, 99, 151, 159
growth, 2, 3, 4, 7, 11, 12, 13, 15, 19, 25, 26, 27, 28, 30, 45, 46, 53, 64, 74, 77, 108, 114, 130, 132, 133, 158, 164
guilty, 145, 154, 166

H

harassment, 30, 31, 129, 163, 164, 167
health, vii, x, 9, 10, 14, 35, 36, 37, 40, 41, 42, 45, 46, 51, 52, 53, 54, 55, 73, 77, 78, 89, 101, 108, 109, 110, 113, 154, 155, 163, 165, 167, 168, 169, 170, 171, 174
health care, x, 35, 41, 52, 101
health care system, x, 35, 101
health problems, x, 14, 54
Hindu Code Bill, viii, xiii, 135, 136, 144, 147, 149, 150
history, 5, 41, 151
homes, 12, 30, 102, 105
host, 12, 163, 165

human, xiii, 22, 24, 37, 38, 52, 78, 100, 136, 137, 138, 143, 150, 155, 158, 163
human rights, xiii, 22, 31, 32, 33, 136, 137, 138, 143, 150, 152
husband, 60, 86, 91, 103, 145, 146, 156, 157
hygiene, 18, 39, 54

I

identity, 102, 109, 136, 139, 170
ideology, xii, 24, 26, 60, 121
illiteracy, 28, 54, 58, 129, 133
income, 5, 11, 27, 39, 54, 65, 75, 77, 80, 84, 86, 109, 154
independence, xiii, 8, 9, 10, 26, 30, 37, 68, 74, 78, 107, 109, 125, 136, 138, 140, 141, 154, 160
individuals, 1, 3, 6, 10, 15, 24, 25, 30, 97, 103, 137, 151, 162, 169
industry, 19, 23, 27, 29, 48, 110, 118, 127
Information and Communication Technologies, 122, 123, 133
information technology, x, 123, 124, 127
inheritance, 137, 145, 156
institutions, 59, 61, 62, 67, 79, 99
integration, x, 25, 104
issues, x, xii, xiii, 2, 3, 7, 10, 12, 14, 18, 24, 36, 42, 45, 52, 53, 54, 55, 95, 97, 102, 104, 105, 117, 119, 129, 132, 136, 150, 153, 162, 163, 165, 169, 170

L

labor force, 5, 154, 155, 163, 164
laws, 23, 30, 62, 77, 103, 142, 147, 149, 150, 151
leadership, 62, 66, 102, 111, 112, 141
life expectancy, x, 35, 55, 58, 101
light, ix, 45, 47, 51, 65, 91
literacy, 15, 45, 61, 79, 88, 89, 92, 129

loans, 16, 29, 79, 80, 82, 84, 85, 86, 87, 88, 91, 92, 116
love, xvi, 112, 167

M

majority, 23, 30, 37, 58, 119, 123, 137, 138, 141, 149, 162, 169
malnutrition, 37, 45, 47, 51, 53, 56, 101
management, 23, 88, 165, 168
marketing, 12, 77, 88, 89, 90, 118
marriage, xi, 71, 73, 76, 77, 137, 139, 140, 145, 146, 147, 148, 150, 156, 157, 159
married women, 115, 167
matter, iv, 118, 145, 148
media, 15, 27, 30, 68, 99, 126, 132
medical, x, 54, 73, 97, 160
mental health, 154, 155, 163, 165, 167, 168, 169
middle class, 26, 46, 47, 50, 63, 117
mission, 2, 68, 78, 128, 133, 139
motivation, 10, 76, 116

N

NGOs, 33, 36, 55, 117, 124, 132
nutrition, xii, 37, 40, 45, 46, 47, 53, 55, 77, 100
nutritional status, 36, 41

O

obstacles, ix, 18, 28
Odisha, vii, ix, 1, 2, 6, 7, 8, 9, 10, 12, 13, 14, 15, 16, 17, 18, 19, 153
officials, 65, 66, 125
opportunities, xi, xii, 10, 15, 17, 22, 26, 29, 30, 36, 41, 53, 73, 75, 76, 81, 89, 100, 104, 107, 111, 113, 115, 117, 119, 126, 132, 133, 150, 160

oppression, xii, 95, 97, 143, 158
organize, 17, 62, 67, 132

P

parents, xv, 12, 38, 40, 62, 97, 103, 105, 165
parity, 3, 18, 151, 154, 155, 156, 160
Parliament, 61, 64, 105, 110, 144, 149
personality, 17, 36, 91, 139
platform, xii, 4, 10, 22, 26, 121, 128, 139
playing, 6, 74, 80, 165
pleasure, xv, 111, 114, 119
policy, 23, 27, 77, 91
politics, 23, 27, 58, 67, 68, 138, 141, 159
population, x, 2, 6, 24, 35, 36, 37, 38, 41, 42, 48, 53, 75, 97, 159, 164, 165, 168
poverty, x, 3, 8, 10, 24, 28, 37, 126, 129, 133, 147
principles, 24, 59, 136
project, xv, 112, 128, 129
protection, 9, 118, 142, 159
proteins, 38, 46, 47

R

race, 110, 111, 142
radio, 27, 28, 91
recognition, xiii, 90, 118, 135, 150
relatives, 76, 101, 116
relevance, 61, 108, 138
religion, 62, 76, 110, 131, 142, 143, 145, 146, 149
resources, 13, 72, 73, 89, 99, 100, 125, 152
restrictions, 75, 107, 144, 145, 146
rights, iv, x, xiii, 3, 10, 13, 16, 22, 23, 24, 25, 27, 28, 30, 31, 57, 58, 60, 63, 68, 76, 91, 100, 119, 135, 136, 137, 138, 140, 141, 142, 143, 144, 145, 150, 151, 152, 157, 158, 160, 164, 173
rules, 16, 79, 146

rural, vii, x, xi, 4, 7, 8, 12, 14, 16, 18, 26, 27, 28, 29, 36, 37, 40, 41, 42, 43, 45, 46, 50, 51, 52, 53, 54, 56, 58, 59, 62, 65, 67, 68, 69, 71, 72, 73, 74, 75, 76, 77, 78, 79, 80, 81, 82, 84, 86, 89, 90, 92, 93, 108, 116, 125, 126, 127, 129, 130, 131, 133, 160, 173
rural areas, 12, 26, 27, 28, 37, 41, 42, 45, 46, 50, 51, 53, 58, 59, 67, 81, 116, 125, 127, 129, 130, 131, 160
rural population, x, 36, 40, 53
rural women, xi, 7, 8, 9, 36, 41, 42, 43, 45, 50, 51, 52, 53, 54, 58, 72, 74, 75, 78, 79, 80, 86, 90, 92, 93, 127, 132, 133

S

savings, 73, 74, 78, 79, 85, 87, 88, 116
school, xii, 11, 28, 38, 39, 40, 42, 61, 67, 87, 89, 90, 91, 95, 96, 99, 101, 102, 103, 105, 140, 146, 148, 151, 174
scope, 24, 123, 126, 137, 165
security, 53, 77, 88, 110, 115, 153, 160, 169
self-confidence, 26, 105, 131
self-esteem, 16, 17, 105
sensitivity, 96, 97, 98, 102, 103, 104, 105
sensitization, 17, 96, 98
services, iv, xi, 22, 23, 26, 28, 72, 73, 74, 78, 80, 82, 86, 89, 90, 91, 110, 114, 123, 124, 128, 129, 131, 132
sex, 6, 39, 40, 61, 98, 101, 103, 142, 159, 166, 167
sex ratio, 6, 61, 101, 159
sexual harassment, 28, 58, 77
social change, 3, 108, 110, 159
social enterprises, vii, ix, 1, 2, 3, 8, 10, 16, 18
social justice, 24, 59, 133, 136
social life, 104, 109, 117
social status, 6, 58, 61, 68, 92, 157

society, xi, xii, xiii, 2, 10, 11, 12, 13, 16, 17, 21, 26, 28, 36, 45, 52, 59, 60, 61, 62, 63, 65, 68, 71, 72, 73, 75, 76, 95, 97, 98, 99, 100, 102, 103, 104, 105, 108, 109, 110, 111, 114, 117, 119, 125, 127, 130, 131, 133, 136, 137, 138, 140, 141, 143, 150, 151,154, 156, 157, 158, 159, 161, 162, 169
stereotypes, ix, 2, 17, 103, 154, 155, 169
stress, xiii, 37, 61, 154, 155, 162, 163, 164, 165, 166, 167, 168, 169, 170
structure, 15, 68, 105, 129, 130, 131, 137, 143
survival, 13, 96, 108

T

teachers, 40, 102, 103, 104, 105
technology, x, xiii, 1, 12, 21, 24, 28, 116, 118, 121, 122, 123, 124, 125, 126, 127, 130, 132, 133, 134, 153
thoughts, xii, 102, 114, 143
tobacco, 38, 53, 161
traditions, 76, 91, 112
training, ix, 2, 15, 17, 28, 30, 62, 68, 78, 80, 87, 88, 89, 103, 104, 105, 115, 126, 164, 168, 169
transactions, 79, 83, 85
transformation, 22, 25, 107, 123, 133
transparency, 124, 128, 132
treatment, 37, 58, 73, 101, 136

U

urban, x, xi, 4, 7, 9, 10, 26, 29, 36, 37, 40, 41, 42, 44, 45, 46, 50, 51, 52, 53, 54, 58, 64, 120, 126, 127, 131, 133, 155, 160, 162
urban areas, 9, 26, 37, 42, 45, 46, 50, 51, 52, 126, 131, 155, 160
urban population, 45, 46, 53

V

vegetables, 39, 40, 45, 46, 47, 79, 82
violence, 3, 95, 100, 126

W

wages, 28, 31, 154, 155
welfare, 23, 30, 63, 77, 126, 141, 156
well-being, 1, 3, 8, 18, 37, 114, 163
women empowerment, xi, 4, 11, 18, 22, 60, 64, 66, 67, 68, 69, 72, 73, 74, 75, 77, 78, 92, 98, 104, 108, 127, 133, 143, 151, 158, 160, 171
women entrepreneurs, viii, ix, xii, 1, 2, 3, 4, 6, 7, 11, 13, 15, 16, 17, 18, 19, 90, 107, 108, 109, 111, 113, 114, 115, 116, 117, 118, 119, 120
women rights, xiii, 76, 136, 140, 143, 144, 150, 151, 158, 170
workers, x, 23, 54, 113, 167, 168
workforce, 5, 160, 161, 163, 171
working hours, 38, 83, 167
working mothers, 162, 165, 166, 167
working women, viii, xiii, 27, 80, 120, 153, 154, 155, 160, 163, 164, 165, 166, 167, 168, 170, 171
workplace, 28, 30, 78, 85, 164, 166, 167
World Bank, 24, 29, 32, 106, 157
worldwide, 22, 25, 107

Imperial Maladies: Literatures on Healthcare and Psychoanalysis in India

Editors: Pritha Kundu and Debashis Bandyopadhyay

Series: Countries and Cultures of the World

Book Description: The thrust-area of this book is the connection between imperial anxieties and tropical health situations along with intriguing psychological questions involving race, politics, gender, history and colonial modernity.

Hardcover ISBN: 978-1-53611-863-6
Retail Price: $195

Reports on British Prison-Camps in India and Burma

Author: Oscar Moten

Series: Political Science and History

Book Description: This book is a compilation of the reports by the International Red Cross Committee on the British Prison-Camps in India and Burma in February, March and April 1917. The British camps in India and Burma for Turkish prisoners of war and civil residents in the Indian Empire of enemy nationality were visited by three accredited representatives of the Red Cross.

eBook ISBN: 978-1-53613-778-1
Retail Price: $82

The Wetlands of India

Author: Krishna Mazumdar

Series: Coastal and Oceanic Landforms, Development and Management

Book Description: Wetlands in India are distributed from the cold arid Trans-Himalayan zone to the wet Teri region of the Himalayan foothills, to the Gangetic plains extended to the flood-plains of Brahmaputra, and to the swamps of Northeastern India including the saline expanses of Gujarat and Rajasthan.

Hardcover ISBN: 978-1-53612-041-7
Retail Price: $160

Rural Development and Management in India: Opportunities and Challenges

Editors: Manish Didwania, Nitin Kishore Saxena and Sanjeev Prashar

Series: Countries and Cultures of the World

Book Description: Research related to rural development in India is almost non-existent, and this book provides a window into the challenges that are faced in rural India. This book presents a window into the need for education in this subject at the same.

Softcover ISBN: 978-1-53611-864-3
Retail Price: $82